GIOVANNI ANSELMO

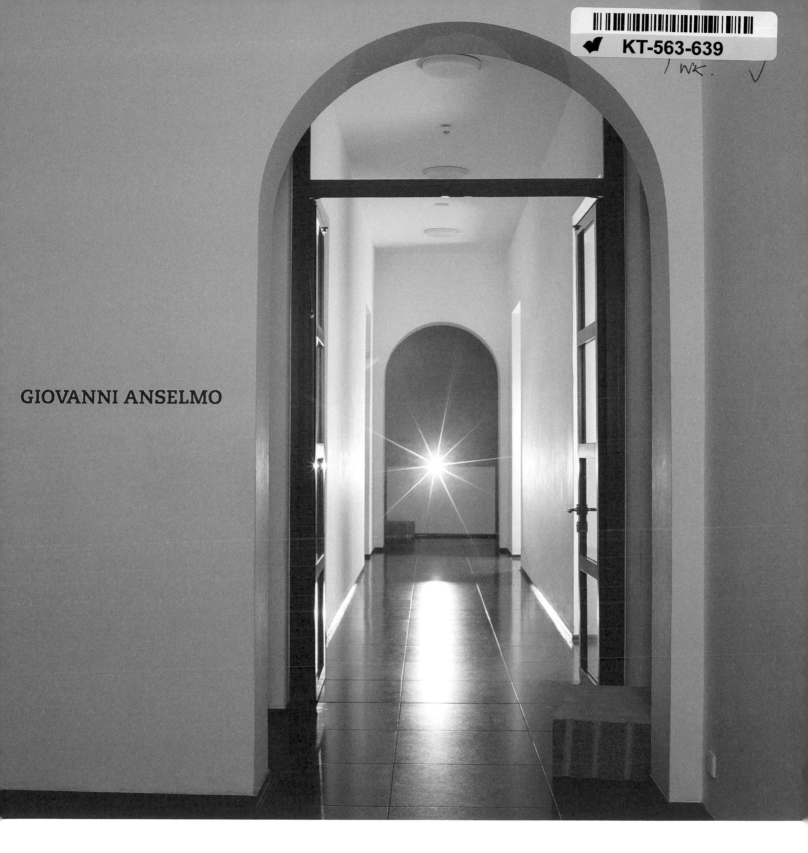

Where the stars are coming

one span closer

in the panorama towards 'oltremare',

with the hand pointing to it,

Wo die Sterne

eine Spanne näher kommen

im Panorama Richtung 'oltremare'

mit der Hand, die darauf weist,

1. Il panorama verso oltremare dove le stelle si avvicinano di una spanna in più mentre il colore solleva la pietra, 2001
Académie de France à Rome, Villa Medici, Atelier del Bosco, Rome · Rom, 2001

2. Il panorama verso oltremare intorno dove le stelle si avvicinano di una spanna in più, 2001
Marian Goodman Gallery, New York, 2001

3. Dove le stelle si avvicinano di una spanna in più nel panorama verso oltremare con mano che lo indica, 2004
Museum Kurhaus Kleve, 2004

4. Mentre il colore solleva la pietra, 2001 (detail · Detail)
Museum Kurhaus Kleve, 2004

5. Dove le stelle si avvicinano di una spanna in più nel panorama verso oltremare con mano che lo indica, 2004 (partial view · Teilansicht)
Museum Kurhaus Kleve, 2004

6. Verso oltremare, 1984
Museum Kurhaus Kleve, 2004

7. Dove le stelle si avvicinano di una spanna in più nel panorama verso oltremare con mano che lo indica, 2004 (partial view · Teilansicht)
Museum Kurhaus Kleve, 2004

8. Il panorama con mano che lo indica, 1982 (detail · Detail)

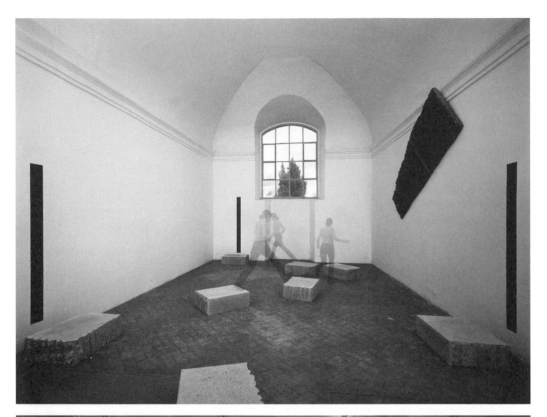

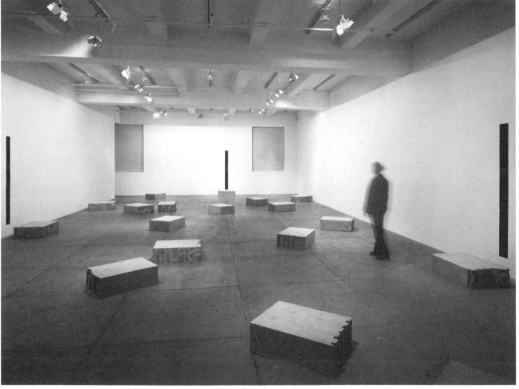

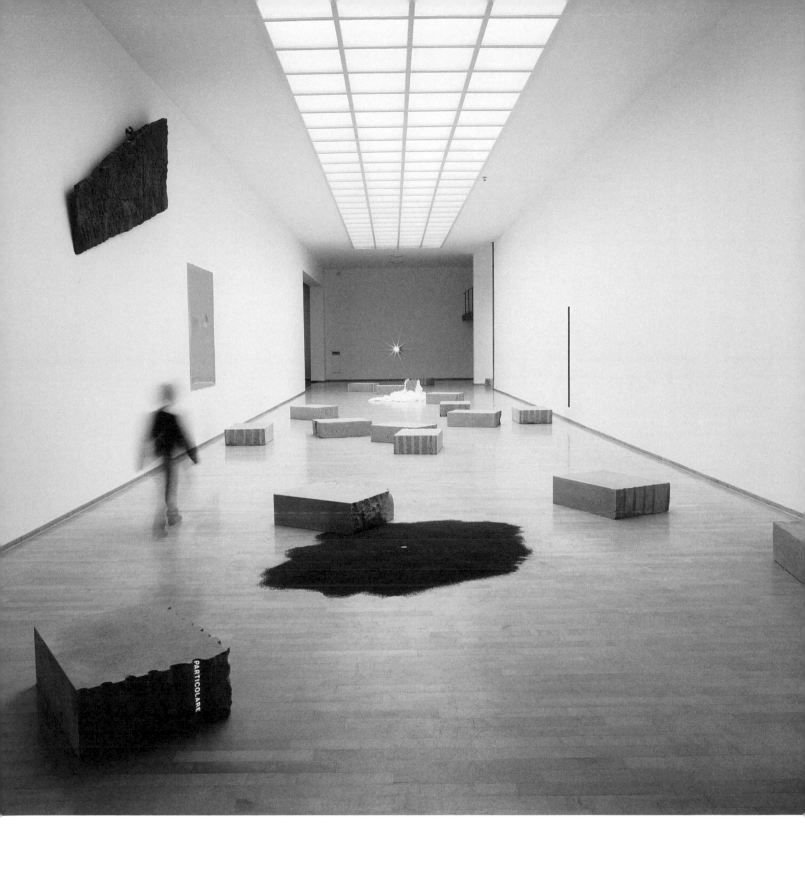

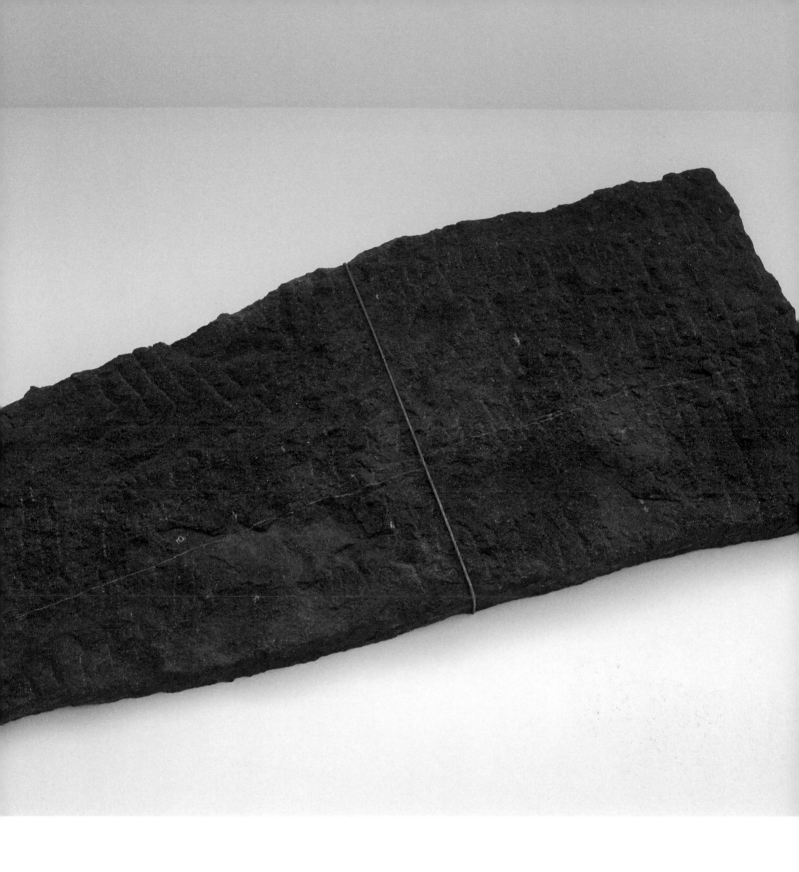

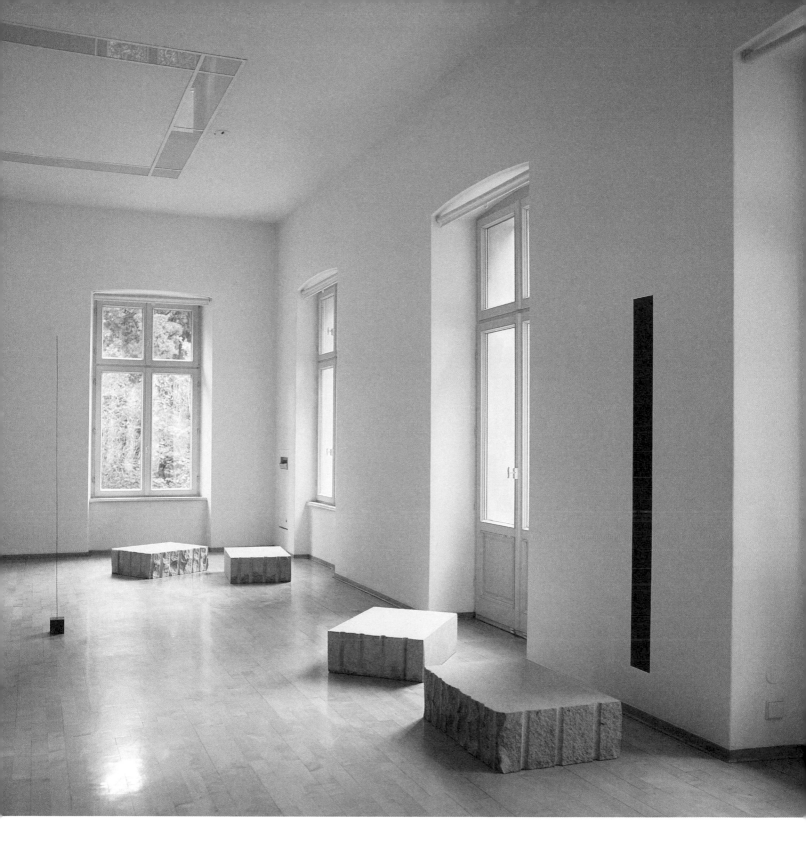

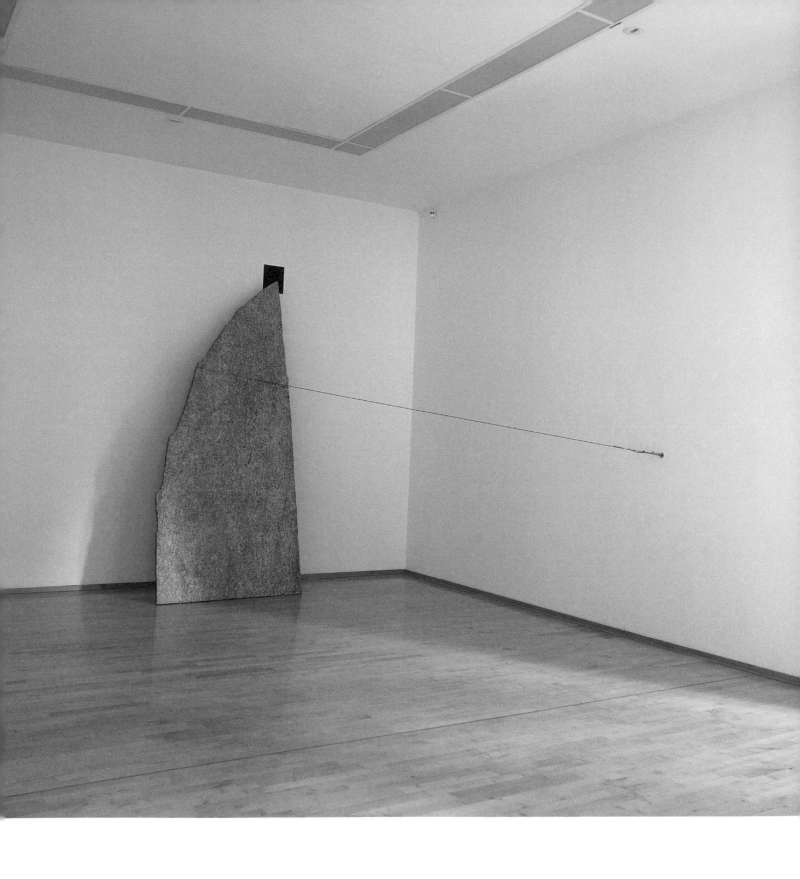

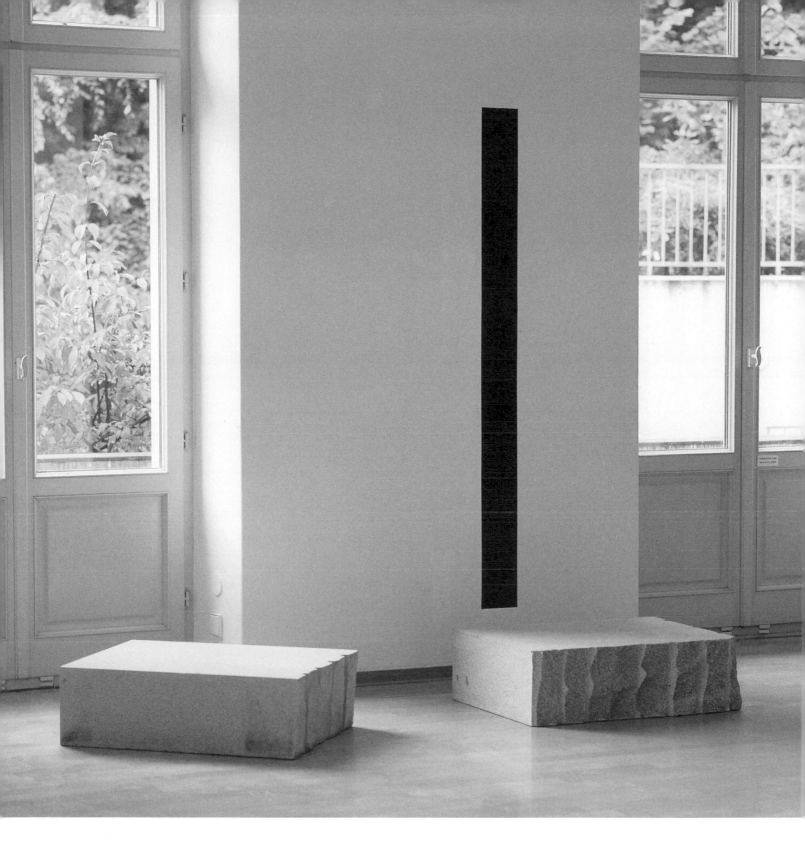

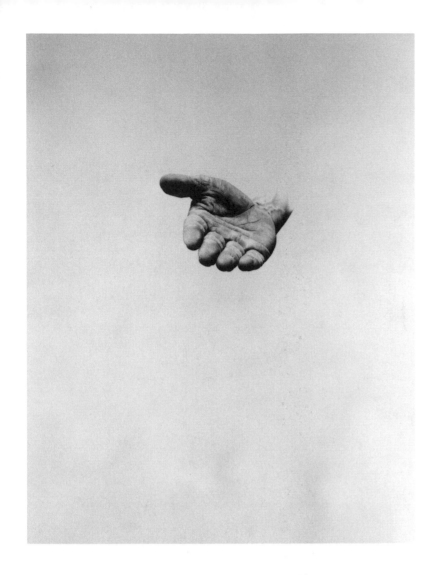

while colour lifts the stone
während die Farbe den Stein hebt,

1. Il panorama verso oltremare dove le stelle si avvicinano di una spanna in più mentre il colore solleva la pietra, 2001
Académie de France à Rome, Villa Medici, Atelier del Bosco, Rome · Rom, 2001

2. Neon nel cemento, 1967–70 · Senza titolo, 1984
Castello di Rivoli, Museo d'Arte Contemporanea, Turin

3. Senza titolo, 1966 · Senza titolo, 1991
Museum Kurhaus Kleve, 2004

4. Senza titolo, 1991 (detail · Detail)

5. Senza titolo, 1966 (detail · Detail)
Museum Kurhaus Kleve, 2004

6. Senza titolo, 1991 (detail · Detail)
Museum Kurhaus Kleve, 2004

7. Nove particolari mentre il colore solleva la pietra, 1990 (partial view · Teilansicht)
'Affinités selectives', Palais des Beaux-Arts, Brussels · Brüssel, 1990

8. L'incontro di due opere, 1987 (partial view · Teilansicht)
Galerie Durand-Dessert, Paris, 1987

9. Particolari visibili e invisibili lungo il sentiero verso oltremare mentre il colore solleva la pietra e la pietra solleva il colore, 1993 (partial view · Teilansicht)
Centre d'Art Contemporain, Geneva · Genf, 1993

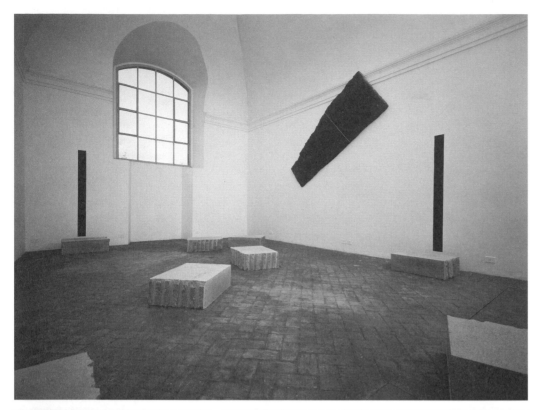

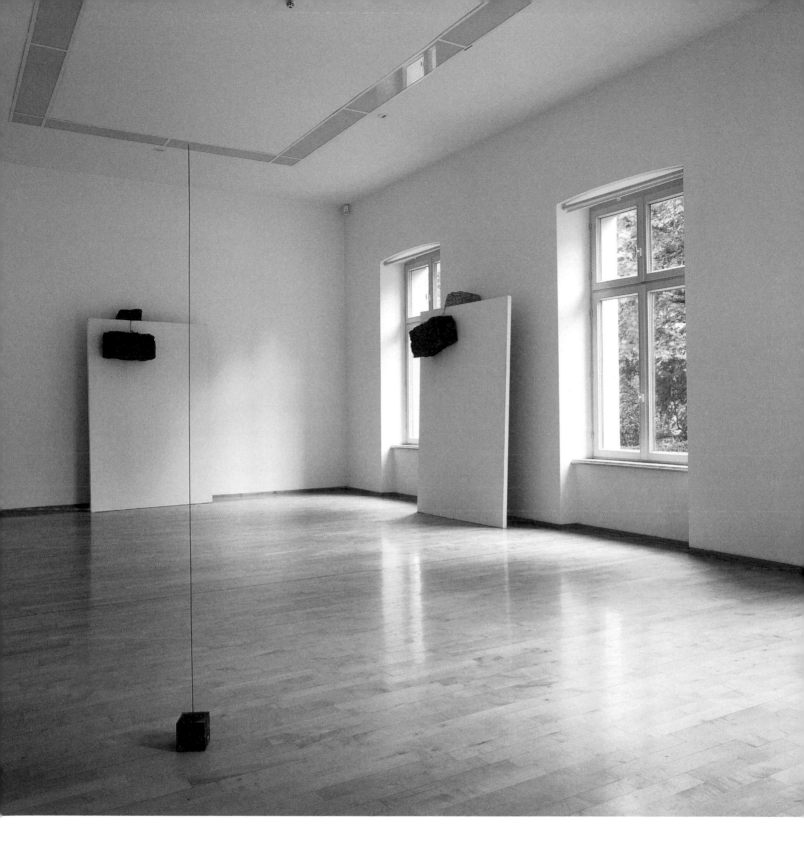

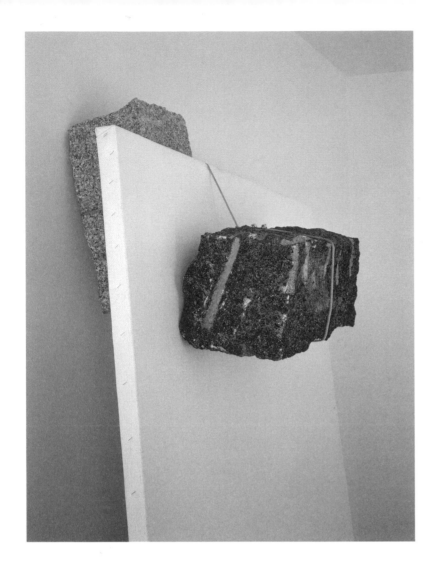

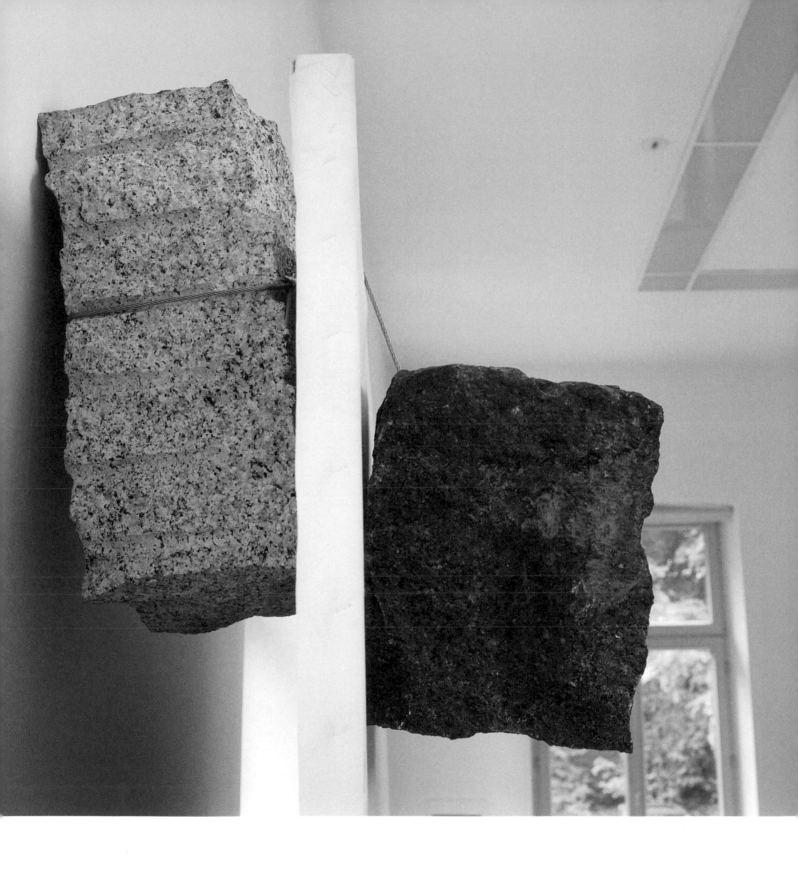

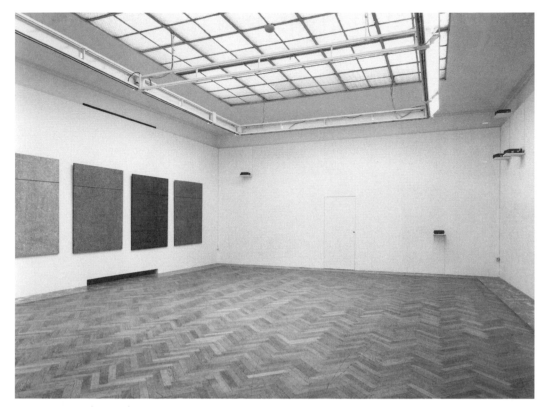

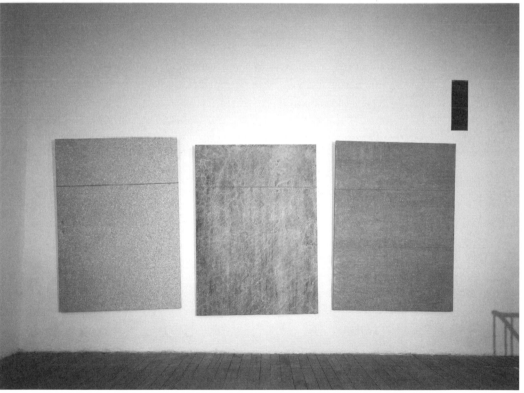

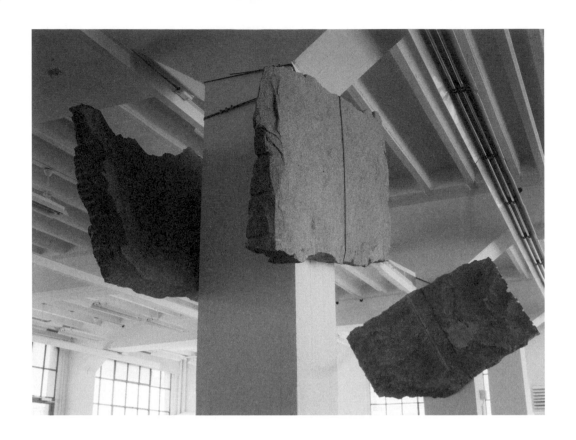

the stone lifts the canvas,

der Stein die Leinwand hebt,

1. Senza titolo, 1989-90
XLIV Biennale Interna-
zionale d'Arte di Venezia,
1990

2. Senza titolo, 1990
Museum Kurhaus Kleve,
2004

3. Senza titolo, 1990
Museum Kurhaus Kleve,
2004

**4. Senza titolo, 1990 (detail
· Detail)**
Museum Kurhaus Kleve,
2004

5. Senza titolo, 1989-90
Galerie Jean Bernier,
Athens · Athen, 1990

6. Senza titolo, 1990
Museum Kurhaus Kleve,
2004

7. Senza titolo, 1989
Marian Goodman Gallery,
New York, 1989

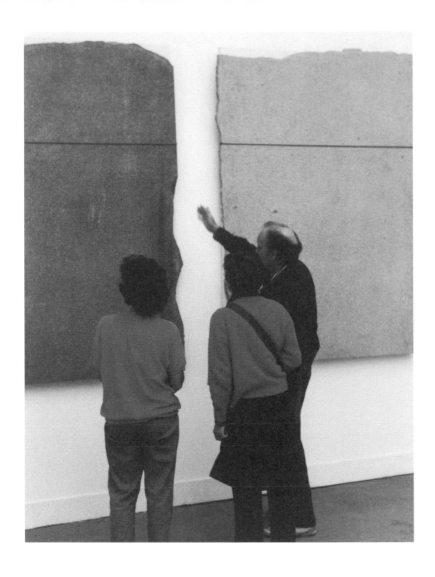

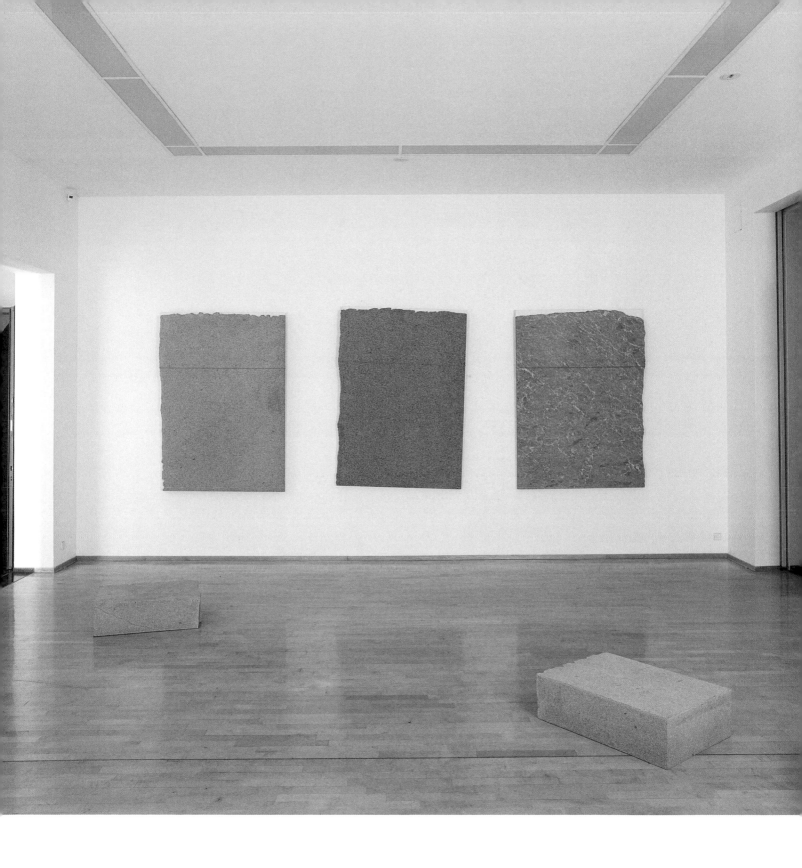

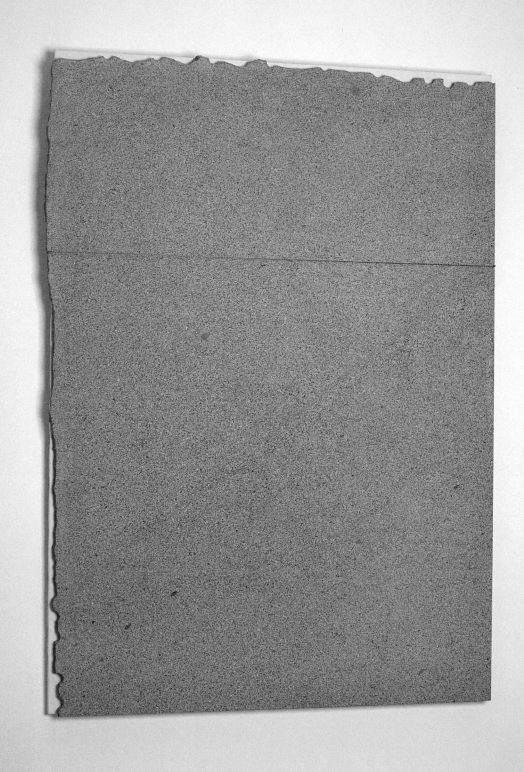

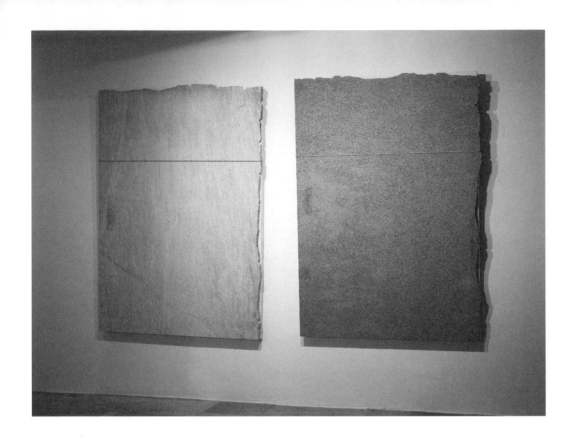

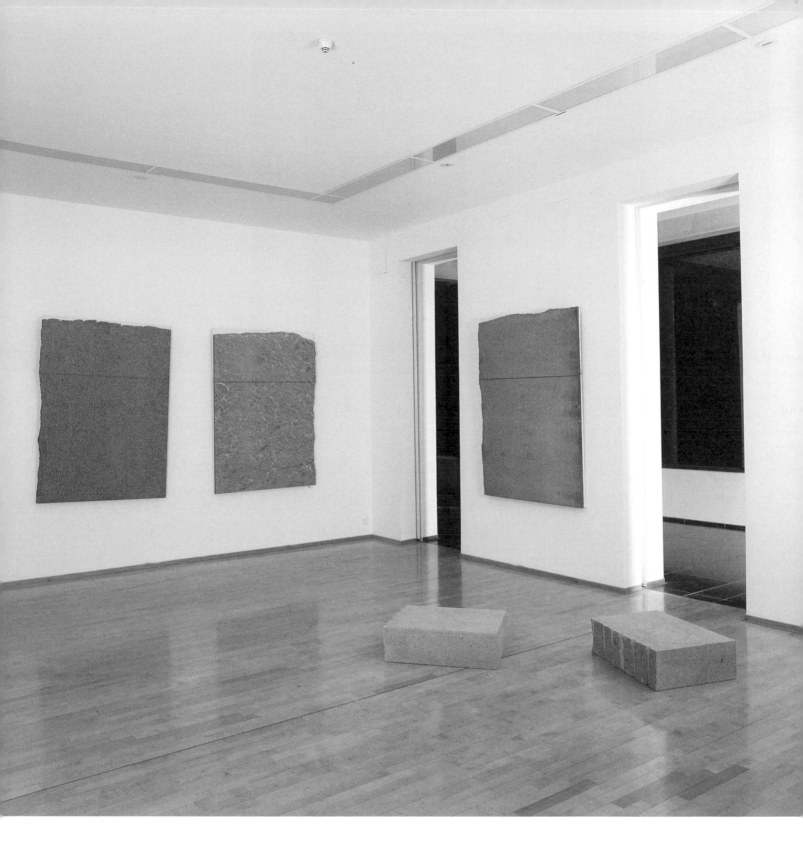

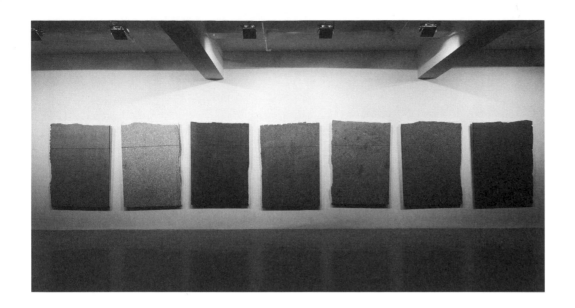

earth and stone find their bearings,
die Erde und der Stein sich ausrichten,

1. **Verso oltremare, 1984**
'Ouverture', Castello di
Rivoli, Museo d'Arte
Contemporanea, Turin,
1984

2. Musée d'Art Contemporain, Lyon, 1989

3. Musée d'Art Contemporain, Lyon, 1989

4. **Oltremare a sud-ovest e sette particolari, 1981 (partial view · Teilansicht)**
Centre Pompidou, Musée
National d'Art Moderne,
Paris, 1981

5. **Otto particolari in alto da est a sud, 1984**
Castello di Rivoli, Museo
d'Arte Contemporanea,
Turin, 1984

6. **Direzione, 2004**
Museum Kurhaus Kleve,
2004

7. **Mentre la luce focalizza e la terra si orienta, 2003 (partial view · Teilansicht)**
'Intorno a Borromini',
Palazzo Falconieri, Rome ·
Rom, 2003

8. **Mentre la luce focalizza e la terra si orienta, 2003 (partial view · Teilansicht)**
'Intorno a Borromini',
Palazzo Falconieri, Rome ·
Rom, 2003

9. **Un disegno e tre particolari a ovest, trecento milioni di anni a est, 1978 (partial view · Teilansicht)**
Studio Tucci Russo, Turin,
1978

10. **Un disegno e tre particolari a ovest, trecento milioni di anni a est, 1978 (partial view · Teilansicht)**
Studio Tucci Russo, Turin,
1978

11. **Senza titolo, 1982–86**
'Ouverture II', Castello di
Rivoli, Museo d'Arte
Contemporanea, Turin,
1986

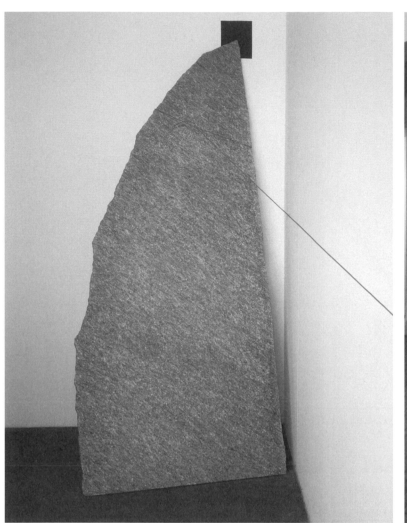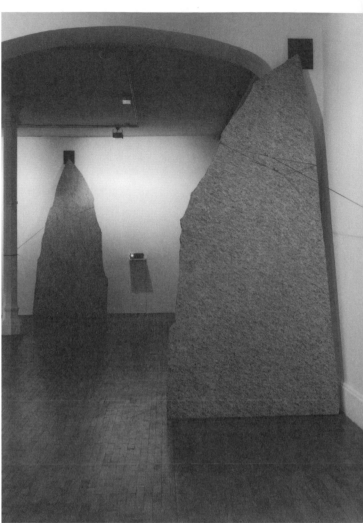

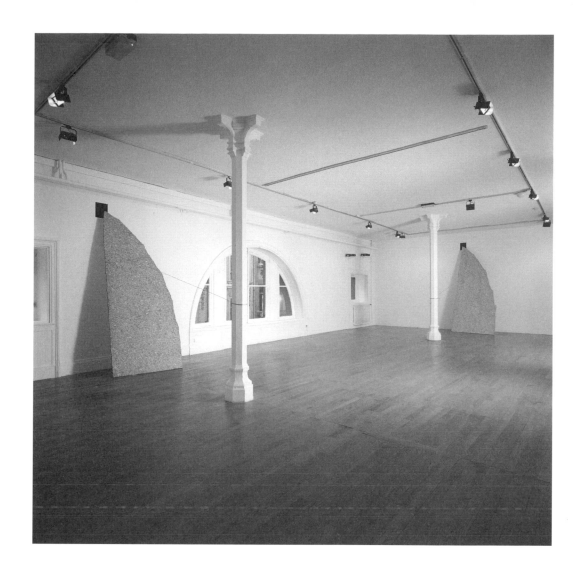

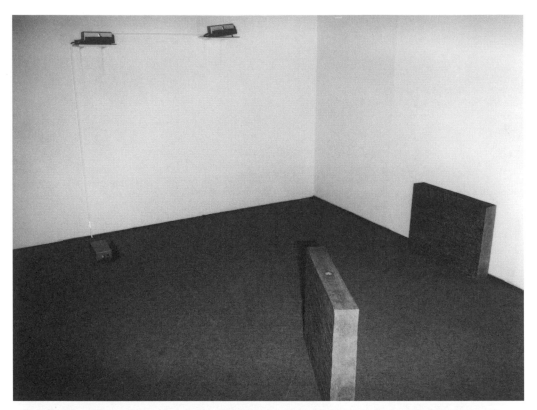

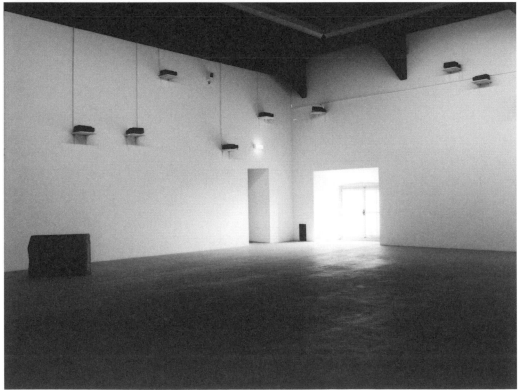

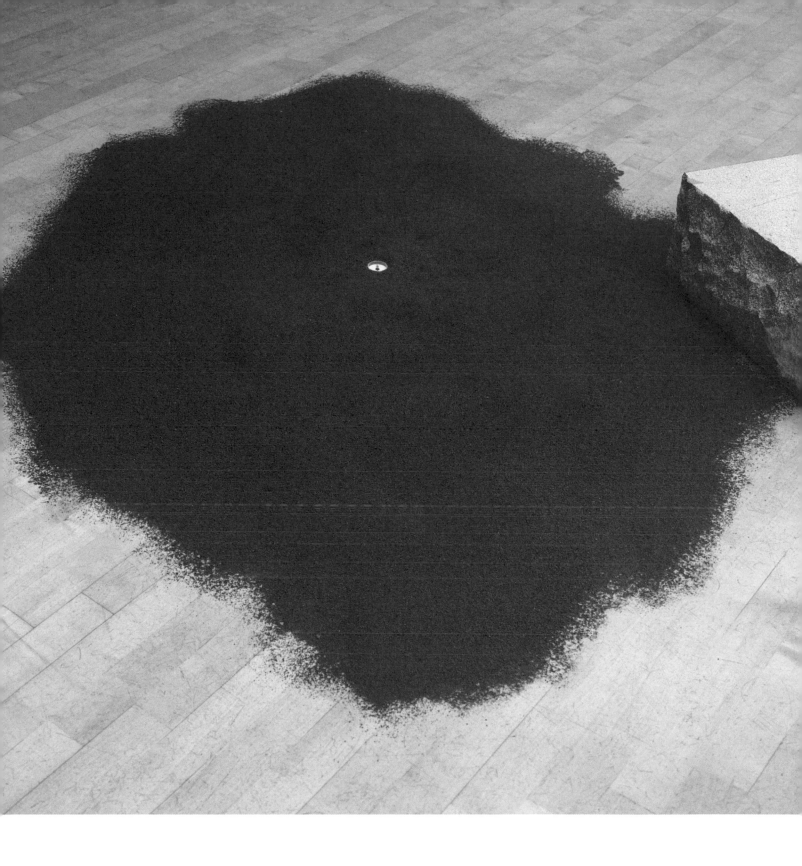

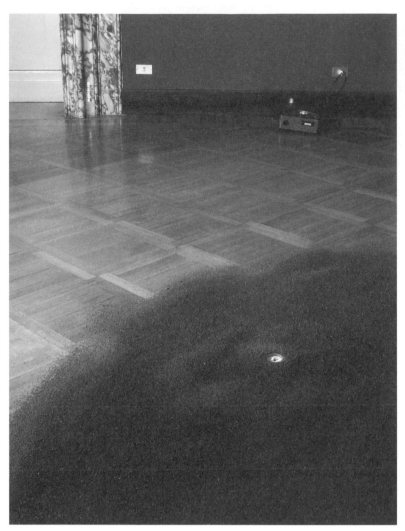
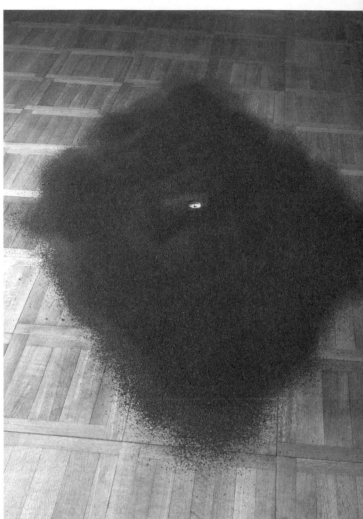

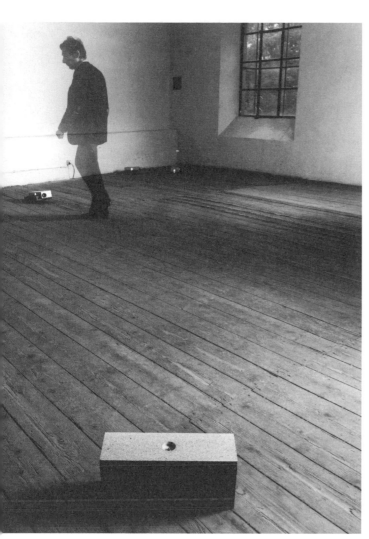
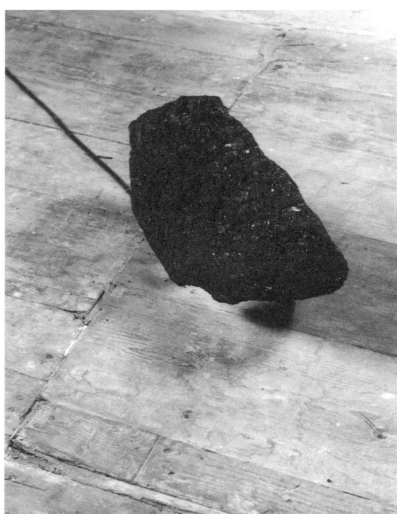

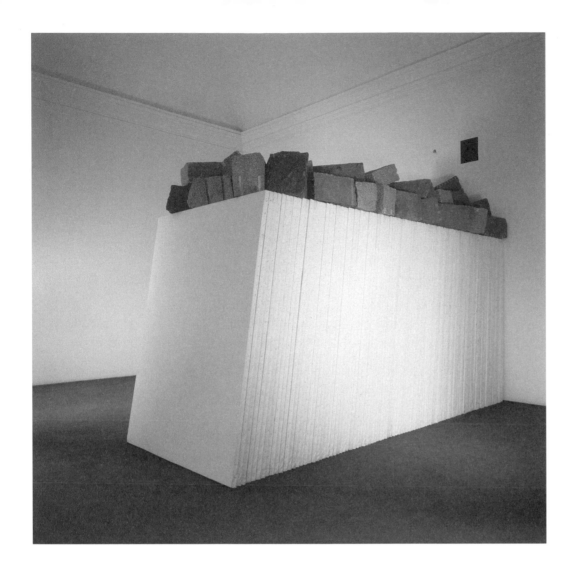

the greys become lighter,
die Grauen leichter werden,

1. Il panorama con mano che lo indica mentre verso oltremare i grigi si alleggeriscono, 1984 (partial view · Teilansicht)
'Ouverture', Castello di Rivoli, Museo d'Arte Contemporanea, Turin, 1984

2. Grigi che si alleggeriscono verso oltremare, 1986
Galerie Jean Bernier, Athens · Athen, 1986

3. Grigi che si alleggeriscono verso oltremare, 1984
'Coerenza in coerenza', Mole Antonelliana, Turin, 1984

4. Il paesaggio con mano che lo indica mentre verso oltremare i grigi si alleggeriscono, 1982 (partial view · Teilansicht)
Galleria Salvatore Ala, Milan · Mailand, 1982

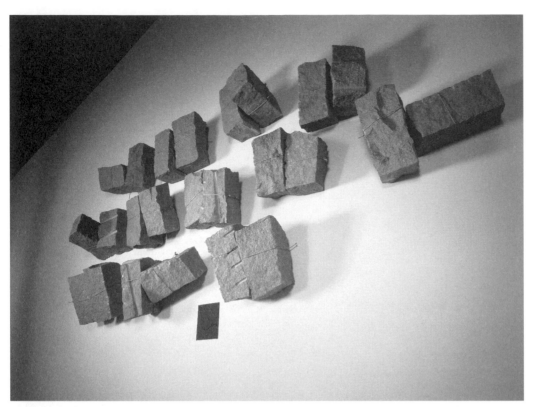

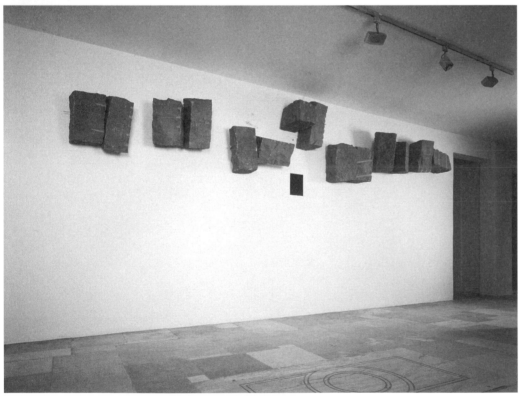

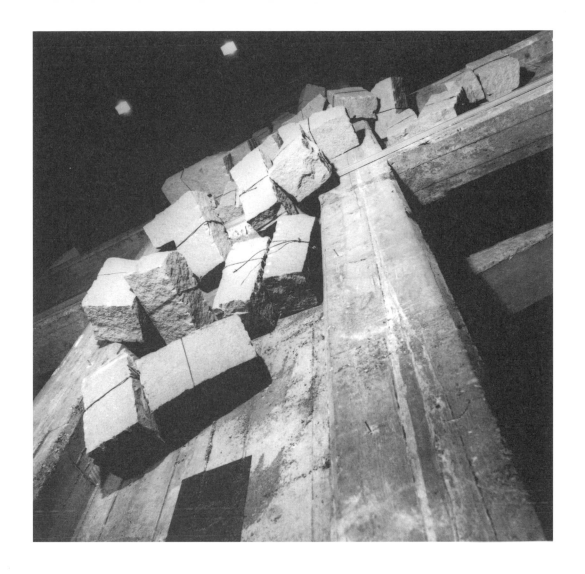

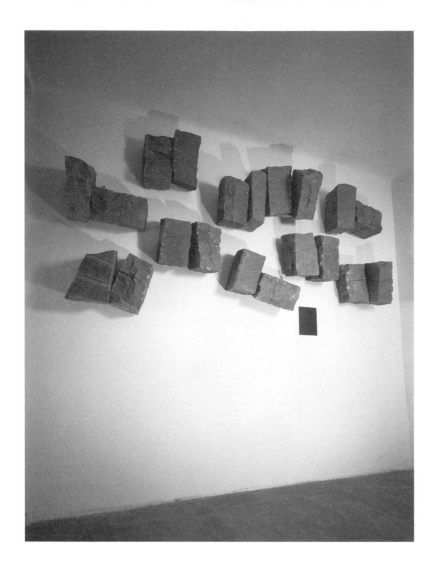

the paths guide,

die Pfade einen Weg weisen,

1. Lungo i sentieri verso oltremare, 1996 (partial view · Teilansicht)
Musée d'Art Moderne et d'Art Contemporain, Nice · Nizza, 1996

2. Senza titolo, 1968
Museum Kurhaus Kleve, 2004

3. Lungo i sentieri verso oltremare, 1996 (partial view · Teilansicht)
Musée d'Art Moderne et d'Art Contemporain, Nice · Nizza, 1996

4. Lungo i sentieri verso oltremare, 1996 (partial view · Teilansicht)
Musée d'Art Moderne et d'Art Contemporain, Nice · Nizza, 1996

5. Quattro particolari sulla terra lungo il sentiero verde-grigio chiaro, 1994
'L'oeuvre a-t-elle lieu?', Witte de With – Center for Contemporary Art, Rotterdam, 1994

6. Particolari visibili e invisibili lungo il sentiero verso oltremare, 1994 (partial view · Teilansicht)
XXII Bienal Internacional de São Paolo (Brasil · Brasilien), 1994

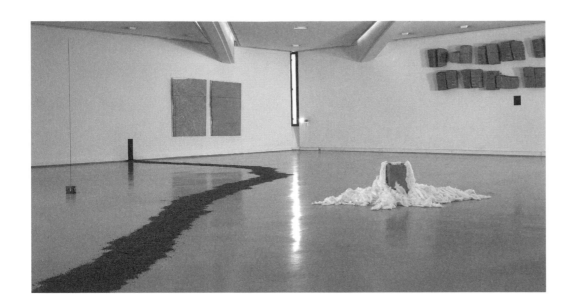

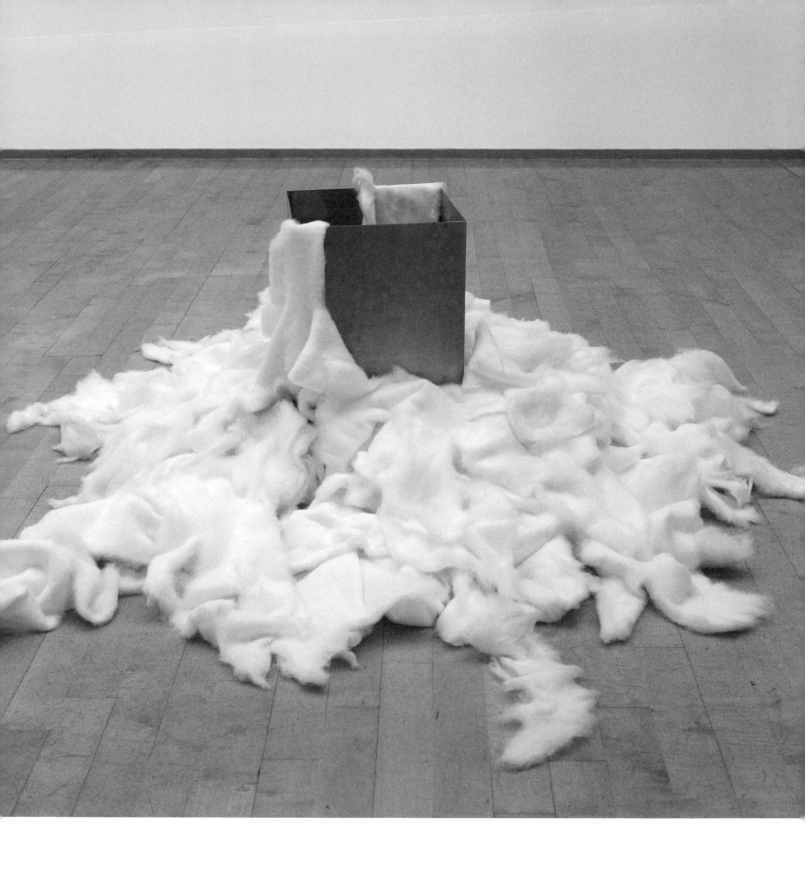

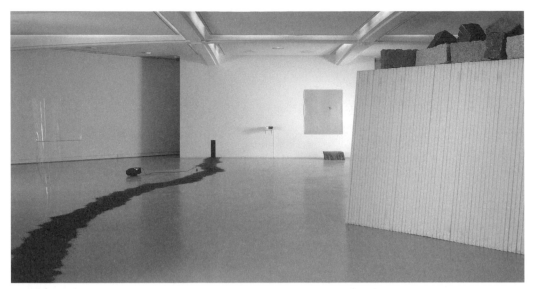

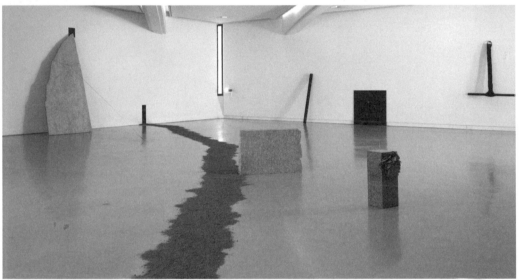

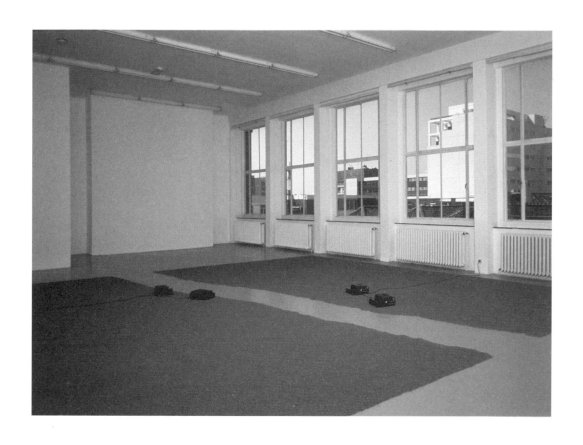

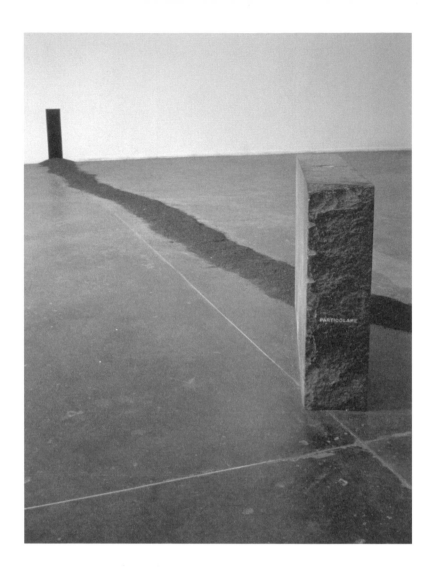

the light focuses,
das Licht fokussiert,

1. Mentre la luce focalizza e la terra si orienta, 2003 (partial view · Teilansicht) 'Intorno a Borromini', Palazzo Falconieri, Rome · Rom, 2003

2. Particolare, 1972–79 Kunsthalle Basel, 1979

3. Particolare, 1972–2004 8 projections · 8 Projektionen Museum Kurhaus Kleve, 2004

4. Particolare, 1972

5. Particolare, 1972–2004 8 projections · 8 Projektionen Museum Kurhaus Kleve, 2004

6. Particolare, 1972–2004 8 projections · 8 Projektionen Museum Kurhaus Kleve, 2004

7. Particolare, 1972–2004 8 projections · 8 Projektionen Museum Kurhaus Kleve, 2004

8. Particolare, 1972–90 5 projections · 5 Projektionen 'Die Endlichkeit der Freiheit', apartment · Wohnung Meyer, Pasteurstraße 40, Berlin, 1990

9. Particolare, 1972–2004 8 projections · 8 Projektionen Museum Kurhaus Kleve, 2004

10. Particolare, 1972–74 16 projections · 16 Projektionen Sperone Gallery, New York, 1974

11. Particolare, 1972–2004 8 projections · 8 Projektionen Museum Kurhaus Kleve, 2004

12. Particolare, 1972–95 7 projections · 7 Projektionen '1965–1975. Reconsidering the Object of Art', The Museum of Contemporary Art, The Temporary Contemporary, Los Angeles, 1995

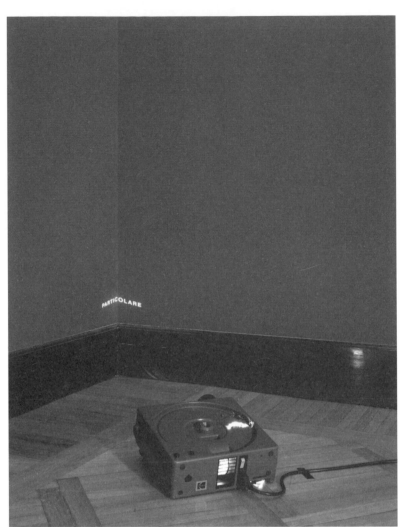

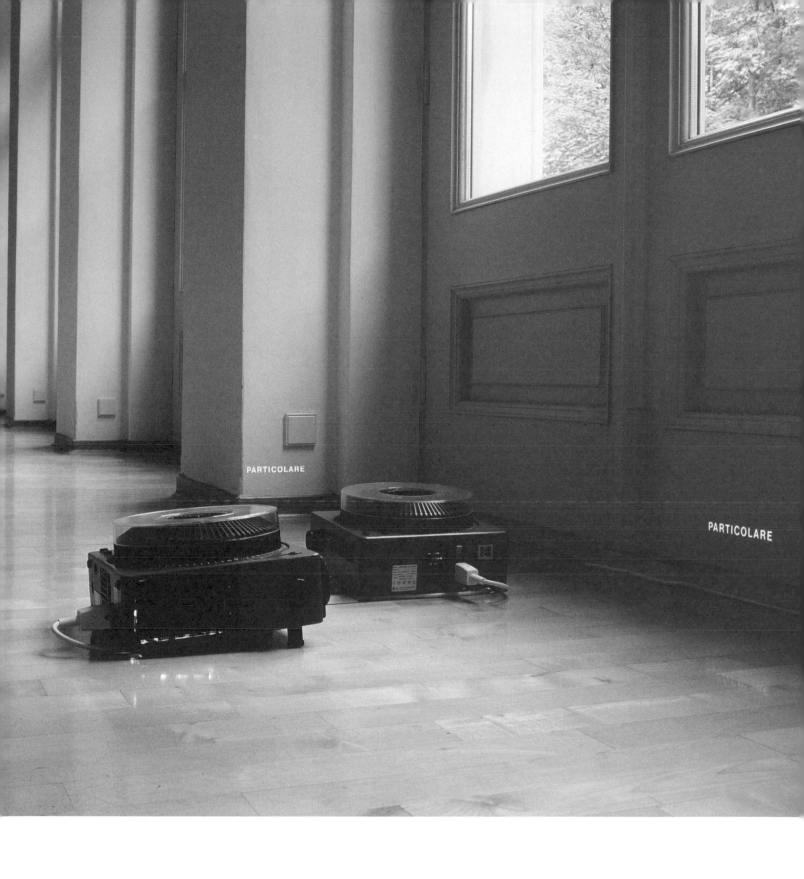

PARTICOLARE

PARTICOLARE

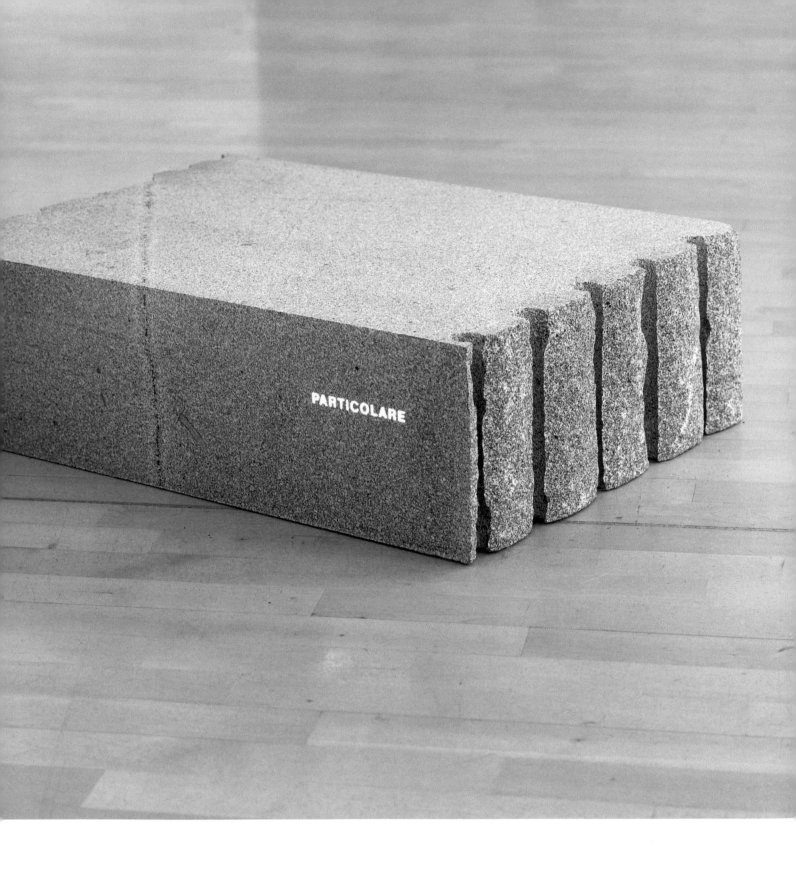

PARTICOLARE

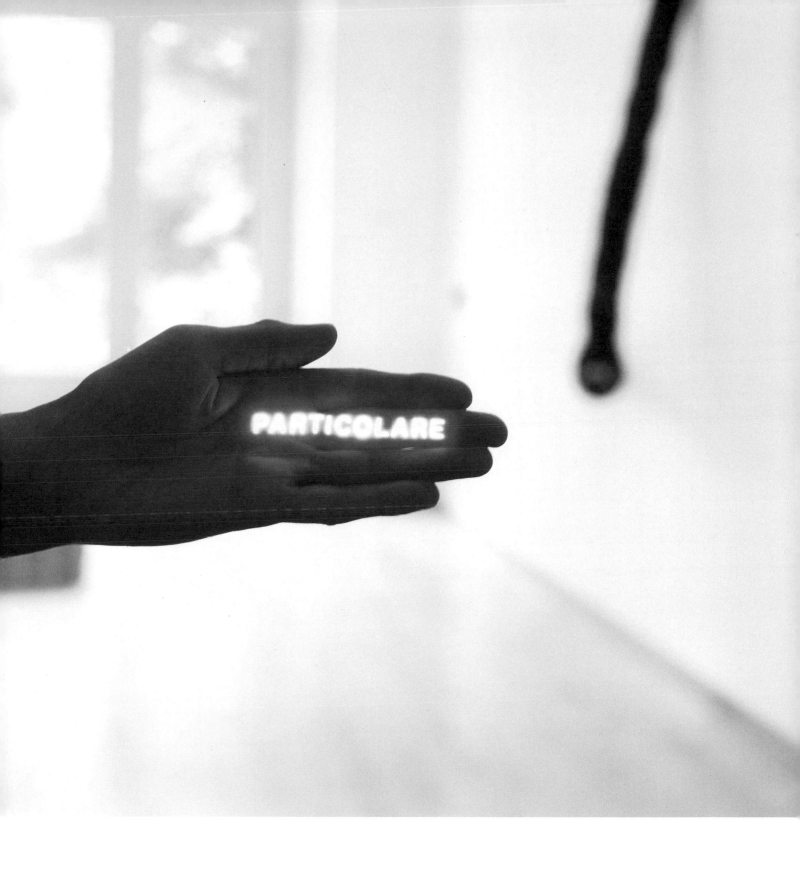

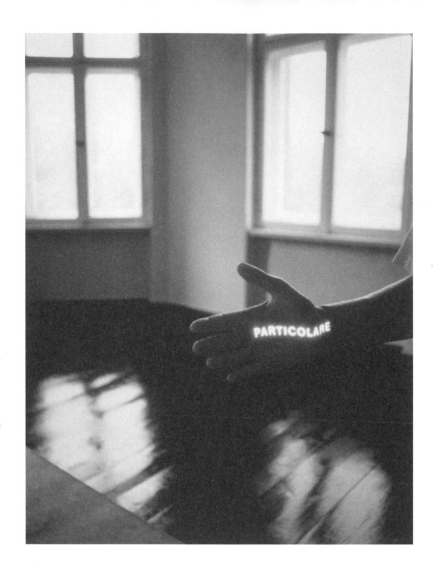

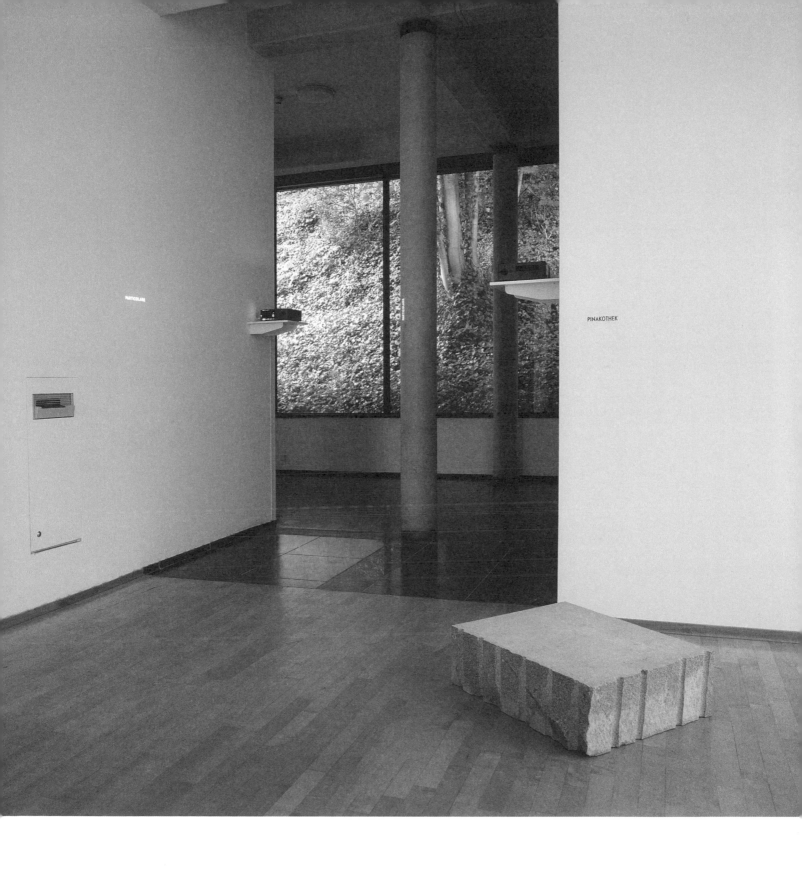

PARTICOLARE

PINAKOTHEK

55

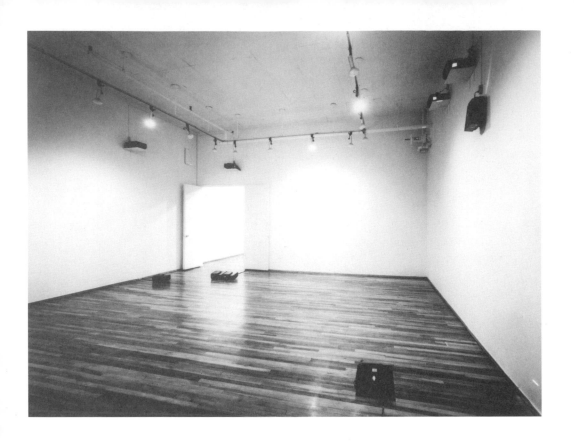

PARTICOLARE

one enters the work,
man in das Werk eintritt,

1. Entrare nell'opera, 1971
Per un'incisione di indefi-
nite migliaia di anni, 1969
Museum Kurhaus Kleve,
2004

2. Senza titolo, 1990
(partial view · Teilansicht)
Museum Kurhaus Kleve,
2004

3. Entrare nell'opera, 1971

4. 'Zero to Infinity: Arte
Povera 1962–1972', Walker
Art Center, Minneapolis,
2001/02

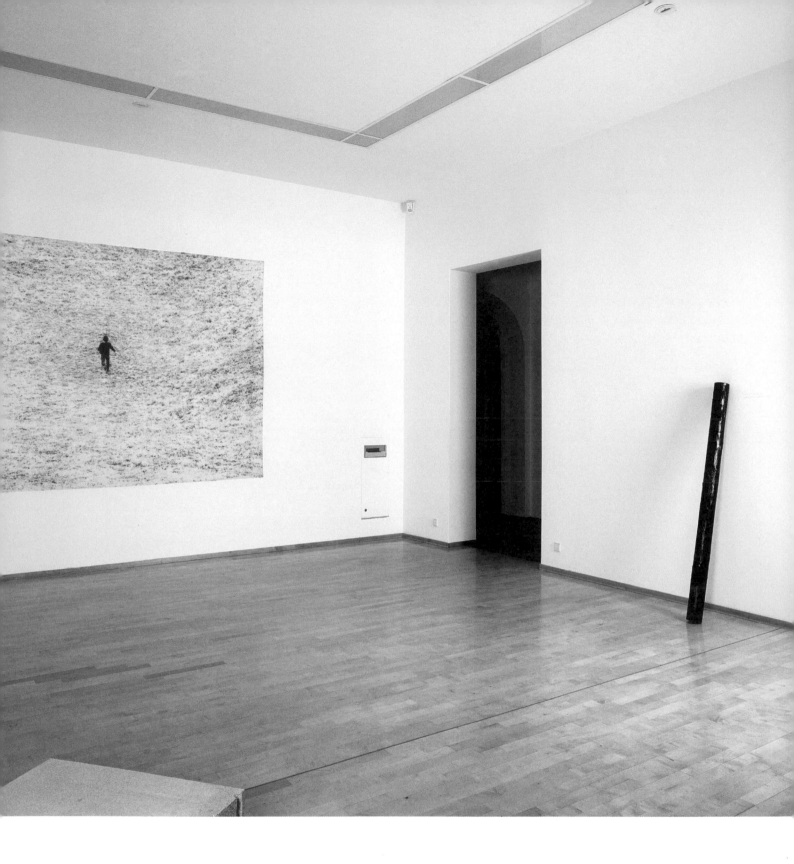

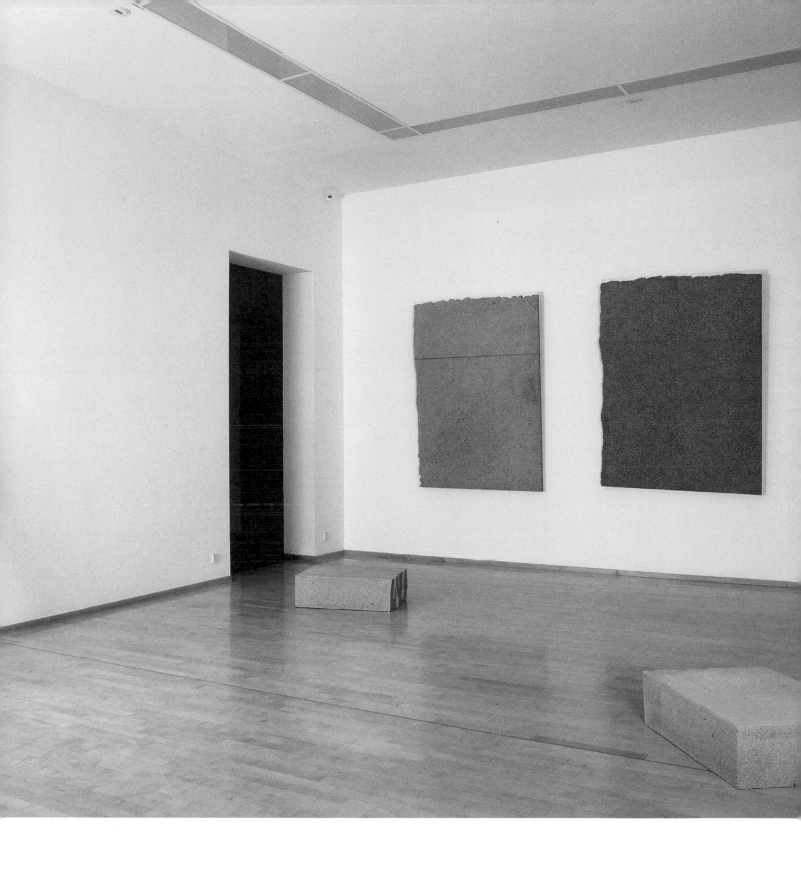

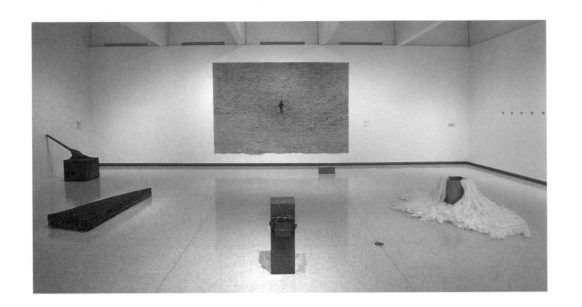

the lettuce is always fresh,

der Lattich immer frisch ist,

1. Senza titolo, 1968
(detail · Detail)
Museum Kurhaus Kleve,
2004

2. Senza titolo, 1968
Museum Kurhaus Kleve,
2004

3. Senza titolo, 1968

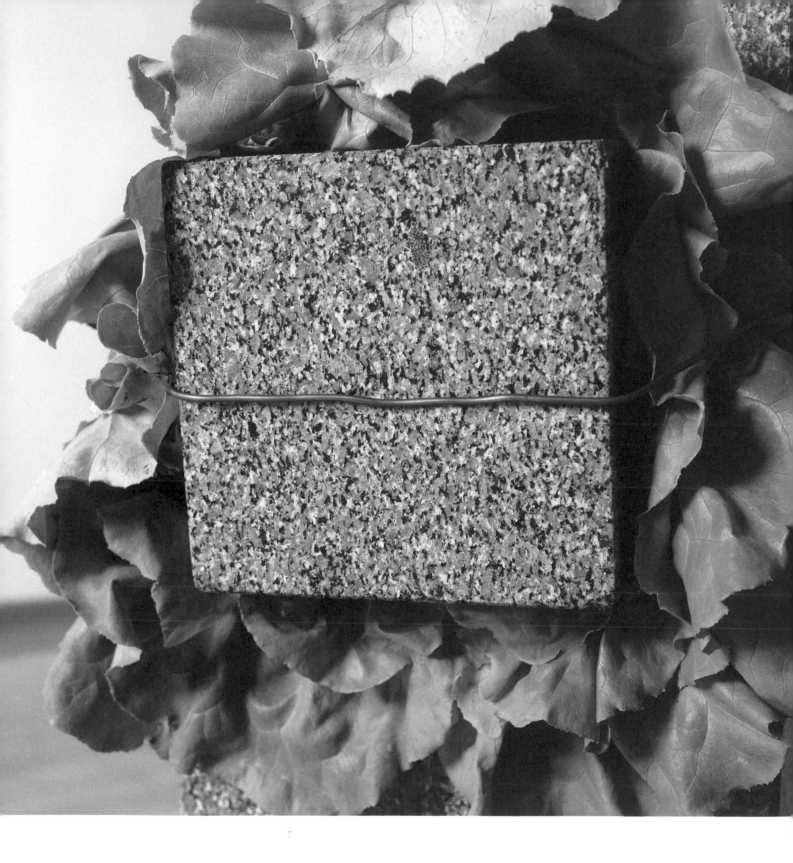

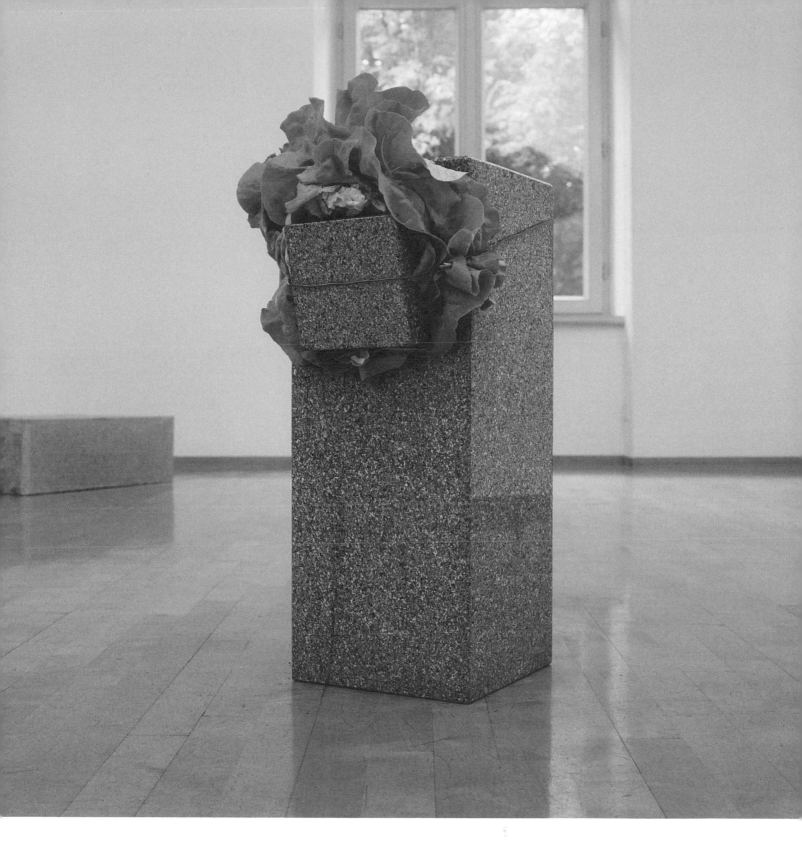

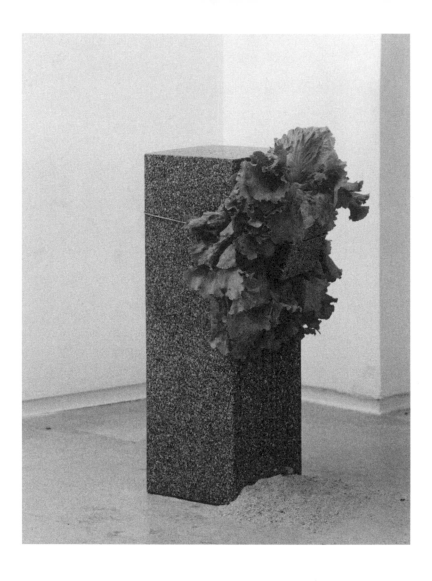

the sea sponge breathes,

der Schwamm aus dem Meer atmet,

1. Respiro, 1969
Castello di Rivoli, Museo
d'Arte Contemporanea,
Turin, 1996

2. Respiro, 1969
Museum Kurhaus Kleve,
2004

**3. Respiro, 1969 (detail ·
Detail)**
Museum Kurhaus Kleve,
2004

**4. Respiro, 1969 (detail ·
Detail)**
Museum Kurhaus Kleve,
2004

**5. Neon nel cemento, 1967–
69 · Trecento milioni di
anni, 1969 · Respiro, 1969**
Galleria Sperone, Turin,
1970

**6. Opere e particolari a
nord, a sud, a ovest, a
nordovest, 1980 (partial
view · Teilansicht)**
Musée de Grenoble, 1980

7. Respiro, 1969
'Processi di pensiero visua-
lizzati', Kunstmuseum
Lucerne · Luzern, 1970

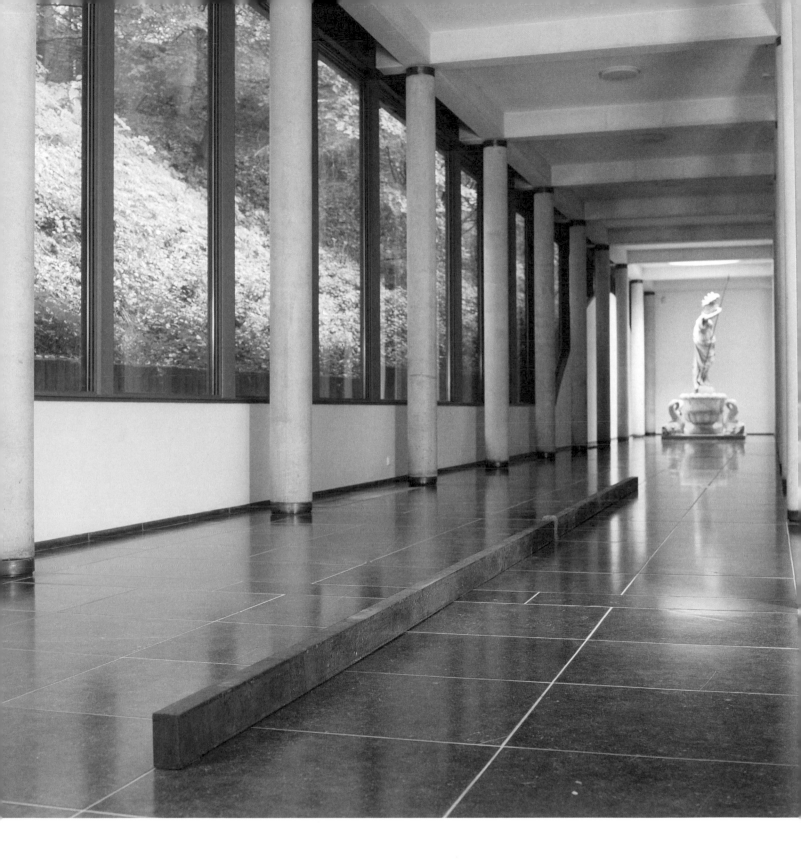

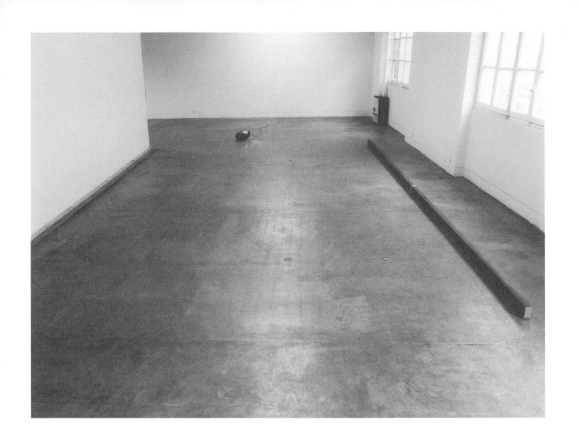

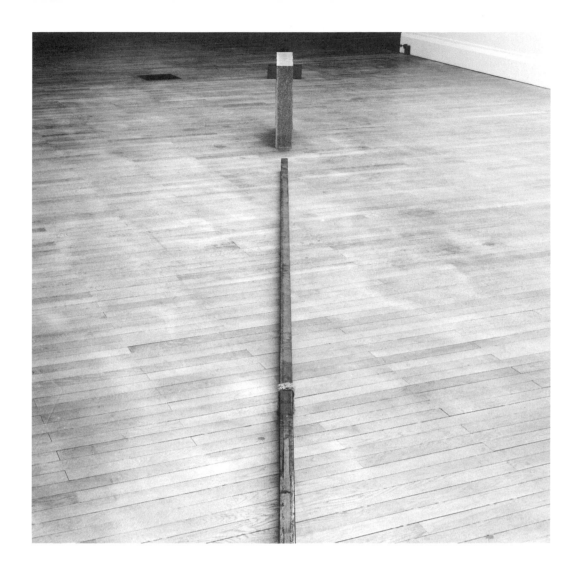

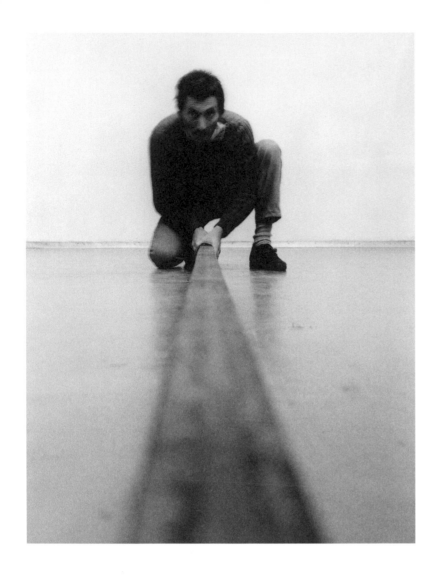

the aura of painting appears,
die Aura der Malerei erscheint,

1. L'aura della pittura, 1996
Museum Kurhaus Kleve,
2004

2. L'aura della pittura, 1996
Museum Kurhaus Kleve,
2004

**3. L'aura della pittura
mentre la pietra si allegge-
risce e la terra si orienta,
1996–2002**
Tucci Russo Studio per
l'Arte Contemporanea,
Torre Pellice, 2002

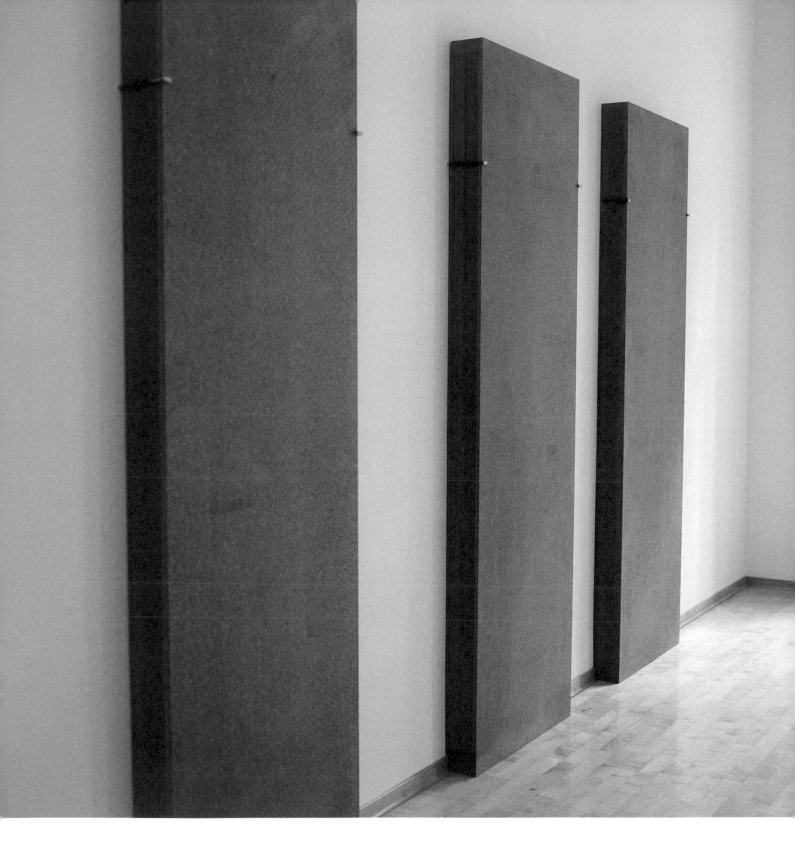

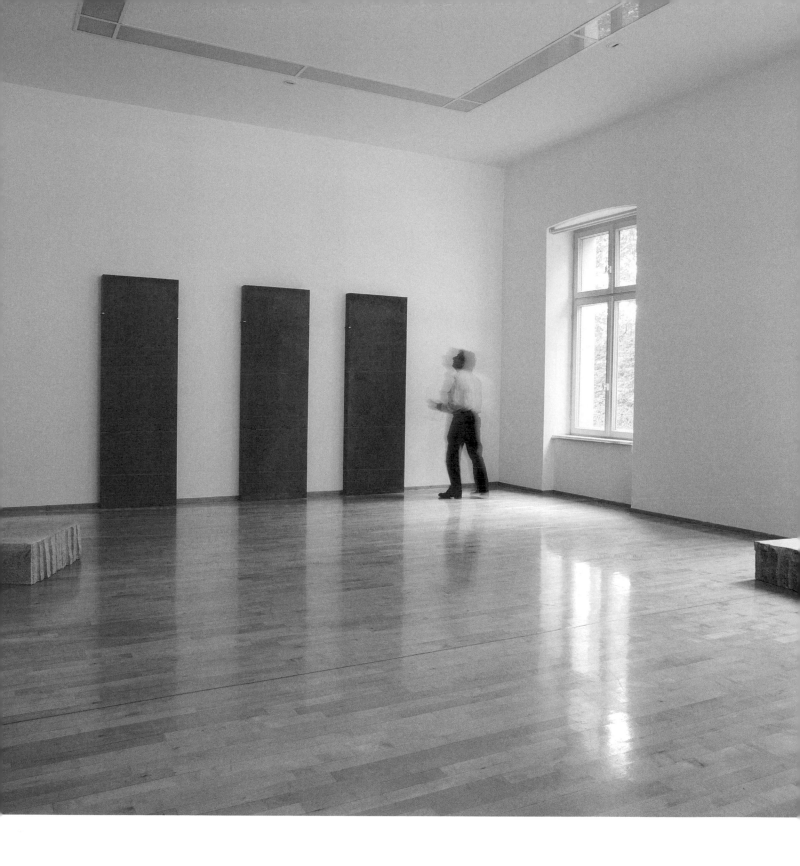

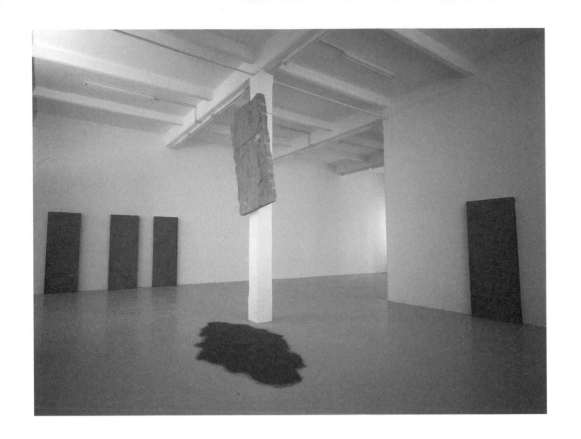

the invisible shows itself
das Unsichtbare sich zeigt

1. Infinito, 1971

2. Invisibile, 1971
Museum Kurhaus Kleve,
2004

3. Invisibile, 1971

4. Invisibile, 1971

5. 116 particolari visibili e
misurabili di INFINITO
Sperone Editore, Turin,
1975

6. 116 particolari visibili e
misurabili di INFINITO
Sperone Editore, Turin,
1975

7. Verso l'infinito, 1969
Kunsthalle Basel, 1979

8. Cielo accorciato, 1969-
70 (detail · Detail)

9. Tutto, 1971–73
Musée d'Art Moderne de
la Ville de Paris, 1985

10. Galleria Sperone, 1971

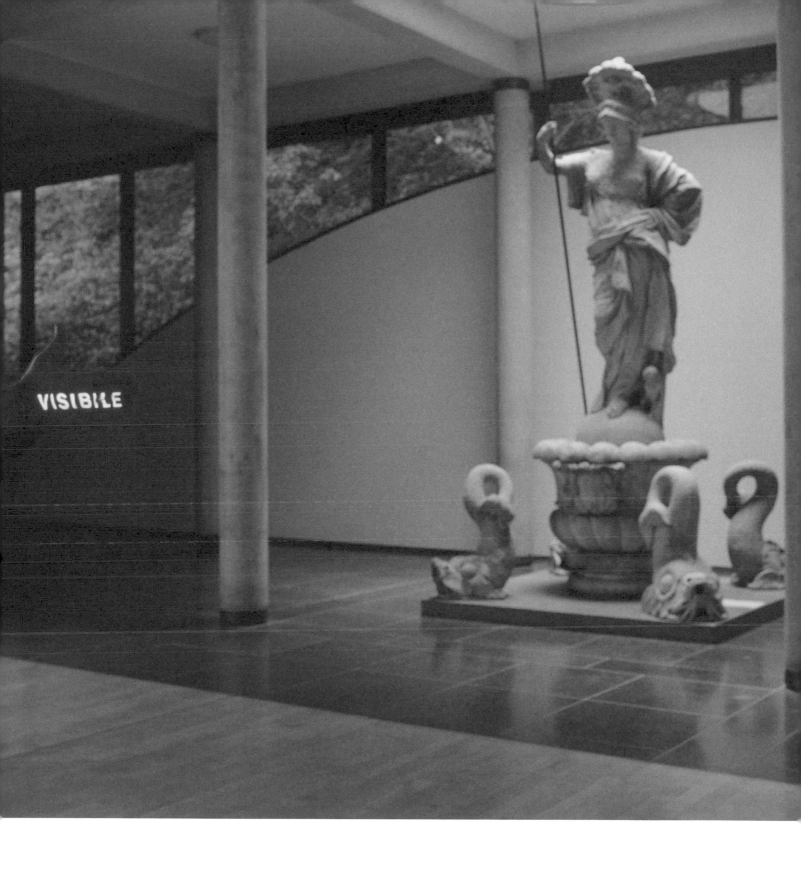

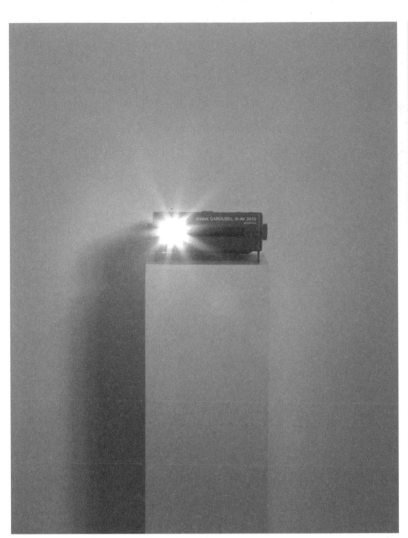

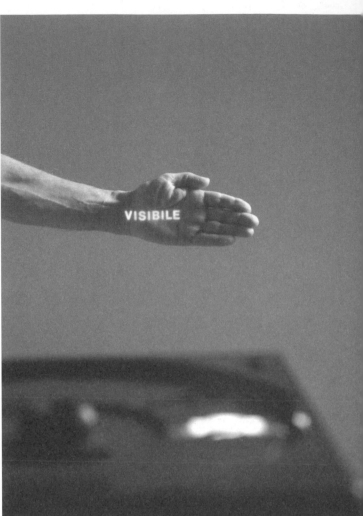

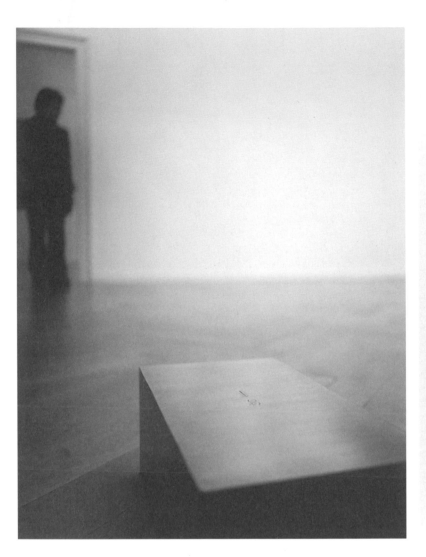

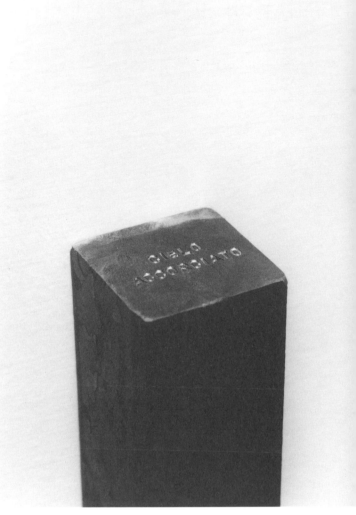

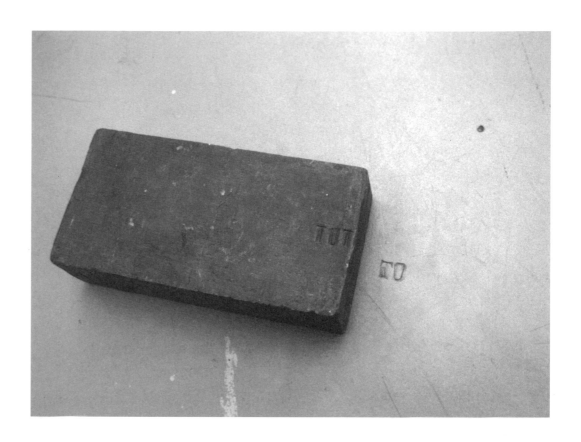

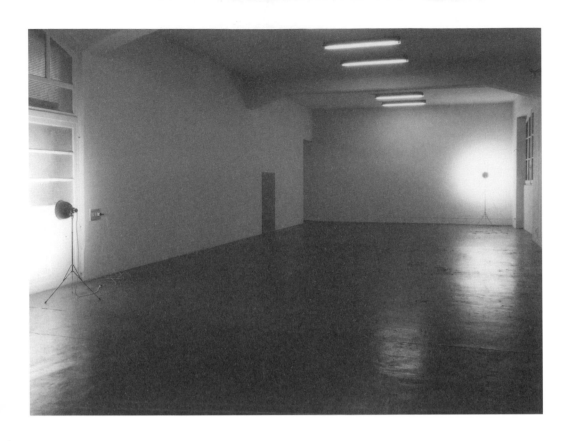

...

...

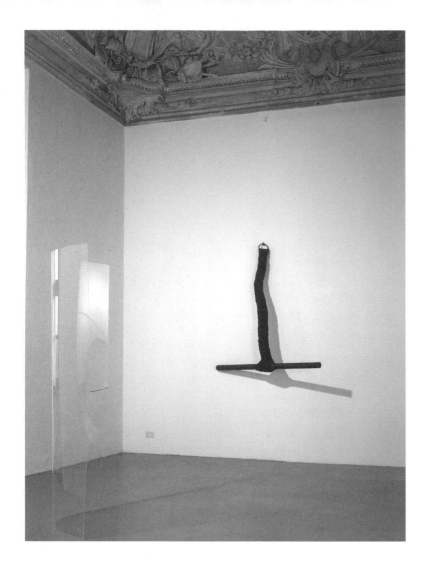

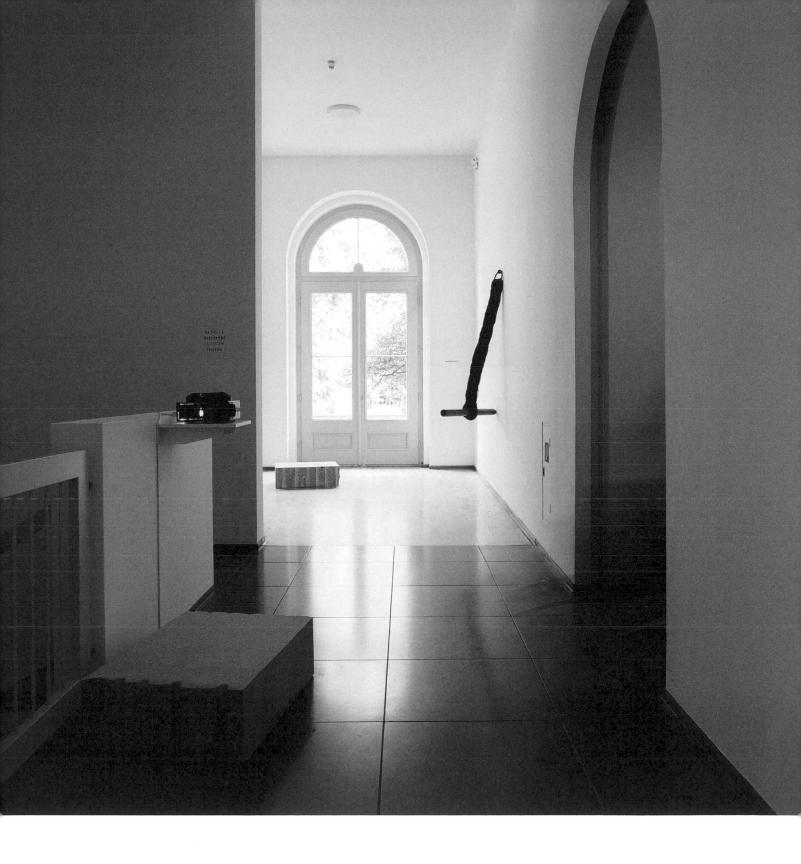

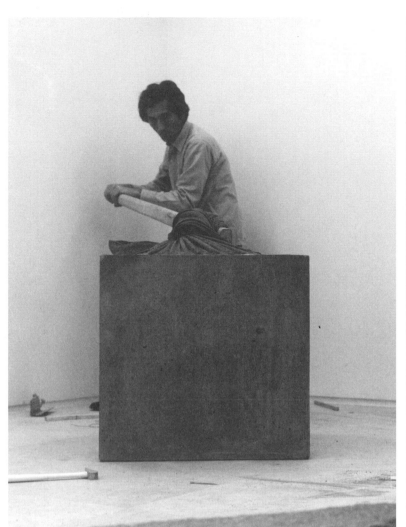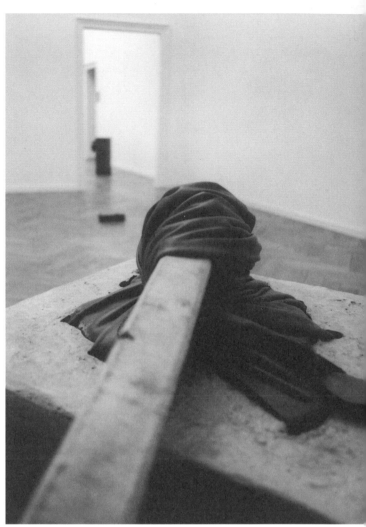

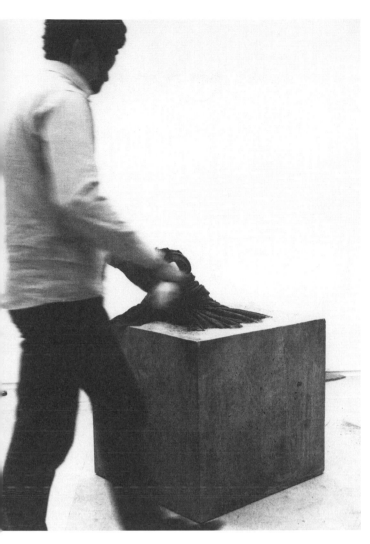
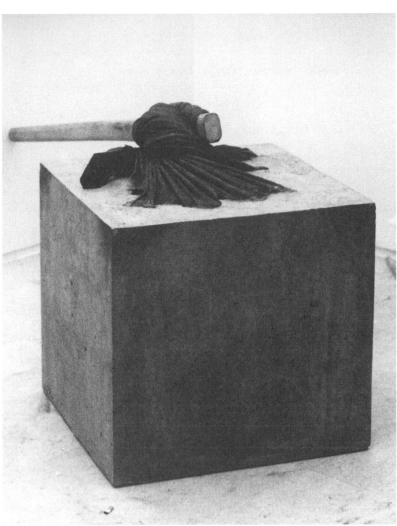

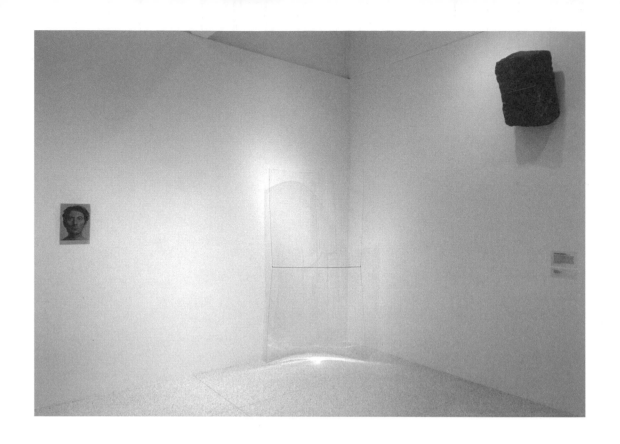

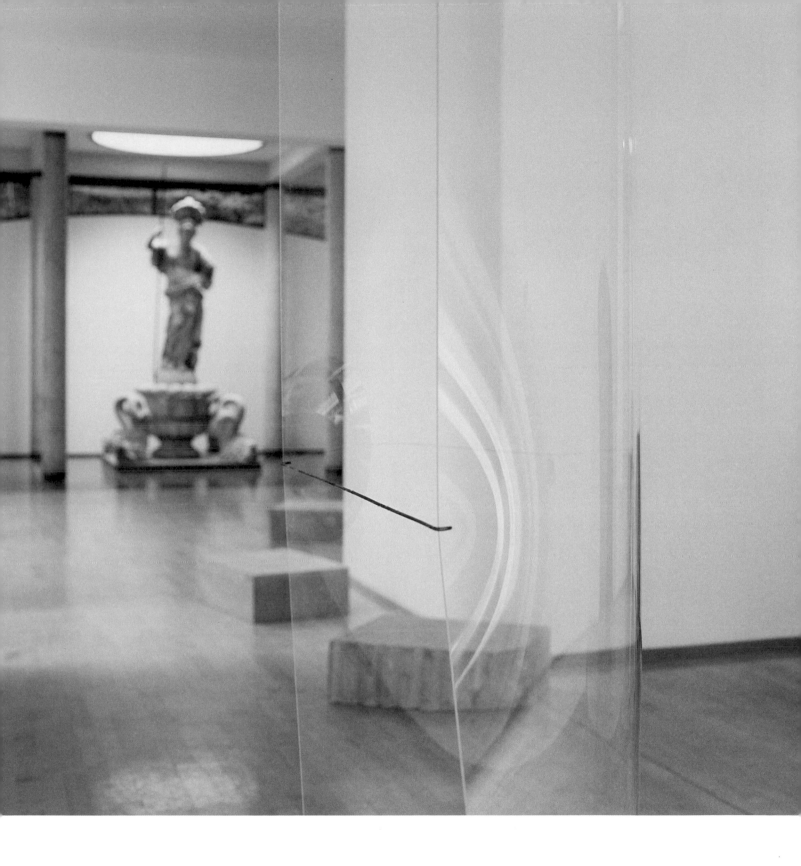

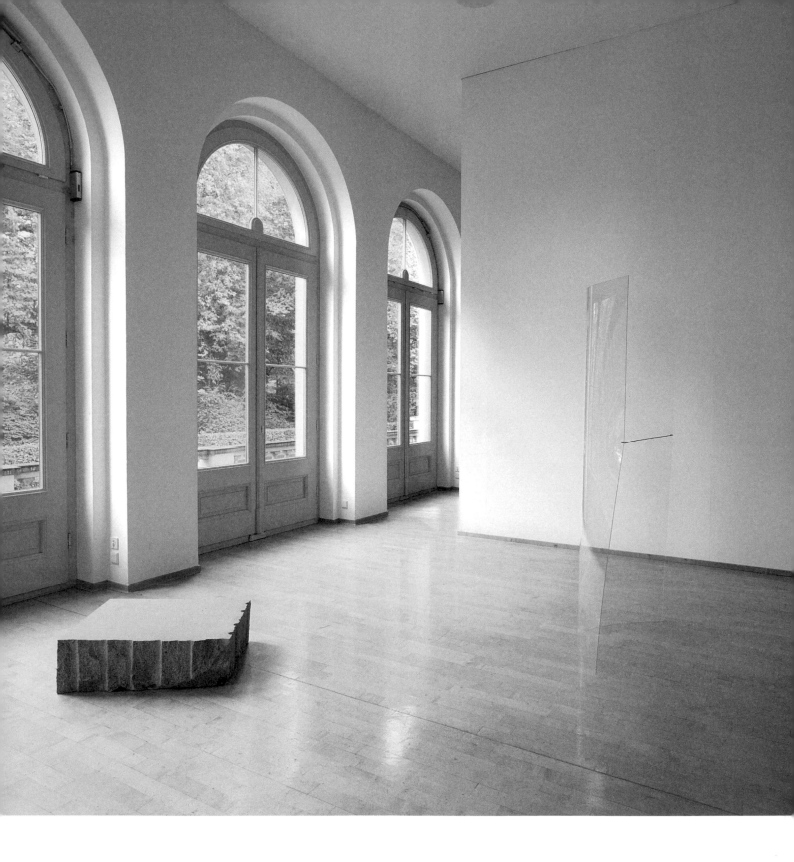

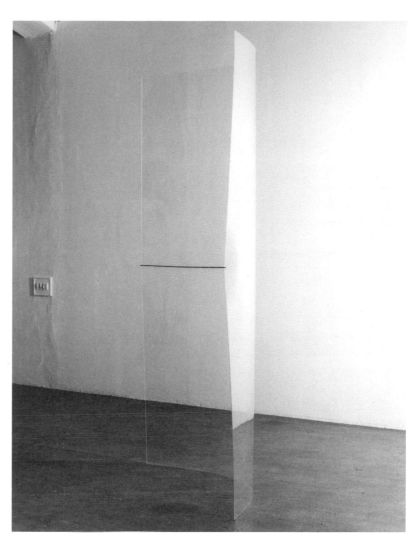

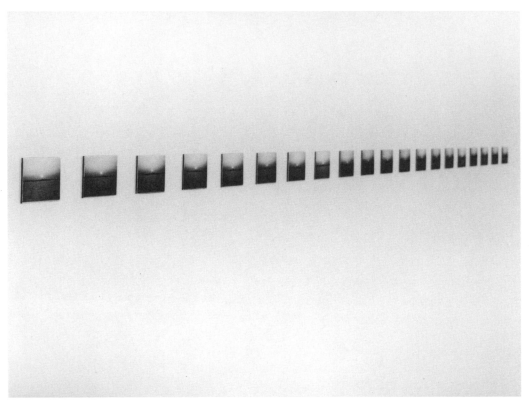

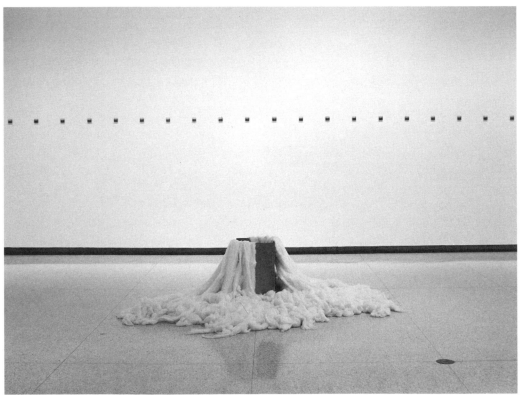

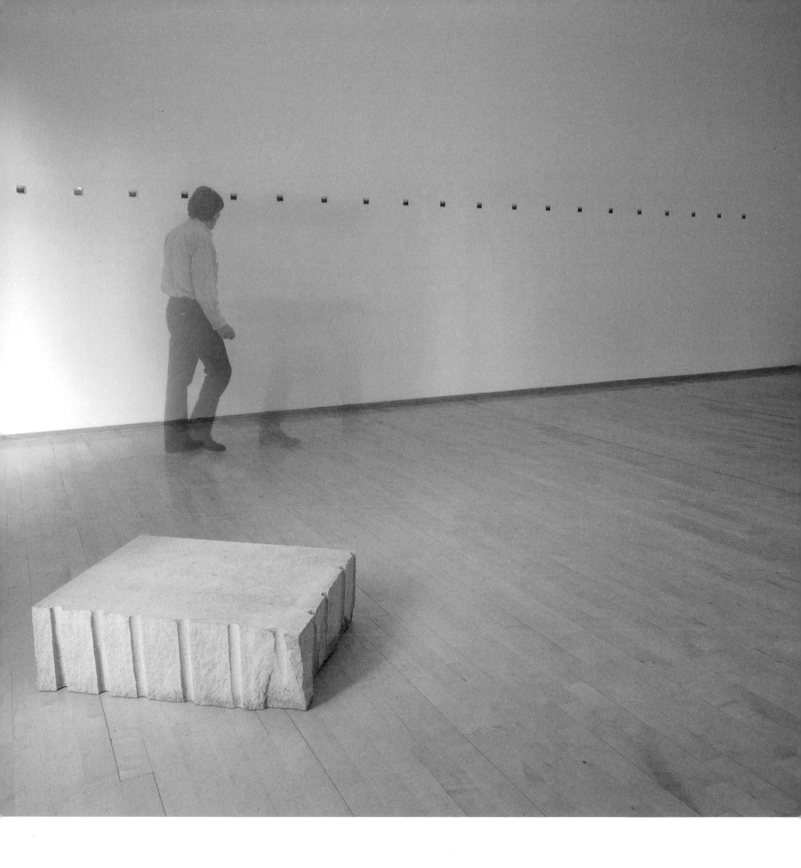

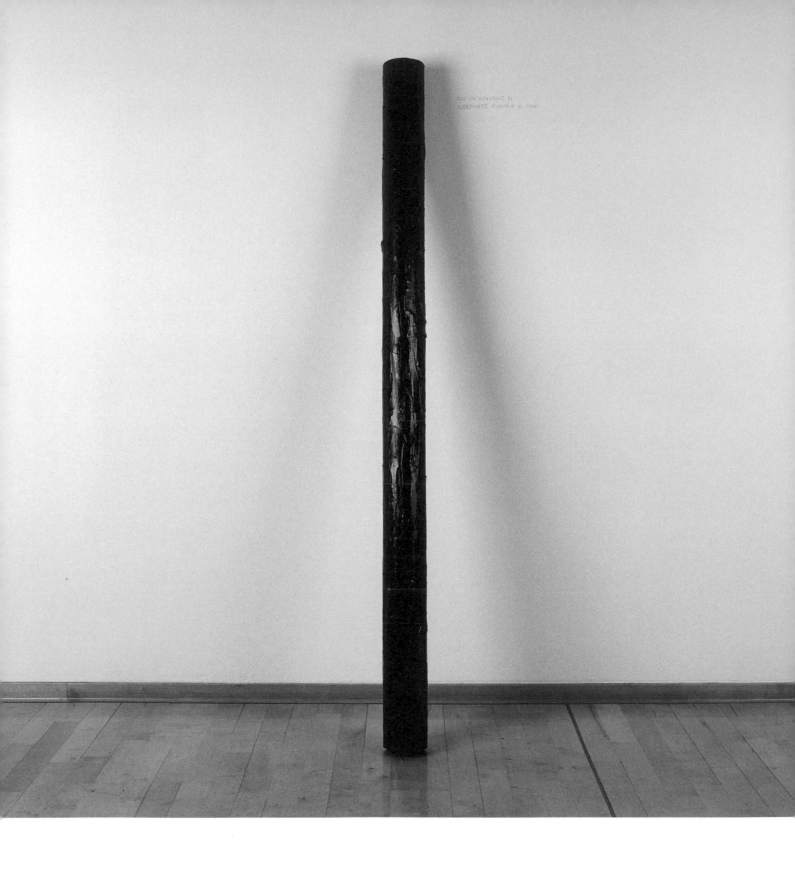

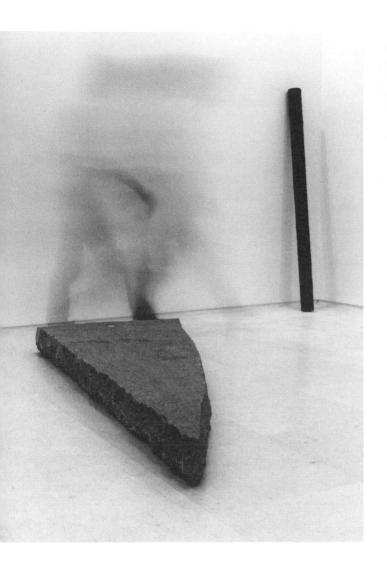

PER UN'INCISIONE
DI INDEFINITE MIGLIAIA DI ANNI

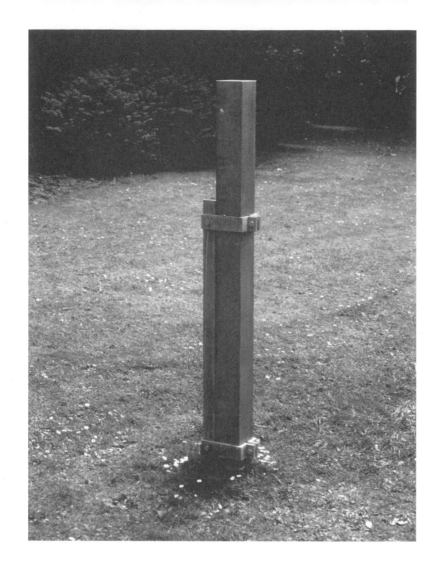

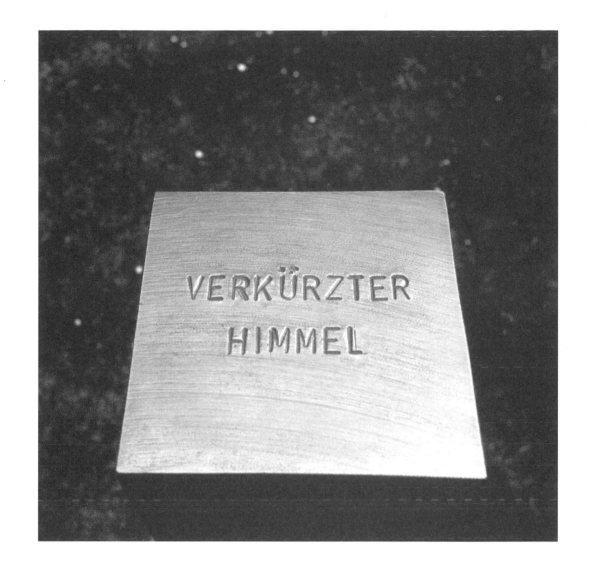

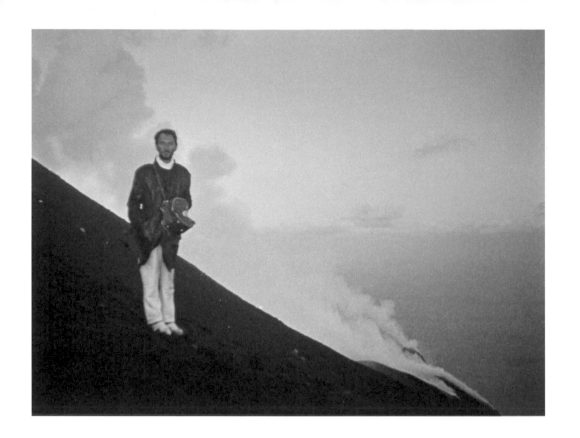

Contents Inhalt

Foreword
Vorwort

An enormous power emanates from Giovanni Anselmo's works. They are physical and poetical energies which the artist activates in an overwhelming way. Since the mid-1960s, nature serves him as a partner and material and since that time he carries it into the international exhibition spaces of art – playing an impressive, serious game around sculptural phenomena such as gravity or around painterly possibilities of visibility and surface.

Boulders hover in front of walls and, like our thoughts, are put into a state of levitation and resonance which we would scarcely have thought possible. In artistic works such as 'Torsione' from 1968 and 'Verso oltremare' from 1984, a tension is generated by fundamental physical laws which can discharge by releasing thoughts in a miraculous way. The pull or leverage visualised in some of Giovanni Anselmo's works thus leads not only to focusing on material properties and conditions of presentation, but also to relaxing and removing the boundaries of rational reflection.

Anselmo is one of the artists of Arte Povera who, since the mid-1960s, have radically renewed art by turning away from traditional forms and turning toward new, poor and natural materials. At the centre of his art which integrates nature, perception and philosophy stands the human being. In seemingly simple interventions and profound projects, the artist calls on each individual viewer to engage, directly and critically. In one of his most famous works, 'Invisibile' from 1971, the viewer even becomes a necessary support who makes the projected lettering in light 'visibile' visible on his or her body. In 'Dove le stelle si avvicinano di una spanna in più …' from 2004 Giovanni Anselmo invites people to step up onto the blocks of stone to get a span closer to the stars. This work, which was developed especially for Kleve and Birmingham, entwines the other exhibited works from all phases of his

Eine ungeheure Kraft geht von den Werken Giovanni Anselmos aus. Es sind physikalische und poetische Energien, die der Künstler auf überwältigende Weise aktiviert. Seit der Mitte der 1960er Jahre dient ihm die Natur als Partnerin und Material, und seitdem trägt er sie in die internationalen Ausstellungsräume der Kunst hinein – und spielt dabei ein eindrucksvolles, ernstes Spiel um skulpturale Phänomene wie die Schwerkraft oder um malerische Möglichkeiten von Sichtbarkeit und Oberfläche.

Felsbrocken schweben vor der Wand und werden wie unsere Gedanken in eine Leichtigkeit und Schwingung versetzt, die wir kaum für möglich gehalten hätten. In künstlerischen Arbeiten wie z.B. 'Torsione' (1968) oder 'Verso oltremare' (1984) wird durch fundamentale physikalische Gesetze eine Spannung erzeugt, die sich in der Freisetzung von Gedanken auf wundersame Weise entladen kann. Die in einigen von Giovanni Anselmos Arbeiten visualisierte Zugkraft oder Hebelwirkung führt somit nicht nur zu einer Fokussierung von Materialeigenschaften und Präsentationsbedingungen, sondern auch zu einer Entspannung und Entgrenzung der rationalen Reflexion.

Anselmo gehört zu den Künstlern der Arte Povera, die seit Mitte der 1960er Jahre durch eine Abkehr von traditionellen Formen und eine Hinwendung zu neuen armen und natürlichen Materialien die Kunst radikal erneuert haben. Im Zentrum seiner Natur, Wahrnehmung und Philosophie einbeziehenden Kunst steht dabei der Mensch. In den einfach anmutenden Interventionen und hintergründigen Projekten fordert der Künstler jeden einzelnen Betrachter zur direkten Auseinandersetzung auf. In einer seiner berühmtesten Arbeiten, 'Invisibile' (1971), wird der Betrachter sogar zum notwendigen Träger, der den projizierten Licht-Schriftzug 'visibile' auf seinem Körper sichtbar macht. In der Arbeit 'Dove le stelle si avvicinano di una spanna in più …' (2004) lädt Giovanni Anselmo die Menschen ein, die Felsblöcke zu betreten und so den Sternen eine Handspanne näher zu kommen. Diese für Kleve und Birmingham neu entwickelte Arbeit umrankt die anderen ausgestellten Werke aus allen Phasen seines Schaffens, von der Mitte der 1960er Jahre bis heute.

Die Ausstellung ist eine Kooperation zwischen dem Museum Kurhaus Kleve und der Ikon Gallery in Birmingham. Wir danken Giovanni Anselmo für diese herausragende Ausstellung, die er minutiös geplant und eingerichtet hat. Wer Giovanni Anselmo jemals beim Aufbau einer seiner

creative life, from the mid-1960s to the present day.

The exhibition is a collaboration between the Museum Kurhaus Kleve and the Ikon Gallery in Birmingham. We thank Giovanni Anselmo for this excellent exhibition which he minutely planned and installed. Those who have ever experienced Anselmo setting up one of his exhibitions know to what degree he is fused with his oeuvre and how he gives expression to his artistic intentions through the installation of his works. Our heartfelt thanks go to him for the magnificent exhibitions in Kleve and Birmingham.

This catalogue includes numerous new images, above all of the presentation in Kleve. Two essays introduce Anselmo's art. Anne Rorimer, Chicago as a profound expert on the art of the 1960s and 1970s has written a brilliant overview of Anselmo's oeuvre. Tiziana Caianiello has elaborated the painterly aspects of the art of Giovanni Anselmo, who was awarded the Golden Lion for Painting at the Venice Biennial in 1990. Our especial thanks go to both of them for their contributions.

Many were involved in realising the exhibition. Tiziana Caianiello from the Museum Kurhaus Kleve played a decisive role in the preparations. She coordinated the organisation in Kleve and supervised editorial work for the catalogue. In Birmingham this work was undertaken by Karen Allen. Roland Mönig, curator at the Museum Kurhaus Kleve, also contributed to all the aspects of the exhibition.

This exhibition was supported by the Istituto Italiano di Cultura in Cologne and London, and we are most grateful to the directors in those cities, Maria Lella and Pier Luigi Barrotta, respectively. For Birmingham, also, the support of The Stanley Thomas Johnson Foundation and The Henry Moore Foundation was invaluable. Such generosity is very much in keeping with the spirit of Anselmo's work, and is inspiring.

Jonathan Watkins
 Guido de Werd
Ikon Gallery Birmingham
 Museum Kurhaus Kleve

Ausstellungen erlebt hat, weiß, in welchem Maße er mit seinem Werk verschmolzen ist, und wie er durch die Installation seiner Werke seinen künstlerischen Intentionen Ausdruck verleiht. Für die großartigen Ausstellungen in Kleve und Birmingham danken wir ihm ganz herzlich.

Der Katalog enthält zahlreiche neue Abbildungen, vor allem der Präsentation in Kleve. Zwei Essays führen in Anselmos Werk ein. Anne Rorimer, Chicago, hat als profunde Kennerin der Kunst der 1960er und 1970er Jahre einen fulminanten Überblick über Anselmos Werk verfasst. Tiziana Caianiello hat die malerischen Aspekte in der Kunst Anselmos, der 1990 den Goldenen Löwen für Malerei auf der Biennale von Venedig erhielt, herausgearbeitet. Beiden gilt unser besonderer Dank für ihre Beiträge.

An der Realisierung der Ausstellung waren viele beteiligt. Tiziana Caianiello vom Museum Kurhaus Kleve hatte bei der Vorbereitung einen entscheidenden Anteil. Sie koordinierte die Organisation in Kleve und betreute die Herausgabe des Katalogs. In Birmingham tat dies Karen Allen. Auch Roland Mönig, Kustos am Museum Kurhaus Kleve, hat zu allen Aspekten der Ausstellung beigetragen.

Die Ausstellung wurde unterstützt vom Istituto Italiano di Cultura in Köln und in London. Den Direktoren der Institute in diesen beiden Städten, Maria Lella bzw. Luigi Barrotta, gilt unser herzlicher Dank. Für Birmingham war überdies die Unterstützung von The Stanley Thomas Johnson Foundation und The Henry Moore Foundation von größter Bedeutung. Solche Großzügigkeit entspricht dem Werk von Giovanni Anselmo und hat eine inspirierende Wirkung.

Jonathan Watkins
 Guido de Werd
Ikon Gallery Birmingham
 Museum Kurhaus Kleve

Giovanni Anselmo: Here and Beyond 1965 – 2004

Giovanni Anselmo: Hier und Anderswo 1965 – 2004

'Dove le stelle si avvicinano di una spanna in più nel panorama verso oltremare con mano che lo indica' (Where the stars are coming one span closer, in the panorama towards 'oltremare', with the hand that points to it, 2004) enunciates the aesthetic principles with which Giovanni Anselmo has been engaged since the mid-1960s. 'Dove le stelle si avvicinano di una spanna in più …' manifests its material reality at the same time that it expresses the open-ended vastness of the universe, of which any and all viewing subjects are a part.

A work to be walked around, and within, and also a work that can be stood upon, 'Dove le stelle si avvicinano di una spanna in più …' consists of about 40 hefty, rectangular granite slabs that each measure approximately 25 × 60 × 80 cm. The artist has expressly positioned the stones on the floor of the gallery to correlate with the way in which stars in the sky, near and far and visible at night, appear to be sprinkled in the heavens.

Visitors to the exhibition can walk among the stones and, when stepping up onto one of them, can survey the room as a whole from a variety of vantage points. Significantly, as suggested by the work's title, all of the granite blocks measure the height of one hand's breadth from the floor. Viewers standing on any one of the stones are thus one span closer to the farthest star at its zenith than they are when standing on the floor.

'Dove le stelle si avvicinano di una spanna in più nel panorama verso oltremare con mano che lo indica' (Wo die Sterne eine Spanne näher kommen im Panorama Richtung 'oltremare', mit der Hand, die darauf weist, 2004) proklamiert mit Nachdruck die ästhetischen Prinzipien, mit denen Giovanni Anselmo seit Mitte der 1960er Jahre gearbeitet hat. 'Dove le stelle si avvicinano di una spanna in più …' manifestiert seine eigene materielle Realität im selben Augenblick, in dem es der unbegrenzten Weite des Universums Ausdruck verleiht, dem alle Betrachter angehören.

'Dove le stelle si avvicinano di una spanna in più …' ist eine Arbeit, um die man herum und durch die man hindurchgehen und die man darüber hinaus auch betreten soll. Sie besteht aus rund 40 massiven rechtwinkligen Granitplatten, die je etwa 25 × 60 × 80 cm messen. Der Künstler hat die Steine mit Bedacht so auf dem Boden des Ausstellungsraums angeordnet, dass sie der Art und Weise entsprechen, wie die bei Nacht nah und fern sichtbaren Sterne am Firmament ausgestreut zu sein scheinen.

Die Besucher der Ausstellung können um die Steine herumwandern, und sie können, wenn sie sie betreten, den Saal als Ganzen von einer Reihe von Aussichtspunkten aus überschauen. Bezeichnenderweise – der Titel der Arbeit deutet das an – beträgt die Höhe aller Granitblöcke eine Spanne (oder eine durchschnittliche Handbreite). Ein Betrachter, der auf einem beliebigen Stein steht, ist deshalb dem fernsten Stern im Zenit seiner Umlaufbahn um eine Spanne näher, als wenn er auf dem Boden stünde.

Die vom Künstler bei einem Steinbruch bestellten und gemäß seinen Angaben zugeschnittenen Platten verweisen auf die sperrige Materialität von Skulptur, ohne dabei jene Zeichen von Kunstfertigkeit zu besitzen, die man traditionellerweise mit dem Medium assoziiert. Stattdessen bezeugen die deutlich sichtbaren Kerben, die die Steinschneidewerkzeuge hinterlassen haben, die rohen Eigenschaften des Granits als Stein. Die 'Hand des Künstlers', die in traditioneller Kunst immer gegenwärtig ist, existiert nur mehr als bloße Spur – als die uralte Maßeinheit, die auf dem Abstand der Spitzen des Daumens und des Mittelfingers (oder auch des kleinen Fingers) der gespreizten Hand beruht. Ohne irgendwelche Zeichen manueller Bearbeitung oder Kraftanwendung aufzuweisen, beziehen die Platten sich auf den Boden als Grund, auf dem der Mensch sich im Kontext der kosmischen Ordnung bewegt.

Ordered by the artist from a quarry and cut to his specifications, the stone slabs signify the obdurate materiality of sculpture but do not display the signs of workmanship traditionally associated with this medium. Instead, exposed incisions left by stone-cutting equipment evince the raw lapidary state of the granite. The 'hand of the artist,' present in traditional art, exists only as a remnant – the age-old unit of measurement based on the distance between the tips of stretched finger and thumb. Without possessing signs of manual craft or labour, the slabs refer to the 'ground' upon which human beings perambulate within the context of the universe.

As in previous exhibition installations throughout the 1980s and 1990s, the artist has adapted elements from prior works to form a new whole. For example, 'Il panorama con mano che lo indica' (1980; 1982–84) encapsulates the notion of the panorama by means of a skilled and detailed pencil drawing of a hand that, seeming to protrude into the viewer's space, extends from a surrounding field of paper. It was first exhibited in the early 1980s with a stepping stone in front of it. While the drawing offers a representational form for inviting viewers to attend to the world around them, the device of the stepping stone, which raises the viewer up from the ground, anticipates the use of floor slabs in the Kleve and Birmingham exhibitions.

In those exhibitions, narrow rectangles of ultramarine ('oltremare' in Italian) paint applied directly on the wall punctuate the visual field of the large stones on the floor. Their deep, vibrant colour articulates the otherwise bare white walls and anchors the granite stones to the overall gallery space. These blue rectangles signal the idea of a verifiable beyond and an extant reality which, although invisible to the eye, is accessible to the mind.

Stone slabs on the floor in concert with the painted rectangles on the walls define the thematic dimensions of a work revolving around the concrete reality of pigment and stone. The specific hue of the pigment, ultramarine, combined with its linguistic appellation, imbue the installation with its fullest aesthetic meaning. On its most basic level, this work consists of granite blocks distributed throughout

Wie schon in früheren Installationen in den 1980er und 1990er Jahren hat der Künstler einzelne Elemente älterer Arbeiten aufgegriffen, um ein neues Ganzes zu schaffen. So formuliert zum Beispiel 'Il panorama con mano che lo indica' (1980, 1982–84) bereits die Vorstellung des Panoramas, und zwar mit Hilfe einer ebenso sicheren wie detaillierten Bleistiftzeichnung einer Hand, die aus der sie umgebenden Fläche des Papiers heraus zu ragen und in den Raum des Betrachters einzudringen scheint. Die Arbeit war zuerst in den frühen 1980er Jahren ausgestellt – mit einem Trittstein davor. Während die Zeichnung dem Betrachter eine gegenständliche Darstellungsform anbietet, um ihn zur Auseinandersetzung mit der Welt um sich herum einzuladen, nimmt die Erfindung des Trittsteins, der den Betrachter über den Grund seiner Existenz erhebt, den Einsatz der am Boden liegenden Platten in den Ausstellungen in Kleve und Birmingham vorweg.

In diesen beiden Ausstellungen wird das von den großen Steinen auf dem Boden gebildete visuelle Feld nochmals durch schmale Rechtecke aus direkt auf die Wände aufgetragenem Ultramarin ('oltremare' im Italienischen) betont. Ihre tiefe, vibrierende Farbe gliedert die sonst leeren Wände und verankert die Granitsteine im Ausstellungsraum insgesamt. Diese blauen Rechtecke signalisieren die Vorstellung eines tatsächlich vorhandenen Anderswo und einer real existierenden Wirklichkeit, die – auch wenn sie den Augen unsichtbar bleibt – dem Geist zugänglich ist.

Steinplatten auf dem Boden im Verein mit gemalten Rechtecken auf den Wänden umreißen die thematischen Dimensionen eines Lebenswerkes, das sich um die konkrete Realität von Pigment und Stein dreht. Der ganz besondere Ton des Pigments Ultramarin lädt – zusammen mit seiner sprachlichen Bezeichnung – die Installation mit größter ästhetischer Bedeutung auf. Oberflächlich gesehen, besteht die Arbeit aus Granitblöcken, die im Ausstellungsraum verteilt sind, sowie aus Markierungen auf der Wand, ausgeführt mit blauer Farbe. Dringt man tiefer ein, so wird klar, dass die Arbeit zeigt, wie Kunst, wenn sie Farbe und Material dem Prozess der Konzeptualisierung unterwirft, ihre eigenen sichtbaren Grenzen überschreiten kann, um auf die zeitlichen und räumlichen Koordinaten der Welt im Großen hinzuweisen. Wenn das aus Lapislazuli gewonnene Ultramarin eine Farbe mit einer bestimmten Wellenlänge ist, die sich dem Auge als intensive Abschattung von Blau zeigt, dann verkörpert sie zugleich auch die Vorstellung eines Ortes 'in Über-

the exhibition space and mural markers of blue paint. On a more profound level, the work demonstrates how art, through modes of conceptualisation via colour and material, is able to penetrate its own visible confines in order to point toward the temporal and spatial coordinates of the world at large. If ultramarine, made from lapis lazuli, is a colour of a particular wave length presenting itself to the eye as an intense shade of blue, it also embodies the notion of somewhere 'overseas.' The fact that this colour was introduced into Europe as an import, gave it the name 'oltremare,' or 'beyond the sea.' As word and hue combined, the ultramarine paint both empirically and linguistically serves in the Kleve and Birmingham installations to carry the eye beyond the line of sight. It thereby reinforces the thrust of a work whose mission is to stimulate contemplation of the immediate surrounds of the material world while taking account of the all-encompassing solar system.

For 'Dove le stelle si avvicinano di una spanna in più …', Anselmo has secured on the wall a large block of red porphyry of China, which weighs as much as six hundred kilograms. Held firmly by a wire slipknot, the heavy stone hovers on the wall while being supported by its own colour – and, by extension, light – as if it had been momentarily freed from the omnipresent gravitational force defining life on the planet. In this manner, the 'uplifting' power of colour and light in combination with the activity of gravity presents a state of energy.

A number of precedents for Anselmo's use of blocks of stone and ultramarine paint are to be found in his earlier production. As early as 1969 the artist had fastened a sizeable rock to the wall above his head. 'Pietra sospesa alla parete il più in alto possibile con cavo d'acciaio' (Stone suspended from as high as possible on a wall by a steel cable, 1969) drew attention to the force of gravity, which the rock resisted while straining against the steel wire and slipknot that prevented it from crashing to the ground. More than a decade after 'Pietra sospesa alla parete …' he initiated the many works that incorporate rocks suspended from walls, columns, or other architectural elements within the exhibition space.

see'. Die Tatsache, dass diese Farbe als Importprodukt nach Europa eingeführt wurde, verlieh ihr den Namen 'oltremare' oder 'jenseits des Meeres'. Als Wort wie als Farbton dient das Ultramarin auf den Ebenen von Erfahrung und Sprache in den Installationen in Kleve und Birmingham dazu, das Auge hinter den Horizont des Sichtbaren zu führen. Es unterstützt damit den Impuls eines Werkes, dessen Anliegen es ist, zum Nachdenken über die unmittelbare Umgebung der materiellen Welt anzuregen, während es zugleich das alles umfassende Sonnensystem berücksichtigt.

Für 'Dove le stelle si avvicinano di una spanna in più …' hat Anselmo einen großen Block aus rotem Porphyr an die Wand gehängt, der nicht weniger als 600 kg wiegt. Mit einem Laufknoten aus Stahl fixiert, schwebt der schwere Stein an der Wand, gehalten von seiner eigenen Farbe und – wenn man weiter denkt: durch sein Licht –, als ob er zeitweilig von dem allgegenwärtigen Gesetz der Schwerkraft befreit worden wäre, das das Leben auf unserem Planeten bestimmt. Auf diese Weise führt die 'erhebende' Kraft von Farbe und Licht im Verein mit dem Wirken der Schwerkraft einen Zustand energetischer Aufladung vor.

Für die Verwendung von Steinblöcken und Ultramarin findet sich in Anselmos früherem Schaffen eine Anzahl von Vorläufern. Schon 1969 hatte der Künstler einen Stein von beträchtlicher Größe über seinem Kopf an die Wand gehängt. 'Pietra sospesa alla parete il più in alto possibile con cavo d'acciaio' (Stein, der mit Hilfe eines Stahlkabels so hoch wie möglich an die Wand gehängt wurde, 1969) lenkte die Aufmerksamkeit auf die Schwerkraft, der der Stein widerstand, indem er sich gegen das Stahlkabel und den Laufknoten stemmte, die ihn daran hinderten, zu Boden zu stürzen. Mehr als ein Jahrzehnt nach 'Pietra sospesa alla parete …' begann Anselmo die umfangreiche Werkreihe mit Steinen, die von Wänden, Säulen oder anderen Architekturelementen des Ausstellungsraumes herabhängen.

Bei mehreren Gelegenheiten hat Anselmo Steine unterschiedlicher Größe auf die Oberseiten von 80, 90 bzw. 100 senkrecht stehenden Leinwänden gelegt, die aneinander lehnen. Die dicht an dicht gestapelten Leinwände drücken gegen die Wand, auf die ein Rechteck aus Ultramarin gemalt worden ist, und streben insofern mit ihrem ganzen Gewicht in Richtung 'oltremare'. Bei anderen Gelegenheiten hat Anselmo zwei untereinander mit einem Kabel verbundene Blöcke über die Oberseite einer einzelnen Leinwand gehängt. Seit den späten 1980er Jahren hat er überdies auf Keilrah-

On several occasions Anselmo has balanced rocks of various colours on the top, respectively, of eighty, ninety, and one hundred upright canvases leaning against each other. The deep stack of canvases push against the wall on which an ultramarine rectangle had been painted and thus, in effect, press with all their weight toward 'oltremare.' On other occasions, he has draped individual rocks connected by a cable over the top of a single canvas. Since the late 1980s, moreover, Anselmo has covered stretched canvases with flat granite slabs for presentation on the wall like conventional paintings. The given hue of the stone determines the colour of a 'painting' that has no paint on its surface. Although they maintain the traditional rectilinearity and planarity of painting, Anselmo's slabs-on-canvas throw off the heavy burden of painting's illusionistic tendencies.

Painting (made manifest through colour) and sculpture (made manifest through stone) join forces in Anselmo's many installations from the last two and more decades in works that transcend separation or categorisation along these traditional lines. For an exhibition at the Marian Goodman Gallery in New York and at the Konrad Fischer Gallery in Düsseldorf in the 1990s, 'L'aura della pittura' (The aura of painting, 1996), Anselmo aligned upright stones measuring 2.35 metres high one beside the other against the wall and, above eye level, applied red, green, blue, yellow, and orange acrylic to each of their respective top surfaces. The colours, reflected on the white wall, produced an 'aura' that emanated from the stones and, through rays of coloured light, made visible the inherent energy of colour.[1]

Anselmo first used ultramarine paint on the wall in 1979 when he participated in the group exhibition, 'Le Stanze,' at Castello Colonna, Genazzano (near Rome). He titled the work 'Oltremare a nord, il paesaggio a est'. On this occasion, he painted a deep blue, short horizontal line on the wall directly in front of a stone block with a compass on its top. The artist angled the block to the north in order to maintain its alignment with its own directional indicator. Pertinently, the window of the exhibition space looked eastward toward the landscape at hand. Whereas the window thus offered a view outside the ex-

men aufgezogene Leinwände mit flachen Granitplatten bedeckt, um sie wie gewöhnliche Bilder an der Wand zu präsentieren. Der vorgegebene Farbton des Steins bestimmt die Farbe eines 'Bildes', dessen Oberfläche tatsächlich frei von jeglicher Farbe ist. Wenn sie auch einerseits die traditionelle Rechtwinkligkeit des Bildes beibehalten, so werfen Anselmos Leinwände mit Platten doch auch andererseits die schwere Bürde des Hangs zum Illusionismus in der Malerei ab.

Malerei (manifestiert durch Farbe) und Skulptur (manifestiert durch Steine) wirken zusammen in Anselmos zahlreichen Installationen aus den letzten gut zwei Jahrzehnten, die sich der Unterscheidung oder Bestimmung entlang der traditionellen Gattungsgrenzen entziehen. Für eine Ausstellung in der Marian Goodman Gallery in New York und in der Konrad Fischer Galerie in Düsseldorf in den 1990er Jahren, 'L'aura della pittura' (Die Aura der Malerei, 1996), lehnte Anselmo senkrecht in einer Reihe nebeneinander stehende Steine von jeweils 2,35 m Höhe an die Wand und trug auf ihre jeweiligen Oberkanten – also über Augenhöhe – rote, grüne, blaue, gelbe und orange Acrylfarbe auf. Die auf die Wand reflektierten Farben brachten eine 'Aura' hervor, die von den Steinen ausging und – durch die Strahlen des farbigen Lichtes – die innere Energie der Farbe sichtbar machte.[1]

Anselmo verwendete Ultramarin auf einer Wand zum ersten Mal 1979, als er an der Gruppenausstellung 'Le Stanze' im Castello Colonna in Genazzano (bei Rom) teilnahm. Er nannte die Arbeit 'Oltremare a nord, il paesaggio a est'. Er malte aus diesem Anlass eine tief blaue horizontale Linie auf die Wand direkt gegenüber einem Steinblock mit einem Kompass an seiner Oberkante. Der Künstler drehte den Block nach Norden, so dass seine Flucht der seines eigenen Richtungsanzeigers entsprach. Passenderweise öffnete das Fenster des Ausstellungsraumes sich nach Osten auf die nahebei gelegene Landschaft. Während also das Fenster einen Blick nach draußen bot, wies die Linie aus Ultramarin an der Nordwand – ebenso wie der Kompass – auf imaginäre Landschaften.

Nicht lange nach der Ausstellung in Genazzano malte Anselmo ein Rechteck aus Ultramarin unter einem Ensemble aus Steinen, die an einer Wand fixiert waren. Das Ultramarin in 'Grigi che si allegeriscono verso oltremare' (Graue, die Richtung 'oltremare' leichter werden, 1982) kam ohne Kompass aus und vermittelte dabei die Vorstellung einer Vielzahl von Richtungen. 'Diese Farbe ist für mich wie ein Kompass', sagt der Künstler[2]. In einigen Installationen

hibition space, the ultramarine line on the wall pointed north – as did the compass – to imagined landscapes.

Not long after the Genazzano exhibition, Anselmo painted an ultramarine rectangle beneath a group of stones affixed to the wall. The ultramarine in 'Grigi che si alleggeriscono verso oltremare' (Greys becoming lighter towards 'oltremare', 1982) functioned without reference to a compass but conveyed the idea of multifarious directions. 'This colour for me is like a compass',[2] the artist maintains. And, in a number of installations, an earthen path has led to and from an impasto ultramarine marker painted on the wall. In association with such paths, the ultramarine occasions a mental interchange between the tangible presence of earth on the floor and an allusion to an infinite view.

Just as in the Kleve and Birmingham exhibitions, ultramarine rectangles, when painted on the wall by Anselmo, metaphorically telescope the extant gallery space and the ever so distant 'beyond.' Included within many different works, they represent the idea of place as that which is encompassed by reality regardless of whether it is near or far, and regardless of whether it is perceivable or not perceivable by the eye.

Since the mid-1960s, Anselmo's practice has taken a number of different turns in its redefinition of the material and thematic parameters of traditional sculpture. A consideration of works from the second half of the 1960s and, subsequently, those of the early 1970s, details the logical evolution of means employed by the artist in his exploration of art in its palpable relationship to impalpable reality.

Anselmo has stated that he 'tries to be real,' noting how he finds it 'incredible to be on the earth, walking about and looking … It is magic just to be here. And often one forgets that.'[3] Works from the outset of his career, launched in 1967 at a forward-looking exhibition at the Sperone Gallery, Turin, set the stage for the artist's ensuing involvement with energy that, broadly understood, must 'live with its true force,' and that, as he has phrased it, 'exists beneath the most varied of appearances and situations.'[4] In 1965, when standing at the summit of

führte ein Pfad aus Erde zu einer dick auf die Wand aufgetragenen Ultramarin-Markierung hin oder von ihr weg. In Verbindung mit solchen Pfaden initiiert das Ultramarin einen geistigen Austausch zwischen der greifbaren Präsenz von Erde auf dem Fußboden und einem angedeuteten Ausblick ins Unendliche.

Wie in den Ausstellungen in Kleve und Birmingham stülpen die von Anselmo auf die Wand gemalten Rechtecke aus Ultramarin den hier und jetzt vorhandenen Saal und das unbestimmbar ferne 'Anderswo' metaphorisch ineinander. In vielen unterschiedlichen Arbeiten eingesetzt, stehen sie für den Gedanken eines Ortes, der Teil der Realität ist, ganz unabhängig davon, ob dieser Ort nah oder fern ist, und unabhängig davon, ob er für das Auge wahrnehmbar ist oder nicht.

Seit der Mitte der 1960er Jahre hat Anselmos künstlerisches Schaffen im Zuge der Neudefinition des Materials sowie der technischen Parameter traditioneller Skulptur eine Anzahl von Wendungen vollzogen. Wenn man Arbeiten der zweiten Hälfte der 1960er und anschließend der frühen 1970er Jahre betrachtet, so wird im Einzelnen deutlich, wie sich die logische Evolution der Mittel vollzieht, die er verwendet, um die Kunst im Hinblick auf ihre sinnlich fassbare Beziehung zu einer un-fassbaren Wirklichkeit zu erkunden.

Anselmo hat gesagt, er versuche 'real zu sein', und dabei bemerkt, wie 'unglaublich' er es finde, 'auf der Welt zu sein, herum zu laufen und zu sehen … Es ist magisch, überhaupt hier zu sein. Und oft vergisst man das.'[3] Arbeiten vom Beginn seiner Karriere, die mit einer zukunftweisenden Ausstellung in der Galleria Sperone, Turin, begann, bereiteten die Bühne für die nachfolgende Beschäftigung des Künstlers mit Energie, die (in einem weiteren Sinne verstanden) 'mit ihrer wirklichen Kraft leben muss' und, wie er es formulierte, 'unter den verschiedensten Erscheinungen und Situationen existiert'.[4] 1965, als er auf dem Gipfel des Stromboli stand, stellte er fest, dass sein Schatten im Unendlichen verschwunden war. Diese Erfahrung – eine Art Epiphanie ohne übernatürliche oder religiöse Komponente – dokumentierte er mit einem Photo: 'La mia ombra verso l'infinito dalla cima dello Stromboli durante l'alba del 16 agosto 1965' (Mein Schatten vom Gipfel des Stromboli aus ins Unendliche projiziert bei Sonnenaufgang am 16. August 1965). Ausgehend von der Erkenntnis, dass er sowohl Zeuge wie auch Teil eines terrestrischen Schauspiels war, begann er sogleich die überkommenen Methoden und Materialien der Kunstproduktion zu überdenken. 'Ich muss mich um die Energie der Erde, die

Stromboli, he had noticed that his shadow had disappeared into infinity. He photographically documented his experience – which was a kind of epiphany with no supernatural or religious component – in 'La mia ombra verso l'infinito dalla cima dello Stromboli durante l'alba del 16 agosto 1965' (My shadow projected to infinity from the top of Stromboli during sunrise on 16 August 1965). With the realisation that he was a witness to and participant in terrestrial phenomena, he began then and there to rethink the heretofore established methods and materials for making art. 'I don't need to purchase the energy of the earth registered by a compass,' he has suggested in retrospect, 'because it is there. I can use it.'[5]

Anselmo describes the construction of his earliest mature pieces as follows:

'In 1966 I screwed onto a wooden base some iron rods that reached as high as possible until their equilibrium hung precariously between the law of gravity and the strength and cohesion of iron. When I don't use a wooden base I bend the iron so that it reaches the ground, enabling the iron to hold its vertical position by balancing its weight. In this manner … it can signal its own energy by its movements.'[6]

Holding themselves upright on their bases, untitled rod pieces demonstrate, quite literally, the thin line between verticality and collapse as they waver in response to even the gentlest form of external pressure.

Works by Anselmo from the latter 1960s, in varied self-referential ways, illustrate states of tension produced in response to conditions arising from the impact of gravitational force. Untitled works of 1967, directly following from the untitled thin metal rods, likewise are informed by the action of gravity. In one way or another each makes materially manifest its omnipresent, yet invisible, pull. A curved sheath of transparent plexiglass, in one of these untitled works, stands about two metres tall. A wire attached to the centre of its two vertical edges brings tensile strength to bear on the plexiglass, which threatens to break loose from its enforced curvilinearity in an attempt to reinstate its former flatness.

der Kompass registriert, nicht bemühen', sagte er im Nachhinein, 'denn sie ist da. Ich kann sie einfach verwenden.'[5]

Anselmo beschreibt die Konstruktion seiner frühesten gültigen Arbeiten wie folgt:

'Im Jahr 1966 setze ich Eisenstangen vertikal in Holzfundamente. Sie ragen so hoch, dass sich ein prekäres Gleichgewicht zwischen dem Gesetz der Schwerkraft und der Kohäsionskraft des Eisens einstellt. Wenn ich keine Holzfundamente verwende, biege ich das Eisen so, dass es den Boden berührt und durch Ausbalancierung des Gewichts seine vertikale Position bewahrt. Auf diese Weise zeigt die Struktur … durch die eigene Bewegung die ihr innewohnende Energie an.'[6]

Die unbetitelten Eisenstangen-Arbeiten, die sich auf ihren Fundamenten selbst aufrecht halten, demonstrieren – und das geradezu im Wortsinnc – die schmale Linie zwischen Vertikalität und Zusammenbruch, denn sie reagieren selbst auf den leisesten Druck von außen mit schwankenden Bewegungen.

Anselmos Arbeiten aus den späten 1960er Jahren illustrieren – immer auf dem Weg der Selbstreferenzialität – Spannungszustände, die von der Wirkung der Schwerkraft hervorgerufen werden. Unbetitelte Arbeiten des Jahres 1967, die direkt auf die unbetitelten Eisenstangen-Arbeiten folgen, sind ebenfalls geprägt von der Wirkung der Gravitation. Jedes einzelne Werk lässt auf dic cinc oder andere Weise ihre allgegenwärtige (gleichwohl unsichtbare) Kraft körperlich fassbar werden. Bei einer dieser Arbeiten handelt es sich um ein gebogenes Futteral aus durchsichtigem Plexiglas, das etwa eine Höhe von zwei Metern hat. Ein jeweils in der Mitte seiner vertikalen Ränder befestigter Draht übt eine Zugkraft auf das Plexiglas aus, das die erzwungene Biegung zu sprengen droht, um zu seiner ursprünglich flachen Form zurückzukehren.

Das Verhalten schwerer Objekte, die im Widerspruch zur allgegenwärtigen Kraft der Gravitation in die Höhe gehoben oder in die Tiefe gezogen werden, ist das wichtigste Thema anderer unbetitelter Arbeiten von 1967. Bei einer aufrecht stehenden Arbeit etwa drängt ein mit Sand gefüllter Stoffsack zu Boden, während er über eine aus Holz mit Kunststoffüberzug gefertigte Stütze mit bogenförmigem oberem Abschluss herabhängt. Zwei weitere Werke verkörpern ihre eigene materielle Reaktion auf die Druckkräfte, die auf sie einwirken. Im einen Beispiel lehnt sich eine eiserne Stange gegen eine durchsichtige, in einem frei stehenden Rahmen

The behaviour of weighted objects that are pushed up or pulled down in opposition to the ubiquitous force of gravity is the main thematic component of other untitled works of 1967. In one standing piece, a cloth sack containing sand tugs toward the floor as it hangs over the edge of its arched, formica-on-wood support. Two additional works embody their own material response to the pressure being exerted on them. An iron bar, in one instance, leans into – and thereby creases – clear plastic sheeting secured to a free-standing frame. In the other, an iron vice, clamped at the centre of similarly framed plastic, permanently holds the material, which it causes to wrinkle, in its grip.

'Senza titolo' (Untitled, 1968) allows gravity to act when a hollow rectangular container is filled with water. Ample wads of cotton placed in the water and billowing onto the floor, absorb the water from the container, which gradually is emptied and must repeatedly be refilled. The reductive, unornamented form of the container is consciously contradicted by the amorphous cotton, which flows from it and all around it.

The demonstrable effect of gravity on materiality infuses Anselmo's early works with detectable energy. Gravitational energy in 'Torsione' (Torsion, 1968) is pent up and offered for view. An iron bar, suspended from a tightly wound cloth, hangs on the wall ready to spin were it let loose. In 'Senza Titolo' (1968), the action of gravity takes place in conjunction with the natural progression of organic processes. For the work to be operative, a fresh head of leafy lettuce (or, in another version, a chunk of raw meat) is sandwiched between a granite pedestal and a smaller piece of granite, all of which are encircled by a wire. As the lettuce begins to rot, pieces fall to the ground, while the small granite block, yielding to gravity as well, sags when it begins to loosen its grip on the lettuce. The inertness and stasis of sculpture are put in question by a work that, wittily self-referential, 'feeds on itself.' The work furthermore represents the passage of time in accordance with the decay of an organic substance and extricates itself from the traditional definition of sculpture, which over centuries has endeavoured to be 'lifelike.'

verspannte Plastikfolie und verursacht eine Beule; im anderen ist eine eiserne Schraubzwinge im Zentrum einer ähnlichen gerahmten Plastikfolie festgeklemmt und lässt das Material in ihrem festen Griff zerknittern.

'Senza titolo' (Ohne Titel, 1968) gestattet es der Schwerkraft zu wirken, indem ein leerer rechtwinkliger Behälter mit Wasser gefüllt wird. Zahlreiche Wattebahnen, die im Wasser platziert sind und sich über den Fußboden ausbreiten, saugen das Wasser aus dem Behälter, der so nach und nach geleert wird und deshalb immer wieder neu befüllt werden muss. Der schmucklosen, auf Reduktion angelegten Form des Behälters kontrastiert die formlose Masse der Watte, die aus ihm heraus und um ihn herum fließt.

Der nachweisbare Effekt der Gravitation auf die materielle Welt erfüllt Anselmos frühe Werke mit spürbarer Energie. Die Energie der Schwerkraft ist 'Torsione' (Torsion, 1968) eingeschrieben und wird in ihr zur Anschauung gebracht. Eine eiserne Stange, die an einer straff gewickelten Stoffbahn befestigt ist, hängt vor der Wand, bereit, sich zu drehen, sollte sie losgelassen werden. In 'Senza Titolo' (1968) wirkt die Schwerkraft im Verein mit dem natürlichen Fortgang organischer Prozesse. Damit die Arbeit funktioniert, wird ein frischer Salatkopf (oder, in einer anderen Version, ein dickes Stück rohen Fleisches) zwischen einen Sockel aus Granit und ein kleineres Granitstück geklemmt und alles mit einem Draht zusammengebunden. Wenn der Salat zu welken beginnt, fallen einzelne Blätter zu Boden, und auch der kleine Granitblock unterwirft sich der Gravitation und sackt ab, sobald die Reibung zwischen ihm und dem Salatkopf nachlässt. Die Unbeweglichkeit und die Stabilität von Skulptur werden von einer – auf geistreiche Weise selbstreferenziellen – Arbeit hinterfragt, die sich 'von sich selbst ernährt'. Die Arbeit zeigt darüber hinaus an Hand des Zerfalls einer organischen Substanz das Vergehen von Zeit und entzieht sich der traditionellen Bestimmung von Skulptur, die sich Jahrhunderte lang bemüht hat, 'lebensecht' zu sein.

Die Verwendung von Lichtquellen wie Neon oder von Elektrizität in Verbindung mit festen Substanzen wie Zement, Stein oder Kohle vertieft Anselmos frühe intensive Beschäftigung mit Energiezuständen ebenso wie, in den späteren Arbeiten der 1980er und 1990er Jahre, die von ihm hergestellte Beziehung zwischen gewichtsloser Farbe und Steinen, die Hunderte von Kilogramm wiegen. Wie die aus einem zwischen zwei Eisenstangen eingeklemmten Meeresschwamm bestehende Bodenarbeit 'Respiro' (Atmung, 1969)

The use of light sources such as neon or electricity in association with hardened substances such as cement, stone, or coal further speak to Anselmo's initial involvement with manifestations of energy and, in later works of the 1980s and 1990s, to the direct relationship he has made between weightless colour and stones weighing hundreds of kilograms. As indicated by a floor piece, 'Respiro' (Breathing, 1969), consisting of a sea sponge inserted between two lengths of iron, Anselmo's work does not attempt to be a copy of real life but, instead, to instill materiality with energy. The iron bars respond to changes in temperature and, alternately dilating and shrinking, exert different degrees of pressure on the sponge. The work is, metaphorically speaking, brought to life via its connection with the heat of the sun.

Works by Anselmo from the second half of the 1960s may be compared in broad terms with those of the same period by Postminimalist artists such as Robert Morris, Bruce Nauman, Eva Hesse, and Richard Serra. Like Postminimal production, Anselmo's art resists subjective intent, representational figuration, and hierarchical compositional form and comparably features an inherent materiality. It is to be clearly distinguished from Postminimalist sculpture, however, by its specific recognition of gravity's impact on material form. A lead 'Prop Piece' (1968) by Serra, for example, acts out its condition with respect to gravity – the condition of shoring itself up against the wall. The action of gravity on material objects is implicit in Serra's work, but in works of the latter 1960s by Anselmo, energy arising from resistance to gravity is meant to be thematically explicit. If Serra's work seeks to resist gravity, Anselmo's expresses its unseen presence.

By virtue of their indexical characterisation of gravity's existence, works from the very beginning of Anselmo's career presage his ensuing works that, as of 1969, would draw upon language and photography and, not long thereafter, embrace their surrounding architecture. In this regard, the magnetic needles, pointing north, set into pieces titled 'Direzione' (Direction, 1967; 1967– 68) testify to the activity of the earth's magnetic field while they also

zeigt, versucht Anselmo keineswegs, das reale Leben zu kopieren, sondern er will Materie mit Energie aufladen. Die Eisenstäbe reagieren auf Temperaturschwankungen und üben, indem sie sich entweder ausdehnen oder zusammenziehen, in unterschiedlichem Maße Druck auf den Schwamm aus. Die Arbeit wird, metaphorisch gesprochen, zum Leben erweckt, weil sie der Wärme der Sonne ausgesetzt ist.

Anselmos Werke der zweiten Hälfte der 1960er Jahre können in einem allgemeinen Sinn mit denen postminimalistischer Künstler aus derselben Zeit verglichen werden, etwa Robert Morris, Bruce Nauman, Eva Hesse und Richard Serra. Wie die Produktion der Postminimalisten widersetzt sich auch Anselmos Kunst subjektiver Absicht, gegenständlicher Darstellung sowie hierarchischen Kompositionsformen, und sie zeichnet sich ebenfalls in vergleichbarer Weise durch eine inhärente Materialität aus. Andererseits lässt sie sich ganz klar dadurch von postminimalistischer Plastik unterscheiden, dass sie dem Einfluss der Schwerkraft auf eine materielle Form besondere Aufmerksamkeit schenkt. Beispielsweise führt ein aus Blei geschaffenes 'Prop Piece' (1968) von Richard Serra seine besondere Eigenschaft im Hinblick auf die Gravitation vor – die Eigenschaft, sich gegen die Wand zu lehnen und sich dabei selbst zu einer Kurve aufzuwerfen. Die Wirkung der Schwerkraft auf materielle Objekte ist Serras Schaffen implizit, aber in Anselmos Arbeiten der späten 1960er Jahre soll die Energie, die aus dem Widerstand gegen die Schwerkraft entsteht, thematisch explizit werden. Wenn Serras Werk der Schwerkraft zu widerstehen sucht, so drückt Anselmos Werk ihre unsichtbare Gegenwart aus.

Insofern sie die Existenz der Schwerkraft mit Hilfe von Indizes charakterisieren, kündigen Anselmos früheste Arbeiten seine späteren an, die sich im Jahr 1969 auf Sprache und Photographie beziehen und bald darauf auch die umgebende Architektur mit einbeziehen. Die nach Norden zeigenden Magnetnadeln, die in die 'Direzione' (Richtung, 1967, 1967– 68) genannten Arbeiten eingesetzt sind, bezeugen – so gesehen – sowohl die Kraft des irdischen Magnetfeldes als auch die Tatsache, dass die Ausrichtung des Werks im Einklang mit dem Raum steht, der es umgibt.

Als Anselmo 1969 die Sprache in sein Werk einführte, weitete er seine künstlerische Recherche aus, um die Kürze eines Menschenlebens im Gegensatz zur Langlebigkeit von Materialien wie etwa Eisen abzuwägen. Mehrere Arbeiten, die eingefettetes Eisen und sprachliche Elemente kombinie-

indicate the work's own directional position within the encompassing room.

With the introduction of language into his work in 1969, Anselmo extended his aesthetic investigation to ponder the brevity of human life vis-à-vis the longevity of materials like iron. Several works combining greased iron and linguistic elements or phrases give concrete form to the idea of indefinite time. The title of 'Per un'incisione di indefinite migliaia di anni' (For a notch in an indefinite number of thousands of years, 1969) is also the text of a pencilled wall inscription. A cylindrical iron bar leans against the wall next to the phrase. Rust preventive coats the full surface of the bar except at its top. The process of oxidation occurs from inside the bar so that, as it disintegrates (over an immeasurable period of time), it might mark the wall. The artist has stated that this 'work is like a drawing which others will continue at the end of my life, etc. It is a work that continues itself, which is directed against death, against time which is determined by man and limited by man.'[7] The greased bar remains to participate in a future beyond any one person's lifetime.

Language has afforded Anselmo the possibility of dealing with the concept of spatial infinity, which intersects with the notion of temporal indeterminacy. 'Particolare di infinito' (Detail of infinity, 1969) is a small pencil drawing measuring only 25 × 25 cm. Even-handed, grey markings fill the entire square of paper. The grey-toned surface represents a part of the letter 'I' from the word 'INFINITY,' which the artist has envisioned as infinitely enlarged. The drawing is on a scale of 1:1 and, for this reason, is only an infinitesimal part of the infinite whole. So immense is the letter in its entirety, it could never be seen.

'Entrare nell' opera' (Entering the work, 1971), a black-and-white photograph printed on a large unstretched canvas, comments on Anselmo's endeavour to peer into the face of reality by acknowledging the concomitant reality of art. A figure viewed from the back runs into the centre of a grassy field that exactly corresponds with the overall field of the picture plane. No distinguishing natural features - no trees, bushes, or hedges, etc. - distract from the

ren, verleihen der Vorstellung einer unbestimmten Zeitspanne konkreten Ausdruck. Der Titel von 'Per un'incisione di indefinite migliaia di anni' (Für eine Gravur in einer unbestimmten Anzahl von Tausenden von Jahren, 1969) ist auch der Text einer mit Bleistift ausgeführten Wandbeschriftung. Neben diesen Worten lehnt eine zylindrische Eisenstange an der Wand. Rostschutzmittel bedeckt die gesamte Oberfläche der Stange mit Ausnahme ihrer Spitze. Der Vorgang der Oxidation findet im Inneren der Stange statt, so dass sie, während sie allmählich (über einen nicht messbaren Zeitraum hinweg) zerfällt, die Wand mit einem Strich markieren wird. Dem Künstler zufolge ist seine Arbeit gleichsam 'eine Zeichnung, die am Ende meines Lebens von anderen fortgeführt wird usw. Es ist eine Arbeit, die sich selbst fortsetzt, die gegen den Tod, gegen die durch den Menschen bestimmte, durch den Menschen begrenzte Zeit gerichtet ist.'[7] Die eingefettete Stange wird bleiben und an einer Zukunft teilhaben, die jenseits der menschlichen Lebenserwartung liegt.

Die Sprache hat Anselmo die Möglichkeit gegeben, vom Konzept räumlicher Unendlichkeit zu handeln, das sich mit dem Gedanken zeitlicher Unbestimmtheit überschneidet. 'Particolare di infinito' (Detail der Unendlichkeit, 1969) ist eine kleine Bleistiftzeichnung, die nicht mehr als 25 × 25 cm misst. Gleichmäßige graue Schraffuren füllen die gesamte quadratische Fläche des Papiers. Die grau getönte Oberfläche stellt einen Teil des Buchstabens 'I' dar – den Anfang des Wortes 'Infinito' (Unendlichkeit), das der Künstler sich als unendlich vergrößert vorstellt. Die Zeichnung hat den Maßstab 1:1 und ist deshalb nur ein unendlich kleiner Teil des unendlichen Ganzen. Der Buchstabe in seiner vollen Größe ist so immens, dass er niemals gesehen werden könnte.

'Entrare nell'opera' (Ins Werk eintreten, 1971), eine Schwarzweiß-Photographie, gedruckt auf eine große, nicht aufgezogene Leinwand, kommentiert Anselmos Bestreben, das Antlitz der Wirklichkeit zu erforschen, indem er die parallele Wirklichkeit der Kunst anerkennt. Eine von hinten gesehene Figur läuft ins Zentrum eines mit Gras bedeckten Feldes, das ganz genau dem Gesamtfeld der Bildfläche entspricht. Keine besonderen landschaftlichen Merkmale – keine Bäume, Büsche oder Hecken usw. – lenken ab von der Verschmelzung von Figur und Grund, denn der Grund, über den die Figur läuft, umschließt sie ganz und gar.

Der Künstler schuf 'Entrare nell' opera', indem er sich selbst photographierte, aber die Figur – letztlich ebenso allgemein wie die Landschaft – repräsentiert den Akt des sich

fusion of figure and ground since the ground on which the figure runs completely envelopes him.

The artist constructed 'Entrare nell'opera' by photographing himself, but the figure – ultimately generic like the landscape – represents the act of immersion in the creation or the contemplation of art. For the realisation of 'Documentazione di interferenza umana nella gravitazione universale' (Documentation of human interference in universal gravitation, 1969), which exists as a multiple and has variable dimensions, Anselmo walked toward the setting sun holding a camera. Without shifting the camera aimed at the horizon, he proceeded twenty steps closer to the sun before taking each of twenty successive photographs. The resulting images document the incremental and almost undetectable changes of the sinking sun's position as the artist was drawing progressively – if ever so slightly – closer to it with the camera. The photographs are displayed consecutively on the wall so that viewers may follow a course of movement in relation to the sun. Anselmo has explained: 'My intent was to move in opposition to the earth documenting my own movements as if I were a small planet or a small moon moving with relation to the earth and the sun.' Moreover, he has elaborated, 'a viewer, too, when walking from one photograph to the next, may be thought of as a small planet.'[8] Conceived three decades and more prior to 'Dove le stelle si avvicinano di una spanna in più …', 'Documentazione di interferenza …' presents observable phenomena within a cosmological frame of reference.

The year 1971 marks the date when Anselmo shifted his engagement with language in association with iron objects to an engagement with words projected within the architectural confines of the exhibition space. Several projector pieces, namely 'Invisibile' (Invisible, 1971), 'Infinito' (Infinity, 1971), and 'Tutto' (All, 1971), culminated in 'Particolare' (Detail, 1972), Anselmo's first full-scale installation anticipating later room-sized works such as 'Dove le stelle si avvicinano di una spanna in più …' For the first of these, the word 'visibile' (visible) is projected into the exhibition space without reference to a specific object. The word can only be seen on a

Einfügens in die Schöpfung oder des Nachdenkens über Kunst. Um die Arbeit 'Documentazione di interferenza umana nella gravitazione universale' (Dokumentation der menschlichen Interferenz mit der universellen Gravitation, 1969) zu realisieren, die als Multiple existiert und unterschiedliche Formate hat, ging Anselmo mit einer Kamera in der Hand auf die untergehende Sonne zu. Ohne die auf den Horizont gerichtete Kamera zu bewegen, näherte er sich der untergehenden Sonne um jeweils zwanzig Schritte, ehe er eine der zwanzig aufeinanderfolgenden Photographien machte. Die so entstandenen Bilder dokumentieren die allmählichen und kaum wahrnehmbaren Positionsveränderungen der untergehenden Sonne, während der Künstler ihr mit seiner Kamera schrittweise – wenn auch nur unmerklich – näher kam. Die Photographien werden in einer fortlaufenden Reihe an der Wand gezeigt, so dass die Betrachter einen auf die Sonne bezogenen Bewegungsablauf verfolgen können. Anselmo erklärte dazu: 'Mein Wunsch war es, mich entgegen der Erddrehung zu bewegen und dabei meine Bewegungen so zu dokumentieren, als ob ich ein kleiner Planet oder ein kleiner Mond wäre, der sich bezogen auf die Erde und die Sonne bewegt.' Darüber hinaus, so ergänzte er, 'kann der Betrachter, der sich von einer Photographie zur nächsten bewegt, ebenfalls als kleiner Planet aufgefasst werden.'[8] Mehr als drei Jahrzehnte vor 'Dove le stelle si avvicinano di una spanna in più …' konzipiert, präsentiert 'Documentazione di interferenza …' einfach zu beobachtende Phänomene in einem kosmologischen Bezugsrahmen.

Das Jahr 1971 markiert den Moment, als Anselmo seine Beschäftigung mit Sprache im Zusammenhang mit eisernen Objekten auf die Beschäftigung mit Worten ausweitete, die innerhalb der Grenzen des jeweiligen Ausstellungsraums projiziert werden. Verschiedene Projektor-Arbeiten, namentlich: 'Invisibile' (Unsichtbar, 1971), 'Infinito' (Unendlich, 1971) und 'Tutto' (Alles, 1971), führten schließlich zu 'Particolare' (Detail, 1972), Anselmos erster großer Installation, die spätere raumgreifende Werke wie 'Dove le stelle si avvicinano di una spanna in più …' vorweg nimmt. Bei der erstgenannten Arbeit wird das Wort 'visibile' (sichtbar) ohne Bezug auf ein bestimmtes Objekt in den Raum projiziert. Das Wort ist sichtbar nur auf einer Oberfläche (wie etwa der Innenseite einer Hand), die in der richtigen Entfernung vor die Linse gehalten wird. Sonst bleibt es unsichtbar, aufgelöst im Strahl des Lichtes. Bei der zweiten Arbeit wird das Wort 'infinito' auf eine Wand projiziert, wobei der Scharfstell-

surface (such as the palm of a hand) held in front of the lens at an appropriate distance. Otherwise it remains imperceptible, diffused within the beam of light. For the second work, the word 'infinito' is projected onto a wall with the projector's focusing mechanism set on 'infinity.' Although light is cast on the wall, the word remains illegible. These two works concretely clarify how the finite and infinite, like the visible and the invisible, are unavoidably functions of one another rather than simply opposites.

'Tutto' synthesises much of Anselmo's thinking about the depiction of reality in view of the invisible and infinite. This work requires two projectors—one for 'tut' and the other for 'to.' The bifurcation of the word meaning 'all' in Italian and its projection on separate surfaces defines the impossibility of representing the infinite variability of the visible. It speaks instead to the unending breakdown of observable reality into an infinite number of contributing parts.

The realisation that reality may be understood as a sum of all of its individual components but never captured in its infinite totality is the inherent message of 'Particolare'. Anselmo's installation of projected slides supersedes material form to bring about its substantiation as part of the architectural actuality of interior spaces. Since its initial showings in the first half of the 1970s, 'Particolare' has been adapted to many different spaces. When the Italian word 'particolare,' (translated as 'detail' as well as 'particular situation') is projected onto distinguishing features of an exhibition area, the work animates the space it occupies. By labelling the floor, wall, and ceiling in this way, along with a possible vent, molding, radiator, or even the clothing or hand of a passer-by, Anselmo articulates the entire context in which the work is inscribed. Issuing from slide projectors appointed within the exhibition space, the illuminated 'particolare' discreetly highlights specific details of the work's setting. Merging with its architectural confines by means of a single word, 'Particolare' presents visible reality as an ineluctable aggregate of parts.

An exhibition at the Tucci Russo gallery, Turin, in 1978 incorporated three 'Particolare' projectors and

Mechanismus des Projektors auf 'Unendlich' eingestellt ist. Auch wenn Licht auf die Wand geworfen wird, so bleibt das Wort doch unlesbar. Diese beiden Arbeiten machen ganz konkret klar, wie das Endliche und das Unendliche, genauso wie das Sichtbare und das Unsichtbare, zwangsläufig eher Funktionen voneinander als einfach Gegensätze sind.

Ein Großteil von Anselmos Reflexionen über die Wiedergabe der Wirklichkeit unter dem Aspekt des Unsichtbaren und des Unendlichen ist in 'Tutto' vereinigt. Für diese Arbeit werden zwei Projektoren gebraucht – der eine für 'tut' und der andere für 'to'. Die Zweiteilung des Wortes, das im Italienischen 'alles' bedeutet, und seine Projektion auf unterschiedliche Oberflächen weisen auf die Unmöglichkeit, die unendliche Vielfalt des Sichtbaren wiederzugeben. Es hebt stattdessen ab auf das unaufhörliche Zerfallen der sichtbaren Realität in eine unendliche Zahl von Einzelteilen.

Die Erkenntnis, dass die Realität als Summe aller ihrer Bestandteile verstanden, aber niemals in ihrer unendlichen Totalität begriffen werden kann, ist die Botschaft, die in 'Particolare' beschlossen liegt. Anselmos Installation aus projizierten Dias gibt die materielle Form auf, um fassbare Gestalt nur als Teil der jeweiligen architektonischen Gegebenheiten von Innenräumen zu gewinnen. Seit die Arbeit in der ersten Hälfte der 1970er Jahre erstmals gezeigt wurde, ist 'Particolare' auf viele unterschiedliche Räume zugeschnitten worden. Sobald das italienische Wort 'particolare' (man kann es ebenso mit 'Detail' wie mit 'besondere Situation' übersetzen) auf charakteristische Bestandteile eines Ausstellungsraums projiziert wird, belebt die Arbeit den Raum, den sie besetzt. Den Fußboden, die Wand und die Decke zusammen mit einer Öffnung, einem Sims oder einem Ventilator, die möglicherweise vorhanden sind, bezeichnend und selbst die Kleidung oder die Hand eines Passanten einbeziehend, artikuliert Anselmo den gesamten Kontext, in den das Werk eingeschrieben ist. Ausgehend von Diaprojektoren, die im Ausstellungsraum aufgestellt sind, hebt das aufleuchtende 'particolare' auf diskrete Weise besondere Details in der Umgebung der Arbeit hervor. Indem die Arbeit sich mit Hilfe nur eines einzigen Wortes mit ihren architektonischen Grenzen verbindet, zeigt 'Particolare' die sichtbare Wirklichkeit als eine integrale Ansammlung von (Einzel-)Teilen.

Eine Ausstellung in der Galleria Tucci Russo, Turin, 1978 umfasste drei 'Particolare'-Projektoren und drei andere schon zuvor existierende Arbeiten. Gemeinsam bildeten

three other previously existing works. Together, these individual works created a new ensemble titled 'Un disegno e tre particolari a ovest, trecento milioni di anni a est' (A drawing and three details to the west, three hundred million years to the east, 1978). The artist focused the projectors, respectively, on a corner, on a neighbouring projector, and into the air. From across the room, the light from the last projector simulated a twinkling star. Whenever a moving object – a person most likely, but perchance a dog or cat (keeping all eventualities open, according to the artist) – passed in front of its beam, the word 'particolare' would fall upon it. Besides the three 'Particolare' projections, the Tucci Russo installation included a stone block with magnetic needle (a version of 'Direzione'), 'Trecento milioni di anni' (a glowing piece of anthracite), and a small pencil drawing from the word 'infinito' (from 'Particolare di Infinito').

Bringing together the major themes of the artist's oeuvre up to this point, the Tucci Russo exhibition may be considered a watershed work in Anselmo's career. Significantly, this exhibition preceded his first use of his signature 'oltremare' (at Castello Colonna, Genazzano) in 1979, which has appeared frequently in the range of works leading up to 'Dove le stelle si avvicinano di una spanna in più …' The ultramarine rectangle has functioned in place of language, replacing words such as 'invisibile,' 'infinito,' or 'particolare,' and has served as a signpost announcing the intersection between the aesthetic and the real. 'Oltremare' designates the open border between the here-and-now and all that lies beyond. As 'Dove le stelle si avvicinano di una spanna in più …' leads the viewer to understand, the 'beyond' encompasses the unseeable whole in all of its infinite temporal and directional manifestations.

Resulting from three and a half decades of thought and practice, 'Dove le stelle si avvicinano di una spanna in più …' falls under the contemporaneous (and intersecting) art historical rubrics of Arte Povera and Conceptual art. Anselmo has participated in the many group exhibitions of Arte Povera since its inception in 1967 while his work may be identified with the representational intentions and

diese drei einzelnen Arbeiten ein neues Ensemble mit dem Titel 'Un disegno e tre particolari a ovest, trecenti milioni di anni a est' (Eine Zeichnung und drei Details im Westen, dreihundert Millionen Jahre im Osten, 1978). Der Künstler richtete die Projektoren auf eine Ecke, auf einen benachbarten Projektor bzw. in die Luft. Von der anderen Seite des Raumes gesehen, simulierte der letztgenannte Projektor einen blinkenden Stern. Wenn ein bewegliches Objekt – am wahrscheinlichsten wohl ein Mensch, vielleicht aber auch ein Hund oder eine Katze (jedenfalls wenn man, den Intentionen des Künstlers folgend, alle Möglichkeiten offen hält) – den Projektionsstrahl passierte, wurde es von dem Wort 'particolare' getroffen. Neben den drei 'Particolare'-Projektionen enthielt die Installation bei Tucci Russo einen Steinblock mit Magnetnadel (eine Version von 'Direzione'), 'Trecento milioni di anni' (ein leuchtendes Stück Anthrazit) sowie eine kleine Bleistiftzeichnung aus dem Wort 'infinito' (aus 'Particolare di infinito').

Insofern sie die wichtigsten Themen im Werk des Künstlers bis zu diesem Zeitpunkt zusammenbrachte, kann man die Ausstellung bei Tucci Russo als Wasserscheide in Anselmos Karriere verstehen. Bezeichnenderweise ging sie dem ersten Gebrauch seines Markenzeichens 'oltremare' 1979 im Castello Colonna, Genazzano, voraus. Es tauchte seither wiederholt in der Reihe der Werke auf, die zu 'Dove le stelle si avvicinano di una spanna in più …' führten. Das Rechteck aus Ultramarin hat die Funktion der Sprache übernommen und ersetzt Worte wie 'invisibile', 'infinito' oder 'particolare' und dient als Signal, das den Kreuzungspunkt zwischen dem Ästhetischen und dem Realen ankündigt. 'Oltremare' bezeichnet die offene Grenze zwischen dem Hier-und-Jetzt und allem, das jenseits liegt: dem Anderswo. 'Dove le stelle si avvicinano di una spanna in più …' führt den Betrachter zu der Erkenntnis, dass dieses 'Anderswo' die unsichtbare Ganzheit sowohl der Zeit als auch des Raumes umfasst.

Hervorgegangen aus dreieinhalb Jahrzehnten der Reflexion und der Praxis, fällt 'Dove le stelle si avvicinano di una spanna in più …' unter die gleichzeitigen (und einander überschneidenden) kunstgeschichtlichen Strömungen von Arte Povera und Konzeptkunst. Anselmo hat an den zahlreichen Gruppenausstellungen der Arte Povera seit deren Beginn 1967 teilgenommen, aber sein Werk kann auch mit den formalen Strategien und Intentionen des Konzeptualismus identifiziert werden, sofern diese darauf abzielen, die Illusion aufzuheben. Wie andere italienische Künstler derselben

methods of Conceptualism insofar as these seek to nullify illusion. Like other Italian artists of the same generation included in Arte Povera, Anselmo has utilised materials in decidedly non-traditional ways. These may be 'poor,' non-art materials such as cotton or lettuce or established materials such as iron or stone. Of major importance to his oeuvre is its use of signifying elements including the needle of a compass and behaviour of materials responding to gravitational force; or signifying elements derived from language, photography, or colour. These indicators deliver the work from the static materiality of traditional sculpture and the fixed planarity of painting on canvas. They participate in one way or another within works that concern themselves with the invisible energies that underlie the multifaceted complexity of material reality.

I would like to thank Giovanni Anselmo for his generous assistance and Tamara Blanich for her editorial insights.

Generation, die man unter dem Begriff Arte Povera zusammenfasst, hat Anselmo Materialien ganz bewusst auf unkonventionelle Weise eingesetzt. Es kann sich dabei gleichermaßen um 'arme', nicht-künstlerische Materialien (z.B. Baumwolle oder Salat) wie auch um etablierte Materialien (z.B. Eisen oder Stein) handeln. Von größter Bedeutung für sein Oeuvre ist die Art und Weise, wie er einzelne Elemente als Bedeutungsträger nutzt, etwa eine Kompassnadel oder das Verhalten von Materialien unter dem Einfluss der Schwerkraft, und wie er Bedeutungsträger aus der Sprache, aus der Photographie oder aus der Farbe gewinnt. Diese Zeichen befreien sein Werk sowohl von der statischen Materialität traditioneller Skulptur als auch von der festgelegten Flächigkeit der Malerei auf Leinwand. Sie bringen sich auf je besondere Weise ein in Arbeiten, die von unsichtbaren Energien handeln, die der facettenreichen Komplexität der materiellen Realität zu Grunde liegen.

Ich möchte Giovanni Anselmo danken für seine großzügige Unterstützung und Tamara Blanich für ihre redaktionellen Anmerkungen.

Übersetzung Roland Mönig

1. For this issue cf. the text by Tiziana Caianiello in this catalogue.
2. Conversation with the author, December 2001.
3. Alan G. Artner, 'I try to be real', 'Chicago Tribune', Sunday, June 8, 1997, Section 7, p. 7.
4. Anselmo, in Richard Flood and Frances Morris, Zero to infinity: Arte Povera 1962–1972, London, Tate Modern / Minneapolis, Walker Art Centre 2001, p. 178.
5. Conversation with the author, December 2001.
6. Anselmo, in R. Flood and F. Morris, p. 178.
7. Anselmo, 'Examples of Works', in *Giovanni Anselmo*, Basel, Kunsthalle Basel / Eindhoven, Stedelijk Van Abbemuseum 1979, p. 18.
8. Conversation with the author, December 2001.

1. Zu diesem Thema vgl. a. den Text von Tiziana Caianiello in diesem Katalog.
2. Gespräch mit der Autorin, Dezember 2001.
3. Alan G. Artner, 'I try to be real', in: Chicago Tribune, Sonntag, 8. Juni 1997, Sektion 7, S. 7.
4. Giovanni Anselmo, o.T. (1969), in: Nike Bätzner (Hrsg.), Arte Povera: Manifeste – Statements – Kritiken, Dresden / Basel 1995, S. 120f., hier: S. 120.
5. Gespräch mit der Autorin, Dezember 2001.
6. Giovanni Anselmo, o.T. (1972), in: Nike Bätzner (Hrsg.), S. 122–126, hier: S. 122.
7. Giovanni Anselmo, Werkbeispiele, in: Kat.d.Ausst. 'Giovanni Anselmo', Basel (Kunsthalle Basel) / Eindhoven (Stedelijk van Abbemuseum) 1979, S. 7.
8. Gespräch mit der Autorin, Dezember 2001.

Beyond painting
Jenseits der Malerei

Since the 1980s, Giovanni Anselmo has created several works that allude to painting. For these, on the whole, he does not use conventional colours, but rather stones. His tools are not brushes and a palette, but steel cable, slip-knots and gravity. The painter's brushstroke is replaced by the traces left by the mechanical splitting of stones from the quarry. The artist's hand is hinted at by indications instead of being directly involved in making the art work. The function of the canvas, which has been the preferred support for centuries, is redefined. Anselmo's art is neither associated with a surface nor restricted by a frame; it is three-dimensional and open. His landscapes are not representations of nature but consist of real natural elements such as earth and stones which occupy the exhibition space and at the same time refer to a space beyond the museum's walls. The forces of nature are immediately present in his works and exercise their effects instead of being merely depicted.

After initial experiments with conventional painting, Anselmo dedicated himself to exploring antonyms such as visible/invisible, finite/infinite and to deriving poetic possibilities from the laws of physics. An experience he went through on Stromboli was decisive. On 16 August 1965 Anselmo climbed up the volcano and reached the summit at daybreak. The sun was beneath him so that his shadow was thrown out into the infinity of the sky. From that moment the artist felt himself as part of a cosmic event. This enlightening experience, documented by a photograph, has continued to inspire his artistic work.

From 1968 Anselmo took part in the exhibitions which were organised by the art critic Germano Celant since 1967 under the title 'Arte Povera'. Celant had borrowed this concept from the theatre theory of Jerzy Grotowski. According to Grotowski, actors should express all physical and psychic movements without the aid of a complicated apparatus, but using

Seit den 1980er Jahren hat Giovanni Anselmo mehrere Arbeiten geschaffen, die auf die Malerei anspielen. Für diese Werke verwendet er meistens keine herkömmlichen Farben, sondern Steine. Nicht Pinsel und Palette sind seine Werkzeuge, sondern Stahlkabel, Laufknoten und die Schwerkraft. Der Pinselduktus des Malers wird in seiner Arbeit durch die Spuren ersetzt, die durch die maschinelle Spaltung der Steine vom Steinbruch hinterlassen werden. Die Hand des Künstlers wird durch Hinweise angedeutet, statt das Kunstwerk direkt zu prägen. Die Funktion der Leinwand, seit Jahrhunderten der bevorzugte Bildträger, wird neu definiert. Anselmos Kunst ist weder einer Fläche verbunden noch von einem Rahmen begrenzt, sie ist dreidimensional und offen. Seine Landschaften sind keine Darstellungen der Natur, sondern bestehen aus realen Naturelementen wie Erde und Steinen, die den Ausstellungsraum besetzen und gleichzeitig auf einen weiteren Raum außerhalb der Museumswände verweisen. In seinen Kunstwerken sind die Kräfte der Natur unmittelbar präsent und üben ihre Wirkung aus, statt in einer Abbildung zu erstarren.

Nach anfänglichen Experimenten mit der konventionellen Malerei widmete sich Anselmo der Erforschung von Antinomien wie Sichtbares – Unsichtbares, Endliches – Unendliches und einer poetischen Verarbeitung von physikalischen Gesetzen. Ausschlaggebend war eine Erfahrung auf dem Stromboli: Am 16. August 1965 bestieg Anselmo den Vulkan und erreichte bei Tagesanbruch den Gipfel. Die Sonne stand tiefer als er, so dass sein Schatten sich gegen den Himmel ins Unendliche erstreckte. In diesem Moment fühlte sich der Künstler als Teil eines kosmischen Ereignisses. Dieses erleuchtende Erlebnis, das in einem Photo dokumentiert ist, inspirierte dauerhaft seine weitere künstlerische Arbeit.

Ab 1968 nahm Anselmo an den Ausstellungen teil, die der Kunstkritiker Germano Celant seit 1967 unter dem Titel 'Arte Povera' organisierte. Celant hatte diesen Begriff aus den Theatertheorien Jerzy Grotowskis entlehnen. Grotowski zufolge sollten die Schauspieler alle physischen und psychischen Bewegungen ohne Hilfe eines komplizierten Apparats, sondern nur mit dem eignen Körper ausdrücken.[1] Diese Forderung nach Reduktion wurde von Celant auf die bildende Kunst übertragen. Konzeptuelle Prozesse sollten mit den einfachsten Mitteln materialisiert werden. In Abgrenzung zu einer 'reichen Kunst', die sich der Imitation und Vermittlung der Realität widmete, zielte die 'arme Kunst' auf eine

only their bodies.[1] Celant transferred this call for reduction to the fine arts. Conceptual processes were to be materialised with the simplest of means. In contrast to a 'rich art' that devoted itself to imitating and mediating reality, 'poor art' aimed at an identification with reality. It was intended to contradict the understanding of history as an evolutionary process and bring out the contingent aspects of the present. Celant rejected literary motifs in favour of an intuitive art practice.[2] The approaches taken by the Arte Povera artists were various, but nevertheless, all of them intended to overcome the limits of conventional painting and sculpture. They questioned painting not only as a mimetic procedure, but also as a pure surface, as an abstract, two-dimensional painting.

The material components of a painting (canvas, frame, colour or paint) became the subject of artistic investigation. The work 'Senza titolo' (Untitled) by Giulio Paolini from as early as 1961, for instance, shows an actual tin can behind transparent plastic film stretched over a wooden frame. The can contains the paint which is supposed to serve to paint the painting. The work is therefore not a representation, but the presentation of a real, three-dimensional object. In contrast to Paolini, who is preoccupied with the nature of art itself, Anselmo does not want to create any self-referential works. Rather he prefers to make artistic gestures that refer to the invisible forces of nature and to the endlessness of the universe.

In the second half of the 1970s, painting again won back significance. In 1979 the art critic Achille Bonito Oliva coined the term 'Transavanguardia' to define an art that once again put subjectivity and handicraft work into the foreground and eclectically involved quotations from all the epochs of art history. Celant disapproved of this tendency as reactionary and opposed it with the 'iconoclastic' stance of Arte Povera.[3] In the meantime, however, even some of the Arte Povera artists integrated painting into their works. Already in 1974, for instance, Mario Merz combined his installations with representations of nature on canvas and continued to make drawings up until the end of his life.[4]

Identifizierung mit der Realität. Sie wollte dem Verständnis der Geschichte als evolutionärem Prozess widersprechen und die kontingenten Aspekte der Gegenwart hervorheben. Literarische Motive wurden von Celant zugunsten einer intuitiven Kunst abgelehnt.[2] Die Ansätze, nach denen die Künstler der Gruppierung 'Arte Povera' arbeiteten, waren unterschiedlich. Jedoch intendierten alle, die traditionellen Grenzen von Tafelbild und Skulptur zu überwinden. Die Arte-Povera-Künstler stellten sowohl die Malerei als mimetisches Verfahren als auch die Malerei als reine Fläche, d.h. als abstraktes zweidimensionales Tafelbild, infrage.

Die materiellen Bestandteile des Gemäldes (Leinwand, Keilrahmen, Farbe) wurden zum Gegenstand der künstlerischen Untersuchung. Das Werk 'Senza titolo' (Ohne Titel) von Giulio Paolini, das bereits im Jahre 1961 entstand, zeigt zum Beispiel eine echte Dose hinter einer durchsichtigen Plastikfolie, die auf einen Rahmen aus Holz aufgespannt ist. Die Dose enthält die Farbe, die dazu dienen sollte, das Bild zu malen. Das Werk ist also keine Darstellung, sondern die Präsentation eines realen, dreidimensionalen Objektes. Im Unterschied zu Paolini, der mit seiner Kunst über die Kunst selbst reflektiert, möchte Anselmo keine selbstreferentiellen Werke schaffen, sondern Zeichen, die auf die unsichtbaren Kräfte der Natur und auf die Unendlichkeit des Universums hinweisen.

In der zweiten Hälfte der 1970er Jahre gewann die Malerei wieder an Bedeutung. 1979 prägte der Kunstkritiker Achille Bonito Oliva den Terminus 'Transavanguardia', um eine Kunst zu definieren, die Subjektivität und Handarbeit wieder in Vordergrund stellte und sich von Zitaten aus allen Epochen der Kunstgeschichte wahllos bediente. Celant missbilligte diese Tendenz als reaktionär und stellte ihr die 'ikonoklastische' Haltung der Arte Povera entgegen.[3] Inzwischen integrierten aber auch einige der Arte-Povera-Künstler die Malerei in ihre Arbeiten: Mario Merz, zum Beispiel, kombinierte bereits 1974 seine Installationen mit Darstellungen der Natur auf Leinwand und realisierte weiterhin Zeichnungen bis zum Ende seines Lebens.[4]

Die Arbeiten, in denen Anselmo seit den 1980er Jahren auf das Tafelbild verweist, reagieren auf dieses Klima, können aber nicht als Rückkehr zur Malerei verstanden werden. Durch die Einbeziehung der Natur und ihrer realen Energien statt ihrer Darstellung sind Anselmos Werke im eigentlichen Sinne 'jenseits der Malerei'. Sie erwecken zwar Assoziationen zur Kunstgeschichte, aber ohne zu den traditionellen

Those works by Anselmo, made since the 1980s, that refer to conventional painting constitute a reaction to this artistic climate, but cannot be understood as a return to painting. By incorporating nature and its real energies instead of its portrayal, Anselmo's works are 'beyond painting' in the proper sense. They do arouse associations with art history, but without involving traditional iconographic encoding and symbols. It is exclusively the sensuous experience of the material and energy of colour that points to the essence of painting. With reference to Anselmo's works, Luc Lang speaks appositely of a 'primitivisme litteraire' (literary primitivism) because the sensuous perception of their simple elements unleashes a chain of associations that is not prescribed by references to the history of art and fragments of history. Rather, it is the oppositions immanent in the works (such as stones that are cut and broken partly geometrically and partly unevenly) that activate the viewer's memory.

Colour

The element of colour takes on two different connotations in Anselmo's work. On one hand, colour as paint can be conceived of as matter, and, on the other, as energy. These two connotations seem to be opposed at first glance. In truth, however, as Albert Einstein demonstrated with his theory of relativity, mass and energy are the same.

Coloured pigments were traditionally derived from pulverized minerals. One example is ultramarine blue, a colour which has played an important role in Anselmo's work since 1979. Its pigment was originally produced from ground lapis lazuli. On one hand, therefore, paint colours can be regarded as matter, related to the palpable material of stone. They have their own mass which gives them inertia and gravity, and consequently they have their own weight. Stones can therefore, in turn, also be used as colours. Anselmo prefers granite, a stone from the depths which, depending on its origins, has a different colour varying from light grey to grey-green and black, from pink to red ...

On the other hand, colours are sensations that are triggered by electromagnetic waves. These

ikonographischen Verschlüsselungen und Symbolen zu greifen. Es ist ausschließlich die sinnliche Erfahrung der Materie und Energie der Farbe, die auf das Wesen der Malerei hindeutet. Mit Bezug auf Anselmos Werke spricht Luc Lang treffend von einem 'primitivisme litteraire' (literarischen Primitivismus), da die sinnliche Wahrnehmung ihrer einfachen Elemente eine Assoziationskette entfesselt, die nicht durch kunsthistorische Zitate und Versatzstücke der Geschichte vorgegeben wird. Es sind vielmehr die den Werken innewohnenden Gegensätze (wie z.B. die Steine, die teils geometrisch und teils unregelmäßig geschnitten bzw. gebrochen sind), die das Gedächtnis des Betrachters aktivieren.[5]

Die Farbe

Das Element Farbe nimmt in Anselmos Werk zwei unterschiedliche Konnotationen an: Farbe kann einerseits als Materie, andererseits als Energie begriffen werden. Diese zwei Konnotationen scheinen auf den ersten Blick entgegengesetzt zu sein. In Wirklichkeit stimmen, wie Albert Einstein mit seiner Relativitätstheorie bewiesen hat, Masse und Energie überein.

Farbpigmente wurden traditionell aus zerstoßenen Mineralien gewonnen. Ein Beispiel ist das Ultramarinblau, eine Farbe, die seit 1979 eine zentrale Rolle in Anselmos Werk spielt. Das Pigment für das Ultramarin wurde ursprünglich aus gemahlenem Lapislazuli hergestellt. Einerseits können also Malfarben als Materie gelten. In diesem Sinne sind sie mit dem plastischen Material Stein verwandt. Sie haben eine eigene Masse, die ihnen Trägheit und Schwere verleiht, und folglich ein eigenes Gewicht. Deswegen können Steine wiederum als Malfarben verwendet werden. Anselmo bevorzugt Granit, ein Tiefengestein, das je nach Herkunft eine verschiedene Färbung (vom Hellgrau zum Graugrün und Schwarz, vom Rosa zum Rot ...) aufweist.

Andererseits sind Farben Sinnesempfindungen, die durch elektromagnetische Wellen ausgelöst werden. Diese gelangen von selbstleuchtenden oder beleuchteten Körpern aus ins Auge. Der Sinneseindruck der Farben wird also durch Energie erzeugt.

In Anselmos Werken mit hängenden Steinen ist es die schwere farbige Materie, die eine energetische Situation schafft: Die Steine sind an einer Schlinge befestigt, die sie durch ihr eignes Gewicht zusammen ziehen. Während die Farbe traditioneller Gemälde nur durch das Licht wirksam werden kann und im Dunkeln unsichtbar wird, ist die

waves reach the eye from luminous or illuminated bodies. The sensuous impression of colours is thus stimulated by energy.

In Anselmo's works with suspended stones it is the heavy coloured matter that creates an energetic situation. The stones are fastened by a slipknot that is drawn tight by their own weight. Whereas the colour of traditional paintings can only have its effects through reflecting light, so that they are invisible in the dark, the effect of the coloured matter in these works by Anselmo is independent of illumination because the energetic tension persists in the dark thanks to gravity.

Colour lifts the stone

In 'Senza titolo' (Untitled, 1991, first version: 1984) a white canvas stretched on a frame stands on the floor. Two granite blocks connected by a steel cable hang over the top of the canvas, one on the front and one on the back, so that they are in equilibrium. The cable makes a loop around each block. The block at the back leans against the wall. Paradoxically, in this case, gravity lifts the stones. Each block pulls the slipknot tight through its own weight and serves simultaneously as a counterweight for the other. As matter, the colour activates gravity and as energy the colour enlivens the granite. The stone on the front refers to the painter's gesture that exerts a slight pressure on the canvas.[6] There where the painter leaves traces, the colour in its materiality weighs on the canvas. Anselmo has realised several versions of this work for which he has employed granite blocks of different colours. The colours are matched by the artist selecting the stones that form each pair.

In 'Mentre il colore solleva la pietra' (While colour lifts the stone, 2001) Anselmo again uses a slipknot to enable a heavy slab of red porphyry weighing about 600 kg to hover on the wall. The diagonal position of the stone gives the impression that it is only the weight of the coloured matter that has determined this position.

The greys become lighter

Since 1969, for several exhibitions Anselmo has hung heavy stones as high as possible on a wall consistent with the idea that there they become a little lighter. The physical law according to which a body

Wirkung der farbigen Materie in diesen Arbeiten von Anselmo unabhängig von den Lichtverhältnissen, da die energetische Spannung dank der Schwerkraft auch im Dunkeln besteht.

Die Farbe hebt den Stein

In 'Senza titolo' (Ohne Titel, 1991, erste Version: 1984) steht eine weiße, auf Keilrahmen gespannte Leinwand auf dem Boden. Zwei Granitblöcke, die durch ein Stahlseil miteinander verbunden sind, hängen einer auf der Vorderseite und der andere auf der Rückseite der Leinwand, so dass sie im Gleichgewicht sind. Das Seil bildet um jeden Block eine Schlinge. Der hintere Block ist an die Wand gelehnt. Paradoxerweise hebt die Schwerkraft in diesem Fall die Steine: Jeder Block zieht durch sein Gewicht die Schlinge zu und dient gleichzeitig als Kontergewicht des anderen. Als Materie aktiviert die Farbe die Schwerkraft, als Energie belebt die Farbe den Granit. Der Stein, der sich auf der Leinwand abstützt, weist auf die Geste des Malers hin, der einen leichten Druck auf den Bildträger ausübt.[6] Dort, wo er seine Spuren hinterlässt, lastet die Farbe mit ihrer Materialität auf der Leinwand. Anselmo hat verschiedene Exemplare dieser Arbeit realisiert, für die er unterschiedlich gefärbte Granitblöcke verwendet hat. Die Farben werden vom Künstler durch die Auswahl der Steine, die das jeweilige Paar bilden, aufeinander abgestimmt.

In 'Mentre il colore solleva la pietra' (Während die Farbe den Stein hebt, 2001) bedient sich Anselmo ebenfalls einer Schlinge, um eine ca. 600 kg schwere Platte aus rotem Porphyr an der Wand schweben zu lassen. Die diagonale Position des Steins vermittelt den Eindruck, dass ausschließlich das Gewicht der farbigen Materie diese Stellung bestimmt hat.

Die Grauen werden leichter

Seit 1969 hat Anselmo für mehrere Ausstellungen schwere Steine so hoch wie möglich an einer Wand aufgehängt, gemäß der Überlegung, dass sie dort ein wenig leichter werden. Das physikalische Gesetz, nach dem ein Körper, der sich vom Zentrum der Erde entfernt, an Gewicht abnimmt, macht sich der Künstler zu Nutzen, um im übertragenen Sinne die Farbe der Steine heller, d.h. leichter, zu machen. Statt eine herkömmliche Malfarbe durch die Zugabe von Weiß zu modulieren, hängt Anselmo die farbigen Steine in verschiedenen Höhen an der Wand auf. Er verwendet dieses Material entsprechend seinen physikalischen Eigenschaften und seiner natürlichen Herkunft, indem er das Kraftfeld der Erde in seine Arbeit mit einbezieht. Über das Werk 'Grigi che si

loses weight the further it is from the centre of the earth is employed by the artist to make the colour of the stones lighter in a metaphorical sense. Instead of modulating a conventional coloured paint by adding white, Anselmo suspends the coloured stones on the wall at various heights. He uses his chosen material according to its physical properties and its natural origins by incorporating the earth's force-field into his work. Regarding the work 'Grigi che si alleggeriscono verso oltremare' ('Greys which become lighter in the direction of 'oltremare', 1984), Anselmo explained in an interview, 'Normally a stone lies on the ground. In this case, however, it is suspended high up. Thanks to gravity, the slipknot holds the stone. Paradoxically we can therefore say that the stone remains suspended thanks to gravity. The stone is lighter. Everything becomes lighter when it is moved farther from the centre of the earth. If we think in painterly concepts and want to make a grey lighter, we add a bit of white to it. I make the grey of the stones lighter by suspending them on the wall. This is a way of regarding the stone as a colour (just as painting, which consists of pigments, can be regarded as stone), not only in relation to the tone of its colour, but also with respect to its mass. If one understands colour in this sense, one can see the traditional painterly categories in relation to gravity and the earth'.[7]

The aura of painting appears

In 'L'aura della pittura' (The aura of painting, 1996), large rectangular slabs of granite (in the exhibition at the Museum Kurhaus Kleve and Ikon Gallery there are three) stand against the wall at irregular intervals. The upper edges of the slabs are painted with various acrylic paints which are visible through their reflection (their aura) on the white wall. The colours are 'spectral' colours or pure colour, emitting the light of a single wavelength. In this work, therefore, the colour is presented not in its materiality, but as pure energy. This energy radiated from the monumental stone slabs enlivens the wall on which it is reflected and consequently the entire room, stimulates the viewer's eye and triggers a process of increasing awareness. 'L'aura della pittura' can be interpreted as the radiation of the colour

alleggeriscono verso oltremare' (Graue, die Richtung 'oltremare' leichter werden, 1984) erklärte Anselmo in einem Interview: 'Ein Stein liegt normalerweise auf dem Boden. In diesem Fall ist er dagegen oben aufgehängt. Dank der Schwerkraft hält der Laufknoten den Stein. Paradoxerweise können wir also sagen, dass der Stein dank der Schwerkraft aufgehängt bleibt. Der Stein ist leichter: Jeder Körper wird leichter, wenn er vom Zentrum der Erde entfernt wird. Wenn wir in malerischen Begriffen denken und ein Grau leichter machen wollen, fügen wir ein bisschen Weiß hinzu. Das Grau der Steine mache ich leichter, indem ich sie an der Wand aufhänge. Das ist eine Art, den Stein als eine Farbe zu betrachten (so wie die Malerei, die aus Pigmenten besteht, auch als Stein betrachtet werden kann), nicht nur in Bezug auf seinen Farbton, sondern auch auf seine Masse. Versteht man die Farbe in diesem Sinne, kann man die traditionellen malerischen Kategorien in Bezug auf die Schwerkraft und auf die Erde sehen.'[7]

Die Aura der Malerei erscheint

Große rechteckige Granitplatten (in der Ausstellung des Museum Kurhaus Kleve und der Ikon Gallery sind es drei) stehen in 'L'aura della pittura' (Die Aura der Malerei, 1996) in unregelmäßigen Abständen an der Wand. Die oberen Kanten der Platten sind jeweils mit einer unterschiedlichen Acrylfarbe bemalt, die nur durch ihren Widerschein (ihre 'Aura') auf der weißen Wand sichtbar ist. Es handelt sich um Spektralfarben oder 'reine Farben'. Eine Spektralfarbe ist das Licht einer Wellenlänge. Die Farbe wird in dieser Arbeit also nicht in ihrer Materialität, sondern als reine Energie präsentiert. Diese Energie, die von den monumentalen Steinplatten ausstrahlt, belebt die Wand, auf der sie reflektiert wird, und folglich den ganzen Raum, stimuliert das Auge des Betrachters und löst einen Bewusstwerdungsvorgang aus. 'L'aura della pittura' kann als die Ausstrahlung der Farbe interpretiert werden, die im Lauf der Kunstgeschichte von allen Künstlern verwendet worden ist.[8] Auf diese Weise wird das Wesen der Malerei selbst sichtbar. Der Begriff Aura verweist auf eine quasi-sakrale Erscheinung: Die Ausstrahlung der Malerei zeigt sich. Walter Benjamin definierte die Aura als 'einmalige Erscheinung einer Ferne, so nah sie sein mag. An einem Sommernachmittag ruhend einem Gebirgszug am Horizont oder einem Zweig folgen, der seinen Schatten auf den Ruhenden wirft – das heißt die Aura dieser Berge, dieses Zweiges atmen.'[9] Von den durch ihr Gewicht so physisch anwesenden Granitplatten Anselmos

that has been used by all artists throughout the history of art.[8] In this way, the essence of painting itself becomes visible. The concept of aura refers to a quasi-sacred manifestation: the radiance of painting reveals itself. Walter Benjamin defines aura as the 'unique manifestation of a distance, no matter how close it may be. Resting on a summer's afternoon, following a mountain chain on the horizon, or a branch that is casting a shadow on the person resting – that means to breathe in the aura of these mountains, of this branch'.[9] From Anselmo's granite slabs, so physically present through their own weight, the intangible reflection of colour is radiated so that a tension between sensuous closeness and fleeting energy occurs.

The canvas

In the first works where Anselmo used canvases, they served as bearers in the most literal sense of the word. This applies not only to the piece described above with two granite blocks tied to each other over the upper edge of a canvas, but also to 'Senza titolo' (Untitled, 1982–1986). In this work, a lot of white canvases stand in front of each other, leant against the wall. Large blocks of stone lie on their upper edges which together form a surface. A field of ultramarine blue is painted on the wall a bit higher than the stones. The canvases lift the coloured mass by resisting gravity which pulls the stones down to the ground. Just as the painter applies the coloured material to the canvas, Anselmo lays the stones on the canvases and thus creates a situation of energy in reality. The painterly material which has been applied to an endless number of canvases throughout the entire history of art is seemingly tangible.[10] Just as granite arises through a slow geological process of formation lasting 150–200 million years, the painterly material that features throughout art history forms a landscape, a 'mountain chain' that stretches in the direction of 'oltremare', 'beyond the sea'.[11] The force with which canvases and stones lean in the direction of the blue field expresses a kind of yearning.

The stone lifts the canvas

Whereas in the works described above the canvas serves as the bearer of colour, it is the colour (in the

geht der ungreifbare Widerschein der Farbe aus, so dass ein Spannungsverhältnis von sinnlicher Nähe und flüchtiger Energie entsteht.

Die Leinwand

In den ersten Arbeiten, in denen Anselmo Leinwände verwendete, dienten diese als Träger im wahrsten Sinne des Wortes. Das gilt sowohl für das oben beschriebene Werk mit zwei untereinander verbundenen Granitblöcken, die über die Oberseite einer Leinwand hängen, als auch für 'Senza Titolo' (Ohne Titel, 1982–1986). In dieser Arbeit stehen etliche weiße Leinwände voreinander an die Wand gelehnt. Auf ihren Oberkanten, die zusammen eine Fläche bilden, liegen große Steinblöcke. Ein Farbfeld in Ultramarinblau ist etwas höher als die Steine auf die Wand gemalt. Die Leinwände heben die farbige Masse, indem sie sich der Schwerkraft widersetzen, die die Steine auf den Boden zieht. Wie der Maler die farbige Materie auf die Leinwand aufträgt, legt Anselmo die Steine auf die Leinwände und schafft somit eine Situation von Energie in der Realität. Die malerische Materie, die auf unzählige Leinwände in der ganzen Kunstgeschichte aufgetragen wurde, scheint physisch erlebbar.[10] Wie der Granit durch einen langsamen, 150–200 Millionen Jahre langen geologischen Bildungsprozess entsteht, bildet die malerische Materie aller Bilder der Geschichte eine Landschaft, eine 'Gebirgskette', die sich Richtung 'oltremare' erstreckt.[11] Die Kraft, mit der sich Leinwände und Steine in der Richtung des blauen Feldes anlehnen, drückt quasi eine Sehnsucht aus.

Der Stein hebt die Leinwand

Während die Leinwand in den zuvor beschriebenen Arbeiten als Träger der Farbe dient, ist es die Farbe (in Form einer Steinplatte), die in 'Senza titolo' (Ohne Titel, 1989) die Leinwand trägt. Das Werk, mit dem Anselmo 1990 den Goldenen Löwen der Biennale von Venedig in der Kategorie Malerei gewann, besteht aus einer Leinwand, auf der eine Granitplatte in derselben Größe angebracht ist. Steinplatte und Leinwand sind mit einem Stahlkabel, das eine Schlinge bildet, an der Wand befestigt. In den Ausstellungen werden von diesem Werk mehrere Exemplare nebeneinander präsentiert, die Steinplatten in verschiedenen Farben aufweisen. Auf den ersten Blick hat man den Eindruck, herkömmliche abstrakte Bilder an der Wand zu betrachten, doch der Schein trügt, da die traditionellen Funktionen von Träger und Farbschicht in dieser Arbeit vertauscht werden. Die farbige Stein-

form of a stone slab) in 'Senza titolo' (Untitled, 1989) that bears the canvas. The work with which Anselmo won the Golden Lion at the Venice Biennial in 1990 in the category of painting, consists of a canvas on which a granite slab of the same size is mounted. The slab of stone and the canvas are fastened to the wall with a steel cable that forms a loop. In the exhibitions, several specimens of this work are presented next to each other with stone slabs in various colours. At first glance one has the impression of viewing conventional abstract paintings on the wall, but the appearance is deceptive because the traditional functions of bearer and layer of colour have been interchanged. The coloured stone slab pulls the loop tight through its weight and thus prevents the canvas from falling to the ground.

Where the stars are coming one span closer …
The installation that Anselmo designed for the Museum Kurhaus Kleve and Ikon brings together works from 1966 to 2004 to form a new ensemble. Forty-two granite blocks about a span high (approx. 25 cm) lie scattered on the floor of the exhibition space. A layer of earth in whose middle a compass is embedded gives the viewer orientation. On the wall rectangles are painted in ultramarine blue applied thickly with a palette knife. The colour ultramarine is so called because in the past it was imported into Europe from far-off countries beyond the sea. The fields of colour in ultramarine thus refer to an indefinite, far-off place beyond the museum's walls and thus give the installation a limitless extension.

The artist's hand is not recognisable through stylistic characteristics, but it is present twice in the installation, once as a drawing on the wall ('Il panorama con mano che lo indica' / Panorama with hand pointing to it, 1982–84) and once as the measure for the stones. The faithful drawing represents Anselmo's left hand viewed in a mirror. The artist drew the hand on tracing paper (carta da spolvero) that is used traditionally for transferring fresco sketches to the wall. This paper has a yellowish colouring that enhances the drawing on the white museum wall. The hand drawn in perspective

platte zieht durch ihr Gewicht die Schlinge zu und vermeidet somit, dass die Leinwand zu Boden fällt.

Wo die Sterne eine Spanne näher kommen …

Die Installation, die Anselmo für das Museum Kurhaus Kleve und die Ikon Gallery Birmingham entworfen hat, fügt Arbeiten aus den Jahren 1966 bis 2004 zu einem neuen Ensemble zusammen. 42 Granitblöcke, die jeweils eine Spanne (ca. 25 cm) hoch sind, liegen auf dem Boden der Ausstellungsräume verstreut. Eine Schicht Erde, in deren Mitte ein Kompass eingelassen ist, bietet dem Betrachter Orientierung. Auf die Wände sind Rechtecke in einem mit Spachtel dick aufgetragenen Ultramarinblau gemalt. Die Farbe 'oltremare' (Ultramarin) wird so genannt, weil sie in der Vergangenheit aus fernen Ländern jenseits des Meeres nach Europa importiert wurde. Die Farbfelder in Ultramarin weisen also auf einen unbestimmten fernen Ort jenseits der Museumswände hin und verleihen somit der Installation eine unbegrenzte Weite.

Die Hand des Künstlers ist nicht durch stilistische Merkmale erkennbar, dennoch ist sie in der Installation zwei Mal präsent: Einerseits als Zeichnung an der Wand ('Il panorama con mano che lo indica' / Das Panorama mit der Hand, die darauf weist, 1982–84), anderseits als Maß der Steine. Die detailgetreue Zeichnung stellt die im Spiegel betrachtete linke Hand von Anselmo dar. Der Künstler zeichnete die Hand auf Stechpausenpapier, das traditionell für die Übertragung von Freskenskizzen auf die Wand verwendet wird. Dieses Papier weist eine gelbliche Färbung auf, die die Zeichnung an der weißen Museumswand hervorhebt. Die perspektivisch verkürzte Hand erinnert an das traditionelle Bild, das auf einer Fläche einen Illusionsraum schafft. Im Fall von Anselmos Zeichnung leitet die Perspektive jedoch den Blick nicht in das Bild, sondern aus diesem heraus. Nicht die Hand an sich ist das Thema der Arbeit – sie befindet sich nicht einmal im Zentrum des Blattes und erscheint klein im Verhältnis zu diesem –, sondern das 'Panorama', auf das sie weist. Die Geste der Hand auf neutralem Hintergrund lässt sich deutlich als ein hinweisendes Zeichen erkennen.[12] Das Bild als 'Fenster in die Welt' wird umgekehrt: Es zeigt nicht mehr eine Illusionswelt, sondern richtet sich nach draußen in die reale Welt. Die gezeichnete Hand, die als Wegweiser dient, macht auf die unmittelbare Umgebung, die Granitblöcke, aufmerksam und lädt quasi dazu ein, sie zu besteigen, um die Installation aus einem höheren Blickwinkel zu betrachten.

recalls the traditional painting that creates an illusory space on a surface. In the case of Anselmo's drawing, however, the perspective guides the gaze not into the painting, but away from it. It is not the hand that is the subject of the work (it is not even in the centre of the sheet of paper and appears small relative to the sheet), but the 'panorama' to which it points. The gesture of the hand on a neutral background can be clearly recognised as a pointing sign.[12] The painting as a 'window onto the world' is turned around. It no longer shows an illusory world, but orients itself toward the real world outside. The drawn hand which serves as a sign draws attention to the immediate surroundings, the blocks of granite, and in effect invites the viewer to climb on them to view the installation from a higher perspective.

According to Anselmo, the granite blocks function as 'subtractions' because they diminish the distance from the ground to the stars by a span. In this way, the immeasurable distance of the stars is related to a human measure. The span, an old natural measure which is defined by the distance from the tip of the thumb to the tip of the little finger of a spanned hand,[13] refers to the artistic instrument par excellence with which artists traditionally paint, model, write, play music, etc. In this installation, art becomes literally a foundation on which one can raise oneself to get closer to the stars.

Although Anselmo uses the laws of physics in his work and sometimes alludes to the art of painting, the poetry of his works can be appreciated also without any knowledge of science and art history. The mass of colour has something sensuous about it in Anselmo's work; it addresses not only the eye, but also the sense of touch. The works invite the viewer to linger in front of them and to discover, from various angles, ever new nuances of colour and the surface structures of the split stones. The sensuous quality of these works emphasises the originary nature of the stone that has scarcely been worked upon and which as a material is extremely old, not only from the perspective of geology, but also from that of the history of civilisation. A distant past becomes immediately present and contributes to the magical aura of the works.

Die Granitblöcke fungieren Anselmo zufolge als 'Subtraktionen', da sie den Abstand vom Boden zu den Sternen um eine Spanne reduzieren. Dadurch wird die unermessliche Entfernung der Sterne auf ein menschliches Maß bezogen. Die Spanne – ein altes Naturmaß, das durch den Abstand zwischen den Spitzen des Daumens und des kleinen Fingers der gespreizten Hand bestimmt wird[13] – verweist auf das künstlerische Instrument par excellence, eben die Hand, mit der Künstler traditionell malen, modellieren, schreiben, Musik spielen usw. Die Kunst wird in dieser Installation wortwörtlich zur 'Grundlage', auf der man sich erheben kann, um den Sternen näher zu kommen.

Obwohl Anselmo sich in seinem Werk die physikalischen Gesetze zu Nutzen macht und manchmal auf die Malerei anspielt, erschließt sich die Poesie seiner Arbeiten auch ohne Kenntnisse von Physik und Kunstgeschichte. Die Farbmasse hat etwas Sinnliches in Anselmos Werk, sie spricht sowohl das Auge als auch den Tastsinn an. Die Arbeiten laden dazu ein, vor ihnen zu verweilen und aus verschiedenen Blickwinkeln immer wieder neue Farbnuancen und Oberflächenstrukturen der gespaltenen Steine zu entdecken. Die sinnliche Qualität dieser Arbeiten betont die Ursprünglichkeit des kaum bearbeiteten Steins, der als Material nicht nur aus der Perspektive der Geologie, sondern auch aus der Sicht der Kulturgeschichte uralt ist. Eine ferne Vergangenheit wird unmittelbar vergegenwärtigt und trägt zur bezaubernden Aura der Werke bei.

In Anselmos Arbeit spiegelt sich die Ambivalenz der Natur: Der überwältigenden Schönheit wohnt auch das Moment der Bedrohung inne. So anziehend ein Vulkan mit seinen zerklüfteten Kratern und seinen Lavaströmen auch sein mag, so ist sich doch jeder seiner gewaltigen Kraft und Gefahr bewusst. Anselmo schafft in seinen Werken ein ähnliches Spannungsfeld: Die hoch gehängten Steine faszinieren durch ihre Sinnlichkeit und ihre scheinbare Schwerelosigkeit. Gleichzeitig beschleicht uns Unbehagen, wenn wir uns das schiere Gewicht der Steine bewusst machen, die wie ein Damoklesschwert über uns schweben. Wir fühlen uns im Angesicht der Natur verletzlich. Doch die Werke von Anselmo lassen uns auch spüren, dass wir 'particolari' (Teile / Besonderheiten) dieser Natur sind und mit unserer Individualität an ihrer Energie und Größe Anteil haben.

The ambivalence of nature is mirrored in Anselmo's work. There is a threatening moment inherent in the overwhelming beauty. No matter how attractive a volcano with its fissured craters and its streams of lava may be, everybody is aware of its enormous power and danger. In his works Anselmo creates a similar tension. The stones suspended up high fascinate the viewer with their sensuousness and their apparent weightlessness. At the same time we become unsettled when we think of the sheer weight of the stones hovering above us like the sword of Damocles. Facing nature we feel vulnerable. But Anselmo's works also allow us to feel that we are 'particolari' (parts) of nature and that, in our individuality, we participate in its energy and greatness.

1. Cf. Nike Bätzner, *Arte povera: zwischen Erinnerung und Ereignis: Giulio Paolini, Michelangelo Pistoletto, Jannis Kounellis,* Nürnberg 2000, p. 35.
2. Cf. Germano Celant, 'Arte povera', in the exhibition catalogue *Arte povera* Bologna, Galleria de' Foscherari 1968, unpaginated.
3. Cf. Germano Celant, 'The Italian Complexity', in the exhibition catalogue *The Knot Arte Povera at P.S. 1* New York, P.S.1 1985, pp. 17–47, here pp. 42ff.
4. Cf. exhibition catalogue *Mario Merz. Die Katze, die durch den Garten geht, ist mein Arzt* Kleve, Museum Kurhaus Kleve 2001. The exhibition showed drawings by the artist from 1997 to 2000, of which some come close to painting in the narrower sense.
5. Cf. Luc Lang, 'L'empirie ou l'histoire au present', in Luc Lang *Les invisibles,* pp. 63–75, here pp. 67–71.
6. Cf. Giorgio Verzotti, 'The Body of Painting', in the exhibition catalogue *Pittura italiana / Italian Painting* Rivoli, Castello di Rivoli 1997, pp. 159–160, here p. 159.
7. Giovanni Anselmo in an interview with Hervé Flinne, February 1996, in M. Disch (ed.), *Giovanni Anselmo,* Lugano 1998, pp. 66–70, here p. 69 (German translation by the author; English translation from German by the translator).
8. Cf. Maddalena Disch 'Situazioni di energia' in M. Disch (ed.), *Giovanni Anselmo,* Lugano 1998, pp. 87–99, here pp. 98f.
9. Walter Benjamin, *Das Kunstwerk im Zeitalter seiner technischen Reproduzierbarkeit,* Frankfurt/Main 1977, p. 15.
10. Cf. Maddalena Disch, 'Situazioni di energia,' pp. 96f.
11. Cf. *ibid.,* pp. 98f.
12. Cf. Johannes Meinhardt, 'Anzeichen der fließenden Welt. Giovanni Anselmos Indizes energetischer Prozesse' in the exhibition catalogue *Arte Povera. Arbeiten und Dokumente aus der Sammlung Goetz 1967 bis heute* Bremen, Neues Museum Weserburg 1997, pp. 47–59, here p. 56.
13. Italian definition of span which corresponds to the English span and the German 'long span' (lange Spanne).

1. Vgl. Nike Bätzner, 'Arte povera: zwischen Erinnerung und Ereignis: Giulio Paolini, Michelangelo Pistoletto, Jannis Kounellis', Nürnberg 2000, S. 35.
2. Vgl. Germano Celant, Arte povera, in: Kat. d. Ausst. 'Arte povera', Bologna, Galleria de' Foscherari, 1968, o.S.
3. Vgl. Germano Celant, The Italian Complexity, in: Kat. d. Ausst. 'The Knot Arte Povera at P.S.1', New York, P.S.1, 1985, S. 17–47, hier S. 42ff.
4. Vgl. Kat. d. Ausst. 'Mario Merz. Die Katze, die durch den Garten geht, ist mein Arzt', Kleve, Museum Kurhaus Kleve, 2001. Die Ausstellung zeigte Zeichnungen des Künstlers aus den Jahren 1997–2000, von denen einige nahe an die Malerei im engeren Sinne herankommen.
5. Vgl. Luc Lang, L'empirie ou l'histoire au present, in: Ders., Les invisibles, S. 63–75, hier S. 67–71.
6. Vgl. Giorgio Verzotti, Il corpo della pittura, in: Kat. d. Ausst. 'Pittura italiana da collezioni italiane', Rivoli, Castello di Rivoli, 1997, S. 157–158, hier S. 157.
7. Giovanni Anselmo im Interview mit Hervé Flinne, Februar 1996, in: M. Disch (Hrsg.), Giovanni Anselmo, Lugano 1998, S. 66–70, hier S. 69 (Übersetzung d. Verf.).
8. Vgl. Maddalena Disch, Situazioni di energia, in: M. Disch (Hrsg.), Giovanni Anselmo, Lugano 1998, S. 87–99, hier S. 98f.
9. Walter Benjamin, Das Kunstwerk im Zeitalter seiner technischen Reproduzierbarkeit, Frankfurt a. M. 1977, S. 15.
10. Vgl. Maddalena Disch, Situazioni di energia, S. 96f.
11. Vgl. ebd., S. 98f.
12. Vgl. Johannes Meinhardt, Anzeichen der fließenden Welt. Giovanni Anselmos Indizes energetischer Prozesse, in: Kat. d. Ausst. 'Arte Povera. Arbeiten und Dokumente aus der Sammlung Goetz 1967 bis heute', Bremen, Neues Museum Weserburg, 1997, S. 47–59, hier S. 56.
13. Italienische Definition der Spanne, die der deutschen 'Langen Spanne' entspricht.

Translation Michael Eldred

Appendix
Anhang

Lenders
Leihgeber

Galerie Micheline Szwajcer,
Antwerp · Antwerpen
Fondazione Pistoletto, Biella
(Italy · Italien)
Konrad Fischer Galerie, Düsseldorf
Van Abbemuseum, Eindhoven
Stedelijk Museum voor Actuele
Kunst, Gent
Kewenig Galerie, Cologne · Köln
Galleria Christian Stein, Milan ·
Mailand
Galerie Tanit, Munich · München
Giovanni Anselmo, Turin

and private lenders who prefer not
to be named · sowie private
Leihgeber, die nicht genannt wer-
den möchten

Biography
Biographie

1934 born in Borgofranco d'Ivrea
(Turin); lives and works in Turin
and on the Isle of Stromboli
1990 Venice Biennial, Golden Lion
for painting

1934 in Borgofranco d'Ivrea
(Turin) geboren; lebt und arbeitet
in Turin und auf Stromboli
1990 Biennale Venedig, Goldener
Löwe für Malerei

List of works in the exhibition
Verzeichnis der ausgestellten Arbeiten

1960

I. Senza titolo, 1966
Untitled · Ohne Titel
iron, wood, gravity · Eisen, Holz, Schwerkraft, ca. 265 × 15 × 15 cm
Giovanni Anselmo, Turin

II. Senza titolo, 1967
Untitled · Ohne Titel
perspex, iron · Plexiglas, Eisen
201 × 91 cm, Giovanni Anselmo, Turin

III. Direzione, 1967–1968
Direction · Richtung
canvas, glass, magnetic compass · Tuch, Glasbehälter, Magnetnadel
23 × 200 × 300 cm, Giovanni Anselmo, Turin

IV. Senza titolo, 1968
Untitled · Ohne Titel
granite, lettuce, copper wire · Granit, Kopfsalat, Kupferdraht
60 × 25 × 25 cm, 12 × 12 × 5 cm
Cittadellarte – Fondazione Pistoletto, Biella

V. Senza titolo, 1968
Untitled · Ohne Titel
steel tank, cotton wool, water · Stahlbehälter, Watte, Wasser
ca. 30 × 30 × 50 cm, Courtesy Galerie Micheline Szwajcer, Antwerp · Antwerpen

VI. Torsione, 1968
Torsion · Drehung
fustian cloth, iron bar · Baumwoll-flanell, Eisenstange, ca. 160 × 160 cm
Collection S.M.A.K. (Stedelijk Museum voor Actuele Kunst), Gent

VII. Documentazione di interferenza umana nella gravitazione universale, 1969
Documentation of human interference in universal gravitation · Dokumentation der menschlichen Interferenz der universellen Gravitation
20 photographs · 20 Photographien each · jeweils 5 × 5 cm, Giovanni Anselmo, Turin

VIII. Per un'incisione di indefinite migliaia di anni, 1969
For a notch in an indefinite number of thousands of years · Für eine Gravur in einer unbestimmten Anzahl von Tausenden von Jahren
iron, rust preventive, wall inscription · Eisen, Rostschutz-mittel, Schrift an der Wand
188,5 × 11 cm, Private collection, Belgium · Privatsammlung, Belgien

IX. Respiro, 1969
Breathing · Atmung
two iron bars, sea sponge · zwei Eisenstangen, Schwamm, 905 × 6 × 11 cm, Private collection, Belgium · Privatsammlung, Belgien

1970

X. Invisibile, 1971
Invisible · Unsichtbar
projector, slide with the word 'visibile' · Diaprojektor, Dia mit dem Wort 'visibile', Giovanni Anselmo, Turin

XI. Entrare nell'opera, 1971
Entering the work · Ins Werk eintreten
inkjet print on canvas · Inkjet auf Leinwand, 2 × 2,5 m, Giovanni Anselmo, Turin

XII. Leggere, 1972
Reading · Lesen
book (56 pages) · Buch (56 Seiten) Collection Library Stedelijk Van Abbemuseum, Eindhoven

XIII. Particolare, 1972
Detail · Detail
projectors, slides with the word 'particolare' · Diaprojektoren, Dias mit dem Wort 'particolare' Giovanni Anselmo, Turin

XIV. 116 particolari visibili e misurabili di INFINITO, 1975
116 visible and measurable details of INFINITO · 116 sichtbare und messbare Details von INFINITO
Book (238 pages) · Buch (238 Seiten), Collection Library Stedelijk Van Abbemuseum, Eindhoven

1980

XV. Il panorama con mano che lo indica, 1982–84
Panorama with the hand pointing to it · Das Panorama mit der Hand, die darauf weist
pencil on paper, stone · Bleistift auf Papier, Stein, 280 × 154 × 110 cm, Galleria Christian Stein, Milan · Mailand

XVI. Verso oltremare, 1984
Towards 'oltremare' · Richtung 'oltremare'
stone, steel cable, ultramarine · Steinplatte, Stahlseil, Ultramarin
320 × 141 × 3 cm, Galleria Christian Stein, Milan · Mailand

1990

XVII. Lire, 1990
Reading · Lesen
book (80 pages) · Buch (80 Seiten), Collection Library Stedelijk Van Abbemuseum, Eindhoven

XVIII. Senza titolo, 1990
Untitled · Ohne Titel
canvas, stone, steel cable, slip-knot · Leinwand, Steinplatte, Stahlseil, Laufknoten, 200 × 140 × 3 cm, Courtesy Galerie Micheline Szwajcer, Antwerp · Antwerpen

XIX. Senza titolo, 1990
Untitled (3 pieces) · Ohne Titel (3 Exemplare)
canvas, stone, steel cable, slipknot · Leinwand, Steinplatte, Stahlseil, Laufknoten, jeweils · each 200 × 140 × 3 cm, Galerie Tanit, Munich · München

XX. Senza titolo, 1991
Untitled · Ohne Titel
canvas (230 × 150 cm), two stones (each ca. 30 × 30 × 55 cm), steel cable, slipknots · Leinwand (230 × 150 cm), zwei Steine (jeweils ca. 30 × 30 × 55 cm), Stahlseil, Laufknoten, Konrad Fischer Galerie, Düsseldorf

XXI. Senza titolo, 1991
Untitled · Ohne Titel
canvas (230 × 150 cm), stones each ca. 30 × 30 × 55 cm), steel cable, slipknots · Leinwand (230 × 150 cm), zwei Steine (jeweils ca. 30 × 30 × 55 cm), Stahlseil, Laufknoten, Courtesy Kewenig Galerie, Cologne · Köln

XXII. L'aura della pittura, 1996
The aura of painting · Die Aura der Malerei
three granite slabs, hooks, acrylic paint · Drei Granitplatten, Haken, Acrylfarbe, each · jeweils 234 × 76 × 11,5 cm, Konrad Fischer Galerie, Düsseldorf

2000

XXIII. Mentre il colore solleva la pietra, 2001
While the colour lifts the stone · Während die Farbe den Stein hebt
stone slab, steel cable, slipknot · Steinplatte, Stahlseil, Schlaufe
ca. 120 × 240 × 10 cm, Giovanni Anselmo, Turin, Courtesy Studio Tucci Russo, Torre Pellice (Turin)

XXIV. Direzione, 2004
Direction · Richtung
earth from Kleve and Birmingham respectively, magnetic compass · Erde aus Kleve bzw. Birmingham, Magnetnadel, Dimensions variable · Abmessungen variabel, Giovanni Anselmo, Turin

XXV. Dove le stelle si avvicinano di una spanna in più …, 2004
Where the stars are coming one span closer … · Wo die Sterne eine Spanne näher kommen …
42 granite slabs, ultramarine · 42 Granitblöcke, Ultramarin, each · jeweils 80 × 60 × 25 cm Giovanni Anselmo, Turin

Solo exhibitions

selection

Einzelausstellungen

Auswahl

1960

1968
Galleria Sperone, Turin
1969
Galleria Sperone, Turin
Galerie Sonnabend, Paris

1970

1970
Galleria Sperone, Turin
Galleria Toselli, Mailand
1971
Galleria Sperone, Turin
Galleria Multipli, Turin
1972
Galleria Sperone, Turin
John Weber Gallery, New York
1973
Galerie MTL, Brüssel
Kunstmuseum, Luzern
1974
Galleria Marilena Bonomo, Bari
Galleria Sperone & Fischer, Rom
Studio Lia Rumma, Neapel
Sperone Gallery, New York
Galerie Foksal, Warschau
1975
Galleria Area, Florenz
Samangallery, Genua
Kabinett für aktuelle Kunst,
 Bremerhaven
Galleria Sperone, Turin
Galleria Sperone, Rom
1976
Samangallery, Genua
Galleria Ghiringhelli-Sperone,
 Mailand
Galleria Nuovi Strumenti, Brescia
1977
Galleria Il Tritone, Biella
Kabinett für aktuelle Kunst,
 Bremerhaven
Galleria De Crescenzo, Rom
1978
Galleria Salvatore Ala, Mailand
Studio Tucci Russo, Torre Pellice
 (Turin)

Galerie Paul Maenz, Köln
Galerie Durand-Dessert, Paris
Sperone Westwater Fischer,
 New York
1979
Kunsthalle, Basel
Galerie Rüdiger Schöttle, München
Galleria Emilio Mazzoli,
 Modena

1980

1980
Stedelijk Van Abbenmuseum,
 Eindhoven
Galerie Helen van der Meij,
 Amsterdam
Galerie Paul Maenz, Köln
Forum Kunst, Rottweil
Musée de Grenoble, Grenoble
Vereniging voor het Museum
 Van Hedendaagse Kunst, Gent
Galleria Sperone, Turin
 [mit Mario Merz]
1981
Salvatore Ala Gallery, New York
1982
Galleria Christian Stein, Turin
Galerie Durand-Dessert, Paris
Galleria Salvatore Ala, Mailand
Galerie Helen van der Meij,
 Amsterdam
1984
Marian Goodman Gallery, New
 York
Galerie Micheline Sczwajcer,
 Antwerpen
1985
Musée d'Art Moderne de la
 Ville de Paris, Paris
1986
Jean Bernier Gallery, Athen
Galleria Christian Stein, Mailand
Galerie Elisabeth Kaufmann, Zürich
1987
Galerie Tanit, München
Galerie Durand-Dessert, Paris
1988
Galerie Micheline Szwajcer,
 Antwerpen
Galleria Christian Stein, Turin
Spazio Pitti Uomo, Florenz
1989
Marian Goodman Gallery,
 New York
Galleria Civica d'Arte Moderna,
 Modena
Musée d'Art Contemporain, Lyon
Lloyds bank chambers, Wales

1990

1990
Galleria Christian Stein, Mailand
Galerie Tanit, München
Galerie Buchmann, Basel
Jean Bernier Gallery, Athen
1991
Galleria Alfonso Artiaco, Pozzuoli
Galeria Marga Paz, Madrid
1992
Marian Goodman Gallery,
 New York
Baron / Boisanté Gallery,
 New York
1993
Centre d'Art Contemporain, Genf
1994
Galerie Micheline Szwajcer,
 Antwerpen
XXII. Bienal Internacional,
 San Paolo
Galerie de l'Ancienne Poste,
 Calais [mit S. Brouwn]
1995
Centro Galego de Arte
 Contemporánea, Santiago
 de Compostela
1996
Forum d'Art Contemporain, Casino
 Luxembourg, Luxemburg
Musée d'Art Moderne et d'Art
 Contemporain, Nizza
Marian Goodman Gallery,
 New York
Konrad Fischer Galerie, Düsseldorf
1997
The Renaissance Society, Chicago
1998
House of Prints, Multiples
 Drawings, Antwerpen

2000

2001
Marian Goodman Gallery,
 New York
Centre Saint-Charles, Université
 Paris I, Panthéon-Sorbonne,
 Paris
Atelier del Bosco, Villa Medici,
 Academie de France à Rome,
 Rom
2002
Studio Tucci Russo, Torre Pellice
 (Turin)
2003
Musée de la Corse, Corte

Group exhibitions

selection

Gruppenausstellungen

Auswahl

1960

1967
Galleria Sperone, Turin
Con temp l'azione, Galleria
 Sperone, Stein, Il Punto, Turin;
 1968: Galleria Flaviana, Lugano
Arte Povera, Istituto di Storia
 dell'Arte, Università di Genova,
 Genua
Collage 1, Galleria de' Foscherari,
 Bologna
1968
Arte Povera, Galleria de' Foscherari,
 Bologna
Arte Povera, Centro Arte Viva
 Feltrinelli, Trieste
Percorso, Galleria Arco d'Alibert,
 Rom
*VI. Premio Nazionale di Pittura
 Masaccio*, San Giovanni Val
 d'Arno
Anselmo, Boetti, Kounellis, Deposito
 d'arte presente, Turin
Prospect 68, Städtische Kunsthalle,
 Düsseldorf
Arte Povera + azioni povere,
 Arsenale di Amalfi
Nine at Castelli, Leo Castelli
 Warehouse, New York
1969
*Op losse Schroeven: situaties en
 cryptostructuren*, Stedelijk
 Museum, Amsterdam
When Attitudes Become Form,
 Kunsthalle, Bern; Museum Haus
 Lange, Krefeld; ICA, London
Disegni e Progetti, Galleria Sperone,
 Turin
Pläne und Projekte als Kunst,
 Kunsthalle, Bern; 1970:
 Aktionsraum, München
Verborgene Strukturen, Museum
 Folkwang, Essen
*I. Rassegna Biennale delle Gallerie
 di Tendenza Italiane*, Galleria
 Civica, Modena
Galleria Sperone, Turin

1970

1970

Gennaio 70, Museo Civico, Bologna

Processi di pensiero visualizzati: junge italienische Avantgarde, Kunstmuseum, Luzern

Conceptual Art, Arte Povera, Land Art, Galleria Civica d'Arte Moderna, Turin

III. Salon international des galeries-pilotes, Musée Cantonal des Beaux-Arts, Lausanne; Musée d'Art Moderne de la Ville, Paris

Vitalitá del negativo nell'arte italiana 1960–70, Palazzo delle Esposizioni, Rom

New Gallery, Cleveland, Ohio

Identifications, Fernsehgalerie Gerry Schum, Köln; 1971: Galleria Toselli, Mailand; Galleria Sperone, Turin

1971

At the Moment, Doorway-Hall, Zagreb

In another Moment, Galeria SKC, Belgrad

Modern Art Agency, Neapel

Arte Povera: 13 italienische Künstler, Kunstverein, München

1972

Anselmo / Zorio, Galleria Sperone, Turin

De Europa, John Weber Gallery, New York

Nova Scotia College of Art and Design, Halifax, Nova Scotia

XV. Festival dei Due Mondi, Chiesa di San Nicolò, Spoleto

documenta 5, Museum Fridericianum, Kassel

XXXVI. Biennale Venedig

Book as Artwork 1960 - 1972, Nigel Greenwood, London

XXIII. Mostra d'Arte Contemporanea, Torre Pellice

1973

Galleria Sperone / Fischer, Rom

Huit italiens / Acht italianes, Galerie MTL, Brüssel; Art & Project, Amsterdam

X. Quadriennale, Palazzo delle Esposizioni, Rom

t-5. Constructive cisual resaerch, computer visual research, Galerija Suvremene umjetnosti, Zagreb

John Weber Gallery, New York

Contemporanea, Parcheggio di Villa Borghese, Rom

An Exhibition of New Italian art, The Arts Council of Northern Ireland Gallery, Belfast; 1973: The David Hendricks Gallery, Dublin

1974

Idea and Image in Recent Art, The Art Institute, Chicago

Studio G7, Bologna

Italia 1950–1970. Italienische Kunst der letzten 20 Jahre, Art 5 '74, Basel

Projekt '74. Kunst bleibt Kunst, Kunsthalle, Köln

Come Eravamo, Galleria Centro, Turin

Galleria Multipli, Turin

1975

Group Show, John Weber Gallery, New York

Disegni, Galleria Sperone, Turin

Kunstmarkt, Köln

Modern Art Agency, Neapel

1976

Drawing / Disegno, Galleria Cannaviello, Rom

Arte Ambiente, Giornate del Quartiere di Porta Venezia, Brescia

Associazione Artisti Bresciani, Brescia

Le stelle, Galleria Christian Stein, Turin

Blow Up, Centro 'Dov'è la tigre', Mailand; Sala Comunale d'Arte Contemporanea, Alessandria

Prospect '76 Retrospect, Kunsthalle, Düsseldorf

Recent international forms in art, The 1976 Biennale of Sydney, Gallery of New South Wales, Sydney

1977

Galleria Sperone, Rom

Arte Povera, Galleria Il Tritone, Biella

10 Jahre Kabinett für Aktuelle Kunst, Kunsthalle, Bremen

Arte in Italia 1960–1970, Galleria Civica d'Arte Moderna, Turin

Europe in the seventies: aspects of recent art, The Art Institute, Chicago; 1978: The Hirshhorn Museum, Washington D.C.; Museum of Modern Art, San Francisco; Fort Worth Art Museum; The Contemporary Art Center, Cincinnati

Trigon 77, Neue Galerie am Landesmusem Joanneum, Graz

Brunelleschi e noi, Chiostro di S. Maria Novella, Florenz

Carl Andre / Giovanni Anselmo / On Kawara, Galleria Sperone, Rom

1978

Le figure del tempo, Galleria de' Foscherari, Bologna

3×3×3, Galerie Durand-Dessert, Paris

XXXVIII. Biennale Venedig

Focus 78, Centre Culturel du Marais, Paris

VI. Biennale Internazionale della grafica d'arte, Palazzo Strozzi, Florenz

1979

Words, Museum Bochum; Palazzo Ducale, Genua

Artistes Italiens, Musée d'Art et d'Industrie, Saint-Etienne

Kunst als Photographie - Photographie als Kunst, Tiroler Landesmuseum Ferdinandeum, Innsbruck

Le Stanze, Castello Colonna, Genazzano

Gerry Schum, Stedelijk Museum, Amsterdam

1980

1980

Pier and Ocean, Hayward Gallery, London; Rijksmuseum Kröller-Müller, Otterlo

XXXIX. Biennale Vendig

L'intensità del disegno, Galleria Stufidre, Turin

Disegni, Libreria OOLP, Turin

Libri, *Libreria OOLP*, Turin

Gerry Schum, Museum Boymans van Beuningen, Rotterdam; Kölnischer Kunstverein, Köln; Museum voor Hedendaagse Kunst, Gent; Vancouver Art Gallery, Vancouver; A Space, Toronto

Usophoto, Galleria Piramide, Florenz

Landscape-Art: two way reaction, Australian National Gallery, Canberra

Galerie Durand-Dessert, Paris

1981

Linee della ricerca artistica in Italia 1960–1980, Palazzo delle Esposizioni, Rom

Disegni, Galleria Sperone, Turin

Westkunst, Rheinhallen Messegelände, Köln

Identité Italienne, l'art en Italie depuis 1959, Musée National d'Art Moderne, Centre Georges Pompidou, Paris

Galerie Durant-Dessert, Paris

Biennale de la critique, Palais des Beaux-Arts, Charleroi; 1982: I.C.C., Antwerpen

1982

Arte Povera-Antiform, Centre d'Arts Plastiques Contemporains, Bordeaux

Libri circa, Galleria D'Alessandro, Turin

Halle 6, Kampnagelfabrik, Hamburg

documenta 7, Museum Fridericianum, Kassel

Galerie Durand-Dessert, Paris

Invitation à un voyage à travers l'art contemporain avec Marilena Bonomo, Centre d'Art Contemporain, Genf

140. Esposizione di Arti Figurative, Promotrice delle Belle Arti, Turin

30 anni di arte italiana 1950–1980, Villa Manzoni, Lecco

Galleria Christian Stein, Turin

1983

Présence discrète, Musée des Beaux-Arts, Dijon

Mostre Parallele, Galleria Comunale d'Arte Moderna e Contemporanea A. Forti, Verona

Concetto - Imago, Kunstverein, Bonn

Sessanta opere, Galleria Massimo Minini, Brescia

Codici e marchingegni 1482–1983, Museo Leonardiano, Vinci

Anselmo / Kounellis / Merz, Galleria Christian Stein, Turin

Gallerie Micheline Szwajcer, Antwerpen

Adamah, la terre, ELAC, Lyon

Eine Kunstgeschichte aus Turin 1965–1983, Kölnischer Kunstverein, Köln

ARS '83, The Art Museum of the Ateneum, Helsinki

Electra, Musée d'Art Moderne de la Ville, Paris

L'Avanguardia plurale. Italia 1960–1970, Centro Servizi Culturali, Pescara

Monuments - Détournements, Bibliothèque Municipale, Boulogne-sur-mer

1984

Anselmo, Kounellis, Mario Merz, Marisa Merz, Paolini, Penone, Zorio, Galleria Christian Stein, Turin

An International Survey of Recent Painting and Sculpture, The Museum of Modern Art, New York

Italien (1968). Das Soziale und das Pathos, Galerie Karsten Greve, Köln

Sculptures Italiennes, Galerie Durand-Dessert, Paris

Skulptur im 20. Jahrhundert, Merian-Park Brügligen, Basel

Histoires de Sculpture, Château des Ducs d'Epernon, Cadillac; Musée d'Art Moderne, Villeneuve d'Ascq

Coerenza in coerenza, Mole Antonelliana, Turin

Que reste-t-il?, Over Studio, Turin

Galleria Giorgio Persano, Turin

Galleria Françoise Lambert, Mailand

Marian Goodman Gallery, New York

Il disegno in dialogo con la terra: Anselmo, Boetti, Gastini, Mario Merz, Marisa Merz, Zorio, Galerie Albert Baronian, Brüssel; Musée d'Art Moderne de la Ville de Liège, Knokke Le Zoute

Deux régions en France: l'Art International d'aujourd'hui, Palais des Beaux-Arts, Charleroi

L'arte povera et les anachronistes, Galerie Antiope France, Paris

60 artisiti per l'Unità, Palazzo Carignano, Turin

L'architecte est absent: an exhibition with works from the collection of Annick and Anton Herbert, Stedelijk Van Abbemuseum, Eindhoven

Ouverture, Castello di Rivoli, Turin

Anselmo / Long / Kirkeby, Castello di Rivoli, Turin

1985

Del Arte Povera a 1985, Palacio de Cristal und Palacio Velázquez, Madrid

The Europien Iceberg. Creativity in Germany and Italy today, Art Gallery of Ontario, Toronto

Histoires de Sculpture, Espace Graslin, Nantes

Anselmo / Fabro / Penone, Galerie Elisabeth Kaufmann, Zürich

Les Immatériaux, Musée National d'Art Moderne, Centre Georges Pompidou, Paris

Piemonte anni ottanta, Sale Wagneriane di Ca'Vendramin, Venedig

Sein und Sehnsucht, 10 italienische Künstler der 60er und 70er Jahre, Villa Merkel, Esslingen; Kunstverein, Kassel

The Knot: Arte Povera at P.S.1, P.S.1, The Institute for Art and Urban Resources, New York

Oeuvres sur papier, Galerie Durand-Dessert, Paris

Transformations in Sculpture – Four Decades of American and European Art, The Solomon R. Guggenheim Museum, New York

Il Museo Sperimentale di Torino. Arte italiana degli anni Sessanta nelle collezioni della Galleria Civica d'Arte Moderna, Castello di Rivoli, Turin

Mehr Licht – More Light, Kunsthalle, Hamburg

Photoworks 1965-1982, University Drill Hall Gallery, Canberra

Sculptures. Première approche pour un parc, Fondation Cartier, Jouy-en-Josas

Collection 1984, Musée Saint-Pierre d'art contemporain, Lyon

La Collection du Van Abbemuseum Eindhoven, Le Noeveau Musée, Villeurbanne

Gallerie Durand-Dessert

1986

A Drawing Show, Marian Goodman Gallery, New York

Fra usikkerhet til samlet Kraft, Kunstnernes Hus, Oslo

Ouverture II., Castello di Rivoli, Turin

Tu es pierre, Association L.A.C., Vassiviére-Limousin

Ooghoogte-Stedelijk van Abbenmuseum 1936-1986, Stedelijk van Abbenmuseum, Eindhoven

Qu'est-ce-que la sculpture moderne?, Musée National d'Art Moderne Centre Georges Pompidou, Paris

Sculture da Camera, Gipsoteca del Castello Svevo, Bari; 1988: Centre d'Art Contemporain, Genf; Museum Hedendaagse Kunst, Ultrecht; Palazzo Spada, Spoleto; Fondazione Deste, Casa di Cipro, Athen; University of Southern California Museum, Fisher Gallery, Los Angeles; Neuer Berliner Kunstverein, Berlin

Che cosa fanno oggi i concettuali?, Rotonda della Besana, Mailand

XI. Quadriennale Nazionale d'Arte, Palazzo delle Esposizioni, Rom

XLII. Biennale Venedig

Beuys zu Ehren, Städtisches Museum im Lenbachhaus, München

Steine Stones Pietre, Galerie Buchman, Basel

Le Fragment & le Hérisson, Musée de l'Abbaye Sainte-Croix, Les Sables d'Olonne

Un regard de Bruno Corà sur les oevres du F.R.A.C. Rhône-Alpes, Centre National d'Art Contemporain, Grenoble; 1987: Accademia di Belle Arti Neapel

Arte Moderna a Torino - Fondazione de Fornaris, Società Promotrice delle Belle Arti, Turin

Il cangiante, Padiglione d'Arte Contemporanea, Mailand

Fideliter, Galleria Christian Stein, Turin

Anselmo / Merz / Zorio, Ecole des Beaux-Arts, Mâcon

Rhona Hoffman Gallery, Chicago

1987

Arte Povera 1965-1971, Galerie Durand-Dessert, Paris

Galleria Locus Solus, Genua

Turin 1965-1987, Musée Savoisien, Chambéry; Musée de l'Hospice Comtesse, Lille; Musée D'Art, La Roche sur Yon

Skulptur Projekte in Münster 1987, Westfäliches Landesmuseum, Münster

Disegno italiano del dopoguerra, Kunstverein, Frankfurt; Galleria Civica, Modena

Italie hors d'Italie, Musée d'Art Contemporain, Nîmes

Century '87, Westertoren, Amsterdam

Voluti inganni, Galleria G7, Bologna

Collection Sonnabend, Centro de Arte Reina Sofia, Madrid; 1988-89: Centre d'Art Plastique Contemporain, Bordeaux; Nationalgalerie, Berlin ; Galleria Nazionale d'Arte Moderna, Rom

Galleria Remolino, Turin

Sculptures de l'Arte Povera, Centre de Creation Contemporaine, Tours

Galleria Christian Stein, Mailand

Galleria Christian Stein, Turin

Musée Saint Pierrre d'Art Contemporain de Lyon, Kunstverein, Frankfurt

Cadres en l'aire, Galerie d'Art et Essai de l'Université, Rennes

Un moderne peut en cacher un autre. Années 70 – Années 80 dans les collection du F.R.A.C. Nord-Pas de Calais, Musée d'Art Moderne, Villeneuve d'Ascq

Acquisizione e depositi 1987, Galleria Comunale d'Arte Moderna, Bologna

Nachtvuur-Nightfire, Galeria De Appel, Amsterdam

1988

Lavori su carta degli anni Settanta, Galleria Françoise Lambert, Mailand

Générations, Maison des Artistes, La Tronche, Grenoble

Zurück zur Natur, aber wie?, Städtische Galerie, Karlsruhe

L'autoritratto non ritratto nell'arte contemporanea italiana, Pinacoteca Comunale, Ravenna

Liaisons, Galleria Eva Menzio, Turin

Verzameling aan zee, Haags Gemeentemuseum, Den Haag

Periplo della scultura italiana contemporanea, Chiese Rupestri Madonna delle Virtù e San Nicola de Greci, Matera

Sotto le antenne il cielo, Giardino Comunale di Pecetto, Turin

Rosc '88, Royal Hospital / Guinness Hop Store, Dublin

Collection du van Abbemuseum Eindhoven II., Musée des Beaux Arts, Nîmes

Worte, Galerie der Künstler, München

Galleria Ippolito Simonis, Turin

Galeria Christian Stein, Turin

Carnegie International 88, Museum of Art, Pittsburgh

Galerie Elisabeth Kaufmann,
Basel
*Les chants de Maldoror
Lautréamont*, Galerie Durand-
Dessert, Paris
Vision sur l'Art Contemporain, Ga-
lerie l'Encan, Louvain-la Neuve
1989
Italian Art in the Twentieth Century,
The Royal Academy of Arts,
London
Verso l'Arte Povera, Padiglione
d'Arte Contemporanea, Mailand;
ELAC, Lyon
MaterialMente, Galleria Comunale
d'Arte Moderna, Bologna
Pagine, Libri, Galleria Cavellini,
Brescia
Kunstmarkt, Messegelände, Köln
*La Collection Liliane & Michel
Durand-Dessert*, Galerie de
la Défense ARF 4, Paris
Magiciens de la terre, Musée
National d'Art Moderne Centre
Georges Pompidou, Paris
Borderland, Antico Foro Boario,
Reggio Emilia
A Sculpture Show, Marian Goodman
Gallery, New York
*Die Sammlung des Musée St. Pierre
Art Contemporain Lyon*, Neue
Galerie am Landesmuseum
Joanneum, Graz
SteinGladstone Gallery, New York
Bilderstreit, Messehallen, Köln
Hic sunt Leones, Parco Michelotti,
Turin
*Wittgenstein – Das Spiel des
Unsagbaren*, Wiener Sezession,
Vereinigung bildender Künstler,
Wien; Palais des Beaux Arts,
Brüssel
Einleuchten, Deichtorhallen,
Hamburg
L'Art Conceptuel: une perspective,
Musée d'Art Moderne de la
Ville, Paris; 1989–90: Fundación
Caja de Pensiones, Madrid;
Deichtorhallen, Hamburg;
Musée d'Art Contemporain,
Montreal
Collezione Sonnabend, Museo
d'Arte Moderna e
Contemporanea di Trento e
Rovereto; Galleria Nazionale
d'Arte Moderna, Roma
Regard sur … l'Arte Povera, Centre
d'Art Contemporain Atelier des
Halles et Musée du Château,
Montebèliard

Galleria Christian Stein, Mailand
Arte da camera, Galleria Remolino,
Turin

1990

1990
XLIV. Biennale Venedig
Arte Povera Multiples 1969–1970,
Galerie Durand-Dessert, Paris
FRACORSE, Museo Fesch, Ajaccio
*Conceptual Art, Minimal Art, Arte
Povera, Land Art – Sammlung
Marzona*, Kunsthalle, Bielefeld
Arte Povera, Galleria in Arco, Turin
Le Territoire de l'Art 1910–1990,
Musée Russe, Leningrad
Von der Natur in der Kunst,
Messeplast, Wien
Hic sunt Leones 2, Parco Michelotti,
Turin
A Group Show, Marian Goodman
Gallery, New York
*Aktuelle Kunst Europas – Sammlung
Centre Pompidou*,
Deichtorhallen, Hamburg
Relazioni pericolose, Galleria Filippo
Fossati, Turin
Arte Povera / Prints – Multiples,
Galerie Coppens & Van de
Velde, Brüssel
Die Endlichkeit der Freiheit, Ein
Ausstellungsprojekt für Ost und
West, Berlin
*Vom Verschwinden der Ferne:
Telekommunikation und Kunst*,
Deutsches Postmuseum,
Frankfurt am Main
*L'Arte Povera dans les collections du
MNAM*, Musée Cantini,
Marseille
Temperamenti, Tramway, Glasgow
Made of Stone, Galerie Isy Brachot,
Brüssel
*Then and now. Giovanni Anselmo –
Sol Lewitt*, SteinGladstone
Gallery, New York
1991
Arte Povera, Studio Oggetto,
Mailand
Toward a New Museum, San
Francisco Museum of Modern
Art, San Francisco, 1985–1991
Extra Large, Galleria Eva Menzio,
Turin
*Intersezione: Arte italiana negli anni
'70-'80*, Galleria Mücsarnok,
Budapest
Un Détail immense, Palais des
Beaux Arts, Charleroi

Antinomia, Facoltà di Architettura –
Castello del Valentino, Turin
Histoires d'oeil, Musée d'Art
Contemporain, ELAC,
Embarcadère, Nouveau Musée
de Villeurbanne, Lyon
*Arte Povera 1971 und 20 Jahre
danach*, Kunstverein, München
This Land …, Marian Goodman
Gallery, New York
Tabula rasa, Biel / Bienne
A Group Show, Marian Goodman
Gallery, New York
This Land …, Marian Goodman
Gallery, New York
Nouvel Espace, Galerie Durand-
Dessert, Paris
Mises en oeuvres, Parc Pommery,
Reims
Schwerelos, Große Orangerie
Schloß Charlottemburg, Berlin
*Anselmo, Bianchi, Kounellis, Merz,
Paolini, Salvatori*, Galleria
Christisan Stein, Mailand
1992
Tierra de nadie, Hospital Real,
Granada
Vorhut aus dem Hinterland, Neues
Museum Weserburg, Bremen;
Städtische Galerie, Göppingen
Territorium Artis, Kunst- und
Ausstellungshalle der Bundes-
republik Deutschland, Bonn
*La Collection Christian Stein. Un
regard sur trente annés d'art ita-
lien (1960–1990)*, Le Nouveau
Musée, Villeurbanne, Lyon,
Centre Regional d'Art
Contemporain Midi-Pyrénées
Ostsee Biennale, Kunsthalle,
Rostock
Avanguardie in Piemonte 1960/1990,
Palazzo Cuttica, Alessandria
Auf kleinstem Raum, Städtische
Galerie, Göppingen
Arte Povera: Early Works, SteinGlad-
stone Gallery, New York
Bild -Objekt -Skulptur, Galerie
Kaufmann, Basel
Bianco / Nero, Galleria Eva Menzio,
Turin
*The artist and the book in Twentieth-
Century Italy*, Museum of
Modern Art, New York
Arte Povera, Kodama Gallery,
Osaka / Japan
*La Collection du Musée d'Art
Contemporain de Lyon*, Museum
Sztuki, Lóds

*Un Regard sur la Collection du
Musée Départamental de
Rochechouart*, Centre d'Art
Contemporain, Creux de
l'enfer, Thiers
Emma Kunz -Oh cet écho!, Centre
Culturel Suisse, Paris
*Los '80 en la Collección de la
Fundación la Caixa*, Estación
Plaza de Armas, Sevilla
1993
*Gravity & Grace: the Changing
Condition of Sculpture*, Hayward
Gallery, London
*Un'avventura internazionale,
Torino e le Arti 1950–1970*,
Castello di Rivoli, Turin
Multipli 1970–1975, Galleria
Giorgio Persano, Turin
Out of Sight, out of Mind, Lisson
Gallery, London
Entrevues – Ars Musica '93, Maison
de la Radio, Brüssel
Werke aus der Sammlung,
Sammlung Goetz, München
Borealis 6, National Gallery of
Iceland, Reykjavik
Azur, Fondation Cartier pour
l'art contemporain, Jouy-
en-Josas
The Spirit of Drawing, Sperone
Westwater Gallery, New York
Un Accrochage, Galerie Micheline
Szwajcer, Antwerpen
Devant, le futur, Taejon Expo '93,
Taejon (Südkorea)
Bienal Internacional de Obidos,
Obidos (Portugal)
Disegni, Galleria Federica
Inghilleri, Mailand
La Metafora Trovata, Galleria
Sperone, Rom
L'ordre du temps, Domaine de
Kerguéhennec, Centre d'Art
Contemporain, Locminé
L'ordre du choses, Domaine de
Kerguéhennec, Centre d'Art
Contemporain, Locminé
L'autre à Montevideo, Museo
Nacional de artes visuales,
Montevideo
*Torino 70-75. Opere e oggetti
moltiplicati*, Studio Oggetto,
Mailand
Moving, Foundation De Appel,
Amsterdam
1994
*Some Kind of Fact - Some Kind of
Fiction*, Sperone Westwater,
New York

L' oeuvre a-t-elle lieu? Witte de With, Centre for Contemporary Art, Rotterdam
Italian Art. From Arte Povera to Transavanguardia, Nicaf 3 Yokohama, Tokyo
Vetro, Galeria Eva Mezio, Turin
Viaggio in Italia, Galleria Eva Menzio, Turin
Jean Bernier Gallery, Athen
The Italian Metamorphosis 1943 – 1968, The Salomon Guggenheim Museum, New York, Kunstmuseum, Wolfsburg
Zeitgenössische Kunst aus Frankfurter Banken, Galerie Hoechst, Frankfurt
Sao ko kelle terre, La Collezione Longo, Cassino
A Sculpture Show, Marian Goodman Gallery, New York

1995
A Sculpture Show, Marian Goodman Gallery, New York
Arte Povera 1965 – 1972, Galerie Durand-Dessert, Paris
Otto Schweins, Köln
Elogio della bugia, Galleria Mazzocchi, Parma
Le fragment du désir, Anciens Bâtiments des Magasins Old England, Brüssel
Die Sammlung Marzona: Arte Povera, Minimal Art, Concept Art, Land Art, Palais Lichtenstein, Wien
La Collection, Carré d'Art, Nimes
Revolution: Art of the Sixties, The Museum of Contemporary Art, Tokyo
Frühe Werke, Galerie Tanit, Köln
Le domaine du diaphane, Domaine de Kerguéhennec, Centre d'Art Contemporain, Locminé / Frankreich
Colisiones – Collsions, Arteleku, San Sebastián
Centre d'Art Contemporain, Bignan / Frankreich
Lettere e Numeri, Eva Menzio, Turin
1965 – 1975: Reconsidering the Object of Art, Museum of Contemporary Art, Los Angeles
Arte italiana 1945 – 1995. Il visibile e l'invisibile, Aichi Perfectural Museum of Art, Aichi Arts Center, Nagoya, Museum of Contemporary Art, Tokyo, Yonago City Museum of Art, Tottori, Hiroshima City Museum

of Contemporary Art, Hiroshima / Japan; The Temporary Contemporary, Los Angeles
La transparence dans l'art du XXe siècle, Musée des Beaux-Arts Andrè Malraux, Le Havre
Morceaux choisis du Fond National d'Art Contemporain, Centre National d'Art Contemporain, Grenoble

1996
Lodi all'arte, Museo Civico, Lodi
Il disegno della scultura contemporanea, Galleria Martano, Turin
Collezionismo a Torino, Castello di Rivoli, Turin
Cast – Cut, Assemble: Contemporary Sculpture from the Permanent Collection, Museum of Modern Art, San Francisco
Arte Povera. Les Multiples 1966 – 1980, Musée d'Art Moderne et Contemporain, Nice
Regole native, Galleria Allessandro Vivas – Studio Simonis, Paris, Galleria Maria Cilena, Mailand
Leonkart, Città del desiderio, Centro sociale Leoncavallo, Mailand
Recaptured Nature, Marian Goodman Gallery, New York
Artists' Books, Galleria Martano, Turin
Arte all'Arte, Palazzo Comunale, San Gimignano
Sammlung Sonnabend: Von der Pop Art bis heute, Deichtorhallen, Hamburg
L'informe: mode d'emploi, Musée National d'Art Moderne Centre Georges Pompidou, Paris
Natura Naturans, Castello di San Giusto, Trieste
Verso i Settanta 1968 – 1970, La Salernitana, Erice
Exposition. Selections from the Permanent Collection, Walker Art Center, Sculpture Garden, Minneapolis

1997
Galleria Christian Stein, Mailand
Tocco Ferro, Galleria Sergio Casoli, Rom
Città Natura, Palazzo delle Esposizioni, Rom
Arte Povera e dintorni, Palazzo Crepadona, Belluno; Galleria Civica, Cortina d'Ampezzo / Italien

Sculpture, Sperone Westwater, New York
Arte Italiana. Ultimi Quarant'anni. Materiali Anomali, Galleria d'Arte Moderna, Bologna
Pittura Italiana da Collezioni Italiane, Castello di Rivoli, Turin
Livres d'artistes. L'invention d'un genre 1960 – 1980, Bibliothèque National de France, Paris
The Berardo Collection, Sintra Museum of Modern Art, Sintra (Spanien)
Minimalia: An Italian Vision in 20th Century Art, Palazzo Querini Dubois, Venedig, Palazzo delle Esposizioni, Rom, P.S.1/Institute for Art and Urban resources, Long Island City, New York
Artmonie, Castel Ivano, Ivano Franceno, Trento
Arte Povera. Arbeiten und Dokumente aus der Sammlung Goetz 1967 bis heute, Neues Museum Weserburg, Bremen; Kunsthalle, Nürnberg; Kölnischer Kunstverein, Köln; Museum moderner Kunst-Stiftung Ludwig, Wien; Konsthallen, Göteborg (Schweden); Sammlung Goetz, München
Arte italiana 1945 – 1995. Il visibile e l'invisibile, Aichi Prefectural Museum of Art, Nagoya; 1998: Museum of Contemporary Art, Tokyo; Yonago City Museum of Art, Tottori; Hiroshima City Museum of Contemporary Art, Hiroshima; Taipei Fine Arts Museum, Taipei

1998
Anselmo, Brouwn, Graham, Kawara, Galerie Micheline Swajcer, Antwerpen
Artecittà: 11 artisti per il Passante Ferroviario di Torino, Galleria d'Arte Moderna e Contemporanea, Turin
Artisti Torinesi a Stoccarda, Galerie Unterm Turm, Stuttgart
Le corps en perspective, Galerie Durand-Dessert, Paris
Minimalia, da Giacomo Balla a …, Palazzo delle Esposizioni, Rom
The first Kimpo International Sculpture Symposium Kimpo Sculpture Park, Kimpo

1968 – 1998. Fotografia ed arte in Italia, Palazzo Santa Margherita, Modena
Breaking Ground, Marian Goodman Gallery, New York
Tracce Significanti. Arte Italiana Oggi, Athens Exhibition Centre, Athen
Rendezvous – Masterpieces from the Centre Georges Pompidou and the Guggenheim Museums, Solomon Guggenheim Museum, New York
Sentimentale journée, Musée d'Art Moderne et Contemporain, Straßburg
Galerie Durand-Dessert

1999
Strengthening Wind from Changing Directions: International Avant-Garde since 1960: The Paul Maenz Collection, Neues Museum Weimar, Weimar
Costruire una collezione. Nuove opere 1994 – 1998, Galleria d'Arte Moderna e Contemporanea, Turin
La collezione, Castello di Rivoli, Turin
Scripta Manent, Esso Gallery, New York
Swisscom, Berne
Artisti all'Opera, Teatro Regio, Turin
De Verzameling – The Collection II, The Choice of Rudi Fuchs, Stedelijk Van Abbemuseum, Eindhoven
Isla de Esculturas, Isla de la Xunqueira del Lérez, Pontevedra
Il libro d'artista in Italia, Galleria Civica d'Arte Moderna e Contemporanea, Turin
Amalfi '68 – Napoli '98, Castel Sant'Elmo, Neapel
Le cercle, le ring, Maison Levanneur, Chatou, France
Something old, Something new, Something borrowed, Something blue, San Giovanni Valdarno / Italien
Lavori diversi 1, Galleria e/static, Turin
Lavori diversi 2, Galleria e/static, Turin
Circa 1968, Museau Seralves, Porto
Minimalia: An Italian Vision in 20th-Century Art, P.S.1, New York

2000

2000

After Life, 11 Duke Street Ldt., London

Le temps-vite, Musée National d'Art Moderne Centre Georges Pompidou, Paris; Centre de Cultura Contemporanea de Barcelona, Barcelona; Palazzo delle Esposizioni, Rom

L'elemento verbale nell'Arte Contemporanea, Galleria Martano, Turin; Galleria Milano, Mailand

E così via – And so on, 99 artisiti della Collezione Marzona, Galleria Comunale d'Arte Moderna e Contemporanea, Rom

Luci in galleria: da Warhol al 2000, Palazzo Cavour, Turin

Anselmo, Merz, Penone, Kounellis, Laib, Konrad Fischer Galerie, Düsseldorf

Del futurisme al laser: l'aventura italiana de la materia, Palau de la Virreina, Barcelona; 2001: Kunstforum in der Grundkredit-Bank, Berlin

Artistas franceses e italianos nas colleccións Fundación ARCO e CGAC, Centro Galero de Arte Contemporaneá, Santiago de Compostela

Arte Povera in collezione, Castello di Rivoli, Turin

La ville / le jardin / la mémoire Académie de France á Rome, Villa Medici, Rom

Sembianti della scultura Palazzo Stella, Bologna

Minimalism and After Museum of Modern Art, New York

2001

Zero to Infinity: Arte Povera 1962–1972, Tate Gallery of Modern Art, London; Walker Art Center, Minneapolis, Minnesota; 2002: The Museum of Contemporary Art, Los Angeles; Hirshhorn Museum and Sculpture Garden, Washington D.C

Multipli 1967–2001, Esso Gallery, New York

La natura, l'arte, la meraviglia, Museo Civico di Storia Naturale, Verona; Museo Naturalistico Archeologico, Vicenza; 2002: Villa Beatrice, Padua; Museo di Storia Naturale ed Archeologia, Montebelluna; Fondazione Bevilacqua la Masa, Venedig

This side of paradise, Marian Goodman Gallery, New York

Belvedere Italiano, Centrum Sztuki Wspolczesnej Zamek Ujadowskj, Warschau

Arte Povera – selections from the Sonnabend Collection, Mariam and Ira D. Wallach Art Gallery, New York

La GAM costruisce il suo futuro: tre anni di acquisizioni di Arte Contemporanea, Palazzina della Promotrice delle Belle Arti e Galleria Civica d'Arte Moderna e Contemporanea, Turin

Sculpture Contemporaine : oeuvres de la Collection Frac Rhône-Alpes de l'Institut d'Art Contemporain, Les Subsistances, Lyon

2002

Private / Corporate, Daimler-Chrysler Contemporary, Berlin

Arte Povera from the Castello di Rivoli Collection, Museum of Contemporary Art, Sydney

Arte Povera na Colecção da Fundação de Serralves, Museo Serralves, Porto

Arte Povera, Gladstone Gallery, New York

Autonomées 2, Ecole Régionale des Beaux-Arts, Rouen

Exempla 2: arte Italiana nella vicenda Europea 1960–2002, Pinacoteca Civica, Teramo

Works from the Daimler Chrysler Collection and from the Paul Maenz Collection: a dialogue, DaimlerChrysler Contemporary, Berlin

From Pop to Now: Selection from the Sonnabend Collection, Frances Young Tang Teaching Museum and Art Gallery Skidmore College, New York; The Ohio State University, Columbus

Grande Opera Italiana, Castel Sant'Elmo, Neapel

Paradiso perduto / Paradise lost, Palazzo dell'Arengo, Rimini

Arte Povera: Art from Italy 1967–2002, Museum of Contemporary Art, Sydney

Ipotesi di collezione, MACRO – Museo d'Arte Contemporanea, Rom

Blick auf Natur, Kunstmuseum, Lichtenstein

Les années 70: l'art en cause, Musée d'Art Contemporain Entrepôt, Bordeaux

Wat is een collectie?, Stedelijk Museum, Amsterdam

La scultura lingua viva – Arturo Martini ed il rinnovamento della scultura in Italia nella seconda metà del Novecento, Spazio ex Kaimano, Aqui Terme

Fotografia negli anni settanta fra concetto e comportamento, Galleria Martano, Turin

Anselmo, Calzolari, Merz, Pistoletto, Zorio, Galleria Persano, Turin

Night Sky – Neuerwerbungen der Graphischen Sammlung, Kunstmuseum, Winterthur

Re(f)use, Centre for curatorial studies tenth anniversary, New York

2003

Memoria Ribelle, Padiglione Latino Americano, Neapel

The Photographic Side of Arte Povera, Esso Gallery, New York

Projection, Konrad Fischer Galerie, Düsseldorf

Group show, Studio per l'Arte Contemporanea Tucci Russo, Torre Pellice

La Collezione del MAXXI, Museo Nazionale delle Arti del XXI secolo, Rom

Gelijk het leven is, Stedelijk Museum voor Actuele Kunst, Gent

Galleria Alfonso Artiaco, Pozzuoli

Contemplazione: Italienische Kunst aus der Sammlung, Kunstmuseum, Winterhur

La Poetica dell'Arte Povera, Kunstmuseum Kloster Unser Lieben Frauen, Magdeburg

Skin Deep, MART Museo di Arte Moderna e Contemporanea di Trento e Rovereto, Trento

The Last Picture Show: Artists Using Photography, 1960–1982, Walker Art Center, Minneapolis, Minnesota; UCLA Hammer Museum, Los Angeles, 2004

Fernsehgalerie Gerry Schum – Ready to Shoot, Kunsthalle, Düsseldorf; 2004: Forum für zeitgenössische Kunst, Casino Luxemburg, Luxemburg; Museu de Arte Contemporânea de Serralves, Porto

Intorno a Borromini, Palazzo Falconieri, Rom

2004

La linea del tempo – Opere scelte 1967–2003, Studio per l'Arte Contemporanea Tucci Russo, Torre Pellice

Interlude I: Arte Povera – Variations sur la collection Du Frac Nord-Pas de Calais, Dünkirchen

Portraits, Esso Gallery, New York

Intra muros, Musée d'Art Moderne et Contemporain, Nizza

Arte Povera, Château de Villeneuve – Art Moderne et Contemporain, Vence

Infiniti, Forte del Belvedere, Florenz

Reflecting the Mirror, Marian Goodman Gallery, New York

Monographs and catalogues

for solo exhibitions, selection

Monographien und Kataloge

zu Einzelausstellungen, Auswahl

1960

Giovanni Anselmo, Texte v. G. Celant u. M. Fagiolo, Turin (Galleria Sperone) 1968

Giovanni Anselmo, Text v. G. Anselmo, New York (Sonnabend Gallery) 1969

1970

Giovanni Anselmo, Text v. J.C. Ammann, Luzern (Kunstmuseum Luzern) 1973

Giovanni Anselmo, Warschau (Galeria Foksal) 1974

Giovanni Anselmo, Texte v. J.C. Ammann u. R. Fuchs, Basel (Kunsthalle) 1979

1980

Giovanni Anselmo, Texte v. J.C. Ammann, R. Fuchs u. T. Raspail, Grenoble (Musée de Grenoble) 1980

Giovanni Anselmo, Texte v. S. Pagé u. D.Soutif, Paris (Musée d'Art Moderne de la Ville) 1985

Senza titolo a nord e due particolari mentre verso oltremare i grigi si alleggeriscono, Text v. B. Corà, Athene (Jean Bernier Gallery) 1986

Giovanni Anselmo, Text v. B. Merz, Florenz (Galleria Civica, Modena / Musée d'Art Contemporain, Lyon) 1989

1990

Arte povera: Giovanni Anselmo, Text v. L. Meneghelli, Osaka / Japan (Kodama Gallery) 1992

Giovanni Anselmo, Texte v. L. Sacca u. P. Herkenhoff, São Paulo (Biennale São Paulo) 1994

Giovanni Anselmo, Texte v. G. Anselmo, G. Moure u. B. Corà, Galicia (Centro Galego de Arte Contemporánea) 1995

Giovanni Anselmo, Text v. G. Moure, Nizza (Musée d'art moderne et d'art contemporain) 1996

Giovanni Anselmo, Texte v. G. Moure, G. Anselmo u. B. Corà, Santiago de Compostela (Centro Galego de Arte Contemporanea) 1996

Giovanni Anselmo, hrsg. von M. Disch, Lugano 1998

Catalogues

for group exhibitions, selection

Kataloge

zu Gruppenausstellungen, Auswahl

1960

Con temp l'azione, Text v. D. Palazzoni, Turin (Galleria Gian Enzo Sperone, Christian Stein, Il Punto) 1967

Arte Povera, Texte v. R. Barilli, P. Bonfiglioli u. G. Celant, Bologna (Galleria de Foscherari) 1968

Arte Povera, Text v. G. Celant, Trieste (Centro Arte Viva Feltrinelli) 1968

Prospect '68, Texte v. K. Fischer u. H. Strelow, Düsseldorf (Städtische Kunsthalle) 1968

Arte povera + azioni povere, Texte v. G. Celant, G.M. Accame, G. Bartolucci, V. Boarini, P. Bonfiglioli, A.B. Oliva, G. Dorfles, P. Gilardi, H. Martin, F. Menna, D. Palazzoni, C. Possati, A. Trimarco u. T. Trini, Salerno (Arsenali dell'Antica Repubblica, Amalfi) 1968

Op Losse Schroeven: situaties en cryptostructuren, Texte v. W. Beeren, P. Gilardi u. H. Szeemann, Amsterdam (Stedelijk Museum) 1969

When Attitudes Become Form, Texte v. S. Burton, G. Muller, H. Szeemann u. T. Trini, Bern (Kunsthalle) 1969

Verborgene Strukturen, Texte v. W. Beeren u. D. Honisch, Essen (Folkwang Museum) 1969

I Rassegna Biennale delle Gallerie di Tendenza Italiane, Text v. O. Goldoni, Modena (Galleria Civica) 1969

1970

III Biennale internazionale della giovane pittura: Gennaio 70, Texte v. R. Barilli, M. Calvesi, u. T. Trini, Bologna (Museo Civico) 1970

Processi di pensiero visualizzati: Junge italienische Avantgarde, Texte v. J.C. Ammann, G. Celant, Luzern, (Kunstmuseum Luzern) 1970

Conceptual Art, Arte Povera, Land Art, Texte v. G. Celant, L. Lippard, L. Mallé u. a., Turin (Galleria Civica d'Arte Moderna) 1970

III Salon International des galeries pilotes, Text v. R. Berger, Lausanne (Musée Cantonal des Beaux Arts) 1970

Vitalità del negativo nell'arte italiana 1960–1970, Texte v. G.C. Argan, A. Boatto, A.B. Oliva, M. Calvesi, G. Dorfles, F. Menna u. C. Vivaldi, Rom (Palazzo delle Esposizioni) 1970

Arte Povera, 13 italienische Künstler, Texte v. G. Celant u. E. Madelung, München (Kunstverein) 1971

De Europa, New York (John Weber Gallery) 1972

420 West Broadway at Spoleto Festival, Texte v. B. Rose, Spoleto (Chiesa di S. Niccolò, Festival dei Due Mondi) 1972

documenta 5, Texte v. I. Bauer, B. Brock, W. Busse, R. Diederich, R. Grubling, H. H. Holz, E. Roters, W. Rotzler, K. Staeck, P. Versins u. C. Wilp, Kassel 1972

XXXV. Biennale di Venezia, Texte v. F. Arcangeli, R. Barilli, A. B. Oliva, D. Palazzoni, G. Schum u.a., Venedig 1972

XXIII. Mostra d'Arte Contemporanea, Text v. G. Romano, Torre Pellice 1972

X. Quadriennale (III Mostra): La ricerca estetica dall 1960 al 1970, Stefano de Luca Editore, Rom (Palazzo delle Esposizioni) 1973

Contemporanea, Texte v. A.B. Oliva, G. Lonardi, P. Sartoga u.a., Rom (Parcheggio di Villa Borghese) 1973

An Exhibition of New Italian Art, Text v. G. Celant, Belfast (The Arts Council of Northern Ireland Gallery) 1973

Projekt '74 – Kunst bleibt Kunst: Aspekte internationaler Kunst am Anfang der 70er Jahre, Köln (Kunsthalle) 1974

Italienische Kunst der letzten 20 Jahre, Basel (Art 5) 1974

Drawing / Disegno, Text v. A. B. Oliva, Rom (Galleria Cannaviello) 1976

Arte Ambiente, Text v. M. Bandini, Brescia (Giornate del Quartiere di Porta Venezia) 1976

Blow up, Text v. M. Bandini, Mailand (Galleria Dov'é la tigre) 1976

Prospect '76 Retrospect, Texte v. J. Harten, K. Fischer, J. Matheson, H. Strelow, B. Buchloh u. R. H. Fuchs, Düsseldorf (Städtische Kunsthalle) 1976

Recent international forms of art, Sydney (Gallery of South Wales) 1976

Arte in Italia 1960–1977. Dall'opera al coinvolgimento, Texte v. R. Barilli, A. del Guercio u. F. Menna, Turin (Galleria Civica d'Arte Moderna) 1977

Europe in the seventies: aspects of recent art, Texte v. J. C. Amman, D. Brown, R. Fuchs u. J. Speyer, Chicago (Art Institute) 1977

Trigon '77, Texte v. W. Skrein, U. Apollonio u. L. Vergine, Graz (Neue Galerie) 1977

Le figure del tempo, Text v. P. G. Castagnoli, Bologna (Galleria De Foscherari) 1978

XXXVIII. Biennale: Dalla natura all'-arte – dall'arte alla natura, Texte v. J. C. Ammann, B. Oliva, A. Del Guercio u. F. Menna, Venedig 1978

Focus 78, Paris (Centre Culturel du Marais) 1978

VI. Biennale Internazionale della grafica d'arte, organisiert von A. Nocentini, Florenz (Palazzo Strozzi) 1978

Words, Text v. I. Puliafito, Bochum (Kunsthalle Bochum) 1979

Kunst als Photographie – Photographie als Kunst, Text v. P. Weiermair, Innsbruck (Tiroler Landesmuseum Ferdinandeum) 1979

Le Stanze, Text v. A. B. Oliva, Genazzano (Castello Colonna) 1979

1980

Pier and Ocean, Texte v. G. von Graevenitz u. N. Dilworth, London (Hayward Gallery) 1980

XXXIX. Biennale di Venezia: Arte visive '80, Texte v. C.G. Argan, A. B. Oliva, L. Carluccio, M. Campton, G. Galasso,

M. Kuns u. H. Szeemann, Venedig 1980

Linee della ricerca artistica in Italia 1960–1980, Texte v. G.C. Argan, M. Calvesi, C. Dardi, V. Fagone, F. Menna, R. Nicolini, N. Ponente, A.C. Quintavalle u. F. Solmi, Rom (Palazzo delle Esposizioni) 1981

Westkunst, Texte v. H. Borger, L. Glozer, K. Koening u. K. Ruhrberg, Köln (Rheinhallen Messegelände) 1981

Identité italienne. L'art en Italie depuis 1959, Texte v. G. L. Buontempo, M. Calvesi, G. Celant, P. Hultén, C. Lonzi u. A. A. Rosa, Paris (Musée National d'Art Moderne, Centre Georges Pompidou) 1981

Arte Povera – Antiform, Text v. G. Celant, Bordeaux (Centre d'Arts Plastiques Contemporains) 1982

Halle 6, Hamburg (Kampnagelfabrik) 1982

Documenta 7, Texte v. S. Bos, C. von Bruggen, G. Celant, H. Eichel, R. H. Fuchs, J. Gachnang, W. Nikkels u. G. Storck, Kassel 1982

140° Esposizioni di Arti Figurative, Turin (Promotrice Belle Arti) 1982

30 anni di arte italiana 1950–1980, Text v. E. Cesana, L. Somaini u. R. G. Lambarelli, Lecco (Villa Manzoni) 1982

Mostre parallele, Text v. M. Bandini, Verona (Galleria d'Arte Moderna e Contemporanea) 1983

Concetto-Imago: Generationswechsel in Italien, Texte v. A.B. Oliva, M. Joachimsen, Z. Felix u.a., Bonn (Kunstverein) 1983

Codici e marchingegni 1482–1983, organisiert von A. Vezzosi u. K. Burmeister, Vinci (Castello dei Conti Guidi / Casa di Leonardo) 1983

Adamah, la terre, Texte v. J. de Loisy, P. Bloch, O. Obalk u. L. Pesanti, Lyon (ELAC) 1983

Eine Kunstgeschichte in Turin 1965 – 1983, Texte v. G. Celant, M. Grüterich u. W. Herzogenrath, Köln (Kunstverein) 1983

Ars 83, Texte v. L. Peltola, B. J. London, Yriänä, J. O. Mallander, P. Paaermaa, M. Ranki u. Mats B., Helsinki (The Art Museum of the Ateneum) 1983

An International survey of recent painting and sculputre, Text v. K. McShine, New York (Museum of Modern Art) 1984

Skulptur im 20. Jahrhundert, Texte v. E. Beyler, Z. Felix, A. Franke, L. Glozer, S. Gossa, J. Heusinger, R. Hohl, W. Jehke, A. Kaiser, F. Meyer, W. Ratzler, M. Schwander, K. Turr, A. von Graevenitz, T. Vischer, V. Waldegg u. A. G. Wilkinson, Basel (Merian Park Brüglingen) 1984

Histoires de Sculpture, Text v. B. Marcadé, Cadillac (Château des Ducs d'Epernon) 1984

Coerenza in Coerenza: Dall'Arte Povera al 1984, Texte v. G. Balmas, G. Castagnoli, G. Celant, I. Granelli, F. Piqué, G. Stromboli u. a., Turin (Mole Antonelliana) 1984

Il disegno in dialogo con la terra: Anselmo, Boetti, Gastini, Mario Merz, Marisa Merz, Zorio, Brüssel (Galerie Albert Baronian) 1984

Ouverture, Text v. R. H. Fuchs, Turin (Castello di Rivoli) 1984

Anselmo, Long, Kirkeby, Text v. R. H. Fuchs, Turin (Castello di Rivoli) 1984

Del Arte Povera a 1985, Texte v. G. Balmas, G. Celant, I. Gianelli, D. H. Gil u. C.Giménez, Madrid (Palacio de Velázquez u. Palacio de Cristal) 1985

The European Iceberg, Texte v. G. Celant, B. Corà u. J. Gachnang, Toronto (The Art Gallery of Ontario) 1985

Les Immateriaux, Text v. J. F. Lyotard, Paris (Musée National d'Art Moderne) 1985

The Knot: Arte Povera at P.S.1, Texte v. G. Celant, A. Heiss, New York (Institute for Art and Urban Resources) 1985

Transformations in sculpture – Four decades of American and European Art, Text v. D. Waldman, New York (Solomon R. Guggenheim Museum) 1985

Il Museo Sperimentale di Torino – Arte italiana degli anni Sessanta nelle collezioni della Galleria Civica, Texte v. M. Bandini u. R. M. Serra, Turin (Castello di Rivoli) 1985

Mehr Licht – More Light, Texte v. A. Lipp u. P. Zec, Hamburg (Kunsthalle) 1985

Frau usikkerheit til samlet Kraft, Text v. B. Merz, Oslo (Kunsternes Hus) 1986

Tu es pierre, Texte v. A. Bonfand u. D. Dobbels, Poitiers (Association L.A.C., Site de Vassiviétre) 1986

Ooghoogte – Stedelijk Van Abbemuseum 1936–1986, Text v. R. Fuchs, Eindhoven (Stedelijk Van Abbemuseum) 1986

Cosa fanno oggi i concettuali?, Text v. R. Barilli, Mailand (Rotonda della Befana) 1986

XI. Quadriennale, Texte v. G. Gatt u. G. Accame, Rom (Palazzo dei Congressl) 1986

XLII. Biennale di Venezia, Texte v. A. Lugli u. a., Venedig 1986

Qu'est-ce que la sculpture Moderne?, Texte v. D. Bozo, M. Rowell, R. Krauss, B.H.D. Buchloh, T. de Duve, B. Rose, F. Meyer, J.P. Criqui u. J.M. Poinsot, Paris (Centre Georges Pompidou) 1986

Joseph Beuys zu Ehren, Texte v. A. Zweite, L. Glozer, G. Jappe, J. Cladders, K. Gallwitz, T. Messer, F. van der Grinten, R. Speck, G. Ulbrich, L. Amelio, R. Feldman, A. d'Offay, J. Schellman u. B. Klüser, München (Städtische Galerie im Lenbachhaus) 1986

Le Fragment et le Hérisson, Texte v. D. Semin u. A. Bonfand, Les Sables d'Olonne (Musée de l'Abbaye Sainte Croix) 1986

Un regard de Bruno Corà sur les oeuvres du F.R.A.C. Rhône-Alpes, Text v. B. Corà, Rhône-Alpes (Museé de Grenoble) 1986

La Fondazione De Fornaris – Arte Moderna a Torino, Text v. R.M. Serra, Turin (Promotrice delle Belle Arti) 1986

Il Cangiante, Text v. C. Levi, Milan (Padiglioni d'Arte Contemporanea) 1986

Skulptur Projekte in Münster,
Texte v. K. Bussmann, K. König,
T. Kellein, V. Loers, C. Schreier,
H. Kersting, A. von Graevenitz,
B. H. D. Buchloh, E. Decker,
F. Meschede, S. Weirich,
U. Wilmes, M Brouwer u.
G. Winter, Münster (Westfä-
lisches Landesmuseum für
Kunst und Kulturgeschichte)
1987

Turin 1965–1987 de l'Arte Povera
dans le collections publiques
françaises, Texte v. D. Soutif,
G. Labrot u. B. Marcadé, Roch-
sur-Yon, (Musée d'Art et d'His-
torie de Chamberry/Museé de
l'Hospice Comtesse (Lille) /
Musée d'art de la Roche-sur-
Yon) 1987

Disegno italiano del dopoguerra,
Texte v. P. G. Castagnoli u.
F. Guardoni, Frankfurt
(Kunstverein) 1987

Italie hors d'Italie, Texte v. R. Calle,
J. Gachnang, R. H. Fuchs,
A. Lukinovich, R. Guidieri u.
J. d. Sanna, Nîmes (Musée des
Beaux-Arts) 1987

Voluti inganni, Texte v. W.
Guadagnini u. P. Jori, Bologna
(Galleria G7) 1987

Colección Sonnabend, Texte v.
J. L. Froment u. M. Bourel,
Madrid (Centro de Arte Reina
Sofia) 1987

Nachtvuur-Nightfire, Texte v.
S. Bos u. E. Van Duyn,
Amsterdam (Gallerie De Appel)
1987

Zurück zur Natur, aber wie?,
Karlsruhe (Städtische Galerie)
1988

Periplo della scultura italiana
contemporanea, Texte v.
G. Apella, P. G. Castagnoli
u. F. D'Amico, Matera (Chiesi
Rupestri) 1988

ROSC'88, Dublin (Royal Hospital –
Guinness Hop Store) 1988

Worte, Text v. P. Zelechovsky,
München (Galerie der Künstler)
1988

1988 Carnegie International, Texte
v. L. Baumgarten, J. Caldwell,
D. Cameron, V A. Clark,
L. Cooke, J. Gambrell, K. Jones,
M. Kalinovska, B. London,
T. McEvillery, S. McFadden,

M. Newman, L. Norden,
N. Princenthal, J. d. Sanna,
S. Schmidt-Wulffen u. M. We-
lish, Pittsburgh (The Carnegie
Museum of Art) 1988

Les Chants de Maldoror, Text v.
L. Durand-Dessert, Paris
(Galerie Durand-Dessert) 1988

Collection du Musée van Abbe
d'Eindhoven (II partie), Nîmes
(Musée des Beaux Arts)
1988

Italian Art in the 20th Century,
Texte v. A. A. Rosa, P. Baldacci,
C. Bertelli, E. Braun, G. Briganti,
M. Calvesi, P. V. Cannistraro,
L. Caramel, G. Celant, E. Coen,
E. Crispolti, A. M. Damigella,
M. De Michelli, J. M. Lukach,
A. Lyttelton, N. Rosenthal,
J. d. Sanna, W. Schmied,
C. Tisdall, P. Vicarelli u. S.
Woolf, London (Royal Academy
of Arts) 1989

Verso l'Arte Povera, Texte v. M.
Meneguzzo u. P. Thea, Mailand
(Padiglione d'arte contempo-
ranea) 1989

MaterialMente, Texte v. D. Auregli
u. C. Marabini, Bologna (Galleria
Comunale d'Arte Moderna) 1989

Bilderstreit, Texte v. L. Gachnang
u.a., Köln (Messehallen) 1989

Wittgenstein. Das Spiel des
Unsagbaren, Wien (Wiener
Sezession) 1989

Hic sunt Leones, Texte v. W. Beck
u.a., Turin (Parco Michelotti)
1989

1990

Vom Verschwinden der Ferne:
Telekommunikation und Kunst,
Texte v. T. Werner, P. Weibel,
E. Decker, B. Fontana, M. Neu-
haus, A. Abramsen, F. Malsch,
S. Zielinsky, F. Pichler, T. Starl,
H. v. Amelunxen, G. H. Lisch-
ka, F. Rötzer u. P. Virilio,
Frankfurt am Main (Deutsches
Postmuseum) 1990

Hic sunt Leones II, Texte v.
W. Beck u.a., Turin (Parco
Michelotti) 1990

Conceptual Art, Minimal Art, Arte
Povera, Land Art. Sammlung
Marzona, Texte v. W. Lippert
u.a., Bielefeld (Kunsthalle)
1990

Die Endlichkeit der Freiheit, Texte
v. Heiner Müller u.a., Berlin
1990

Temperamenti, Texte v. T. Jackson
u. P.G. Castagnoli, Glasgow
(Tramway) 1990

Arte conceptual: una perspectiva,
Texte v. C. Gintz, B. Buchloh,
J. Kosuth, C. Harrison, G. Guer-
cio, A. R. Rose, S. Siegenlaub
u. R. C. Morgan, Madrid
(Fundación Caja de Pensiones)
1990

XLIV. La Biennale di Venezia:
Dimensione Futuro. L'Artista e
lo spazio, Texte v. P. Portoghesi,
L. Cherubini, A.B. Oliva,
R. Barilli, B. Blistène u.a.,
Venedig (Biennale di Venezia)
1990

Arte Povera, Text v. F. Piquè,
Turin (Galleria in Arco) 1990

Arte Povera 1971 und 20 Jahre
danach, Text v. Z. Felix,
München (Kunstverein) 1991

Towards a New Museum, Texte v.
J. R. Lane, J. Caldwell u. J. C.
Bishop, San Francisco (Museum
of Modern Art) 1991

Intersezioni: Arte italiana negli anni
'70-'80, Text v. P. G. Castagnoli,
Budapest (Galleria Mücsarnok)
1991

La Collection Christian Stein. Un
regard sur trente annés d'art
italien (1960–1990), Text v.
C. Francblin, Villeurbanne
(Le Nouveau Musée) 1992

Territorium Artis, Text v. P. Hultén,
Bonn (Kunst- und Ausstellungs-
halle der Bundesrepublik
Deutschland) 1992

Ostsee Biennale 1992, Text v. U.
Bischoff, Rostock (Kunsthalle)
1992

Tierra de nadie, Texte v. J.L. A.
Stals u. H.K. Bhabha, Granada
(Hospital Real) 1992

Avanguardie in Piemonte 1960/1990,
Texte v. M. Bandini u.a.,
Alessandria (Palazzo Cuttica)
1992

Gravity & Grace: the Changing
Condition of Sculpture, Texte
v. Y. Safran, J. Thompson u.
W. Tucker, London (Hayward
Gallery) 1993

Bienal Internacional de Obidos,
Obidos / Portugal 1993

Devant, le futur, Texte v. P. Hultén
u. Y. Setaik, Taejon (Taejon
Expo '93) 1993

Un'avventura internazionale. Torino
e le arti 1950–1970, Texte v.
G. Celant, I. Granelli, P. Fossati,
A. Papuzzi u.a., Turin (Castello
di Rivoli) 1993

Azur, Paris (Fondation Cartier
pour l'art contemporain) 1993

L'œuvre a-t-elle lieu?, Rotterdam
(Witte de With) 1994

Die Sammlung Marzona, Text v.
E. Marzona, Wien (Museum
Moderner Kunst Stiftung
Ludwig) 1995

Arte Povera. Arbeiten und
Dokumente aus der Sammlung
Goetz 1958 bis heute, Texte v.
I. Goetz, G. Anselmo, Johannes
Meinhardt u. C. Meyer-Stoll,
München 1997

Pittura italiana da collezioni italiane,
Text über Anselmo von G.
Verzotti, Turin (Castello di
Rivoli), 1997

2000

E così via, Texte v. E. Marzona,
M. Codognato u. E. Coen, Lon-
don 2000

Arte povera in collezione, Texte
v. G. Anselmo, I. Gianelli,
M. Beccaria u. G. Verzotti,
Turin (Castello di Rivoli) 2000

Zero to Infinity, Text v. K. Jacobson,
Minneapolis (Walker Art Center)
2001

Grande opera italiana: Alighiero
Boetti, Domenico Bianchi, Ettore
Spalletti, Giovanni Anselmo,
Giulio Paolini, Giuseppe Penone,
Gilberto Zorio, Jannis Kounellis,
Neapel (Castel Sant'Elmo)
2003

La Poetica dell'Arte Povera, Texte
v. N. Bätzner, P. Gilardi, C. Cri-
ticos, K. Kohlhoff, C. Meyer-
Stoll, T. Zervosen, U. G. Jellner,
A, Hornemann, G. B. Salerno,
Magdeburg (Kunstmuseum
Unser Lieben Frauen) 2003

Artist's books
Künstlerbücher

1970 – 1990

Leggere, Turin 1972
116 Particolari visibili e misurabli di INFINITO, Turin 1975
Lire, Gent 1990

Photo credits
Bildnachweis

Giovanni Anselmo

Museum Kurhaus Kleve,
26. 9. 2004 – 9.1. 2005
Ikon Gallery, Birmingham,
1. 2. – 28. 3. 2005

Exhibition · Ausstellung
Concept · Konzept
Jonathan Watkins, Guido de Werd
Assisted by · Assistenz
Karen Allen, Tiziana Caianiello
*Installation of the exhibition ·
Ausstellungsaufbau*
Kleve: Wilhelm Dückerhoff,
Norbert van Appeldorn
Birmingham: Helen Juffs, Chris
Maggs, Jo Jones, Julie Brown,
Phil Duckworth, Steve Evans

Catalogue · Katalog
Editors · Herausgeber
Jonathan Watkins, Guido de Werd
Editing · Redaktion
Karen Allen, Tiziana Caianiello,
Roland Mönig, Jonathan Watkins,
Guido de Werd
Assisted by · Mitarbeit
Ramona Kun-Kuti
Graphic design · Typographie
Michael Zöllner, Cologne · Köln
& Ingo Offermanns, Antwerp ·
Antwerpen
Printing · Druck
B.o.s.s Druck und Medien, Kleve
Separations · Lithographie
Farbanalyse, Cologne · Köln

© 2004
Giovanni Anselmo, Ikon Gallery
Birmingham, Museum Kurhaus
Kleve and authors · und Autoren

ISBN 3-934935-18-4
(Schriftenreihe Museum
Kurhaus Kleve – Ewald Mataré-
Sammlung, Nr. 24)

ISBN 1-904864-07-4 (UK)

With special thanks to ·
Mit besonderem Dank an:
Pier Luigi Barrotta, Italian Cultural
 Institute London
Marie-Therese Champesme
Peter Doroshenko
Dorothee Fischer, Konrad Fischer
 Galerie, Düsseldorf
Mario Fortunato
Michael Kewenig, Kewenig Galerie
Maria Lella, Italienisches Kultur-
 institut, Köln
Tim Llewellyn, The Henry Moore
 Foundation
Joseph Schnyder, Stanley Thomas
 Johnson Foundation
Micheline Szwajcer

Die Ausstellung im Museum
Kurhaus Kleve steht unter der
Schirmherrschaft Seiner Exzellenz,
des Botschafters der italienischen
Republik, Silvio Fagiolo.

Die Ausstellung im Museum
Kurhaus Kleve wurde unter-
stützt von

GEORGIA **HOTEL CLEVE**

Sparkasse Kleve
Partner des Museum Kurhaus Kleve

Ikon gratefully acknowledges
financial assistance from Arts
Council England and Birmingham
City Council.

The exhibition at Ikon is
supported by

The Henry Moore
Foundation

STANLEY THOMAS
JOHNSON FOUNDATION